ETERNAL
GOTH

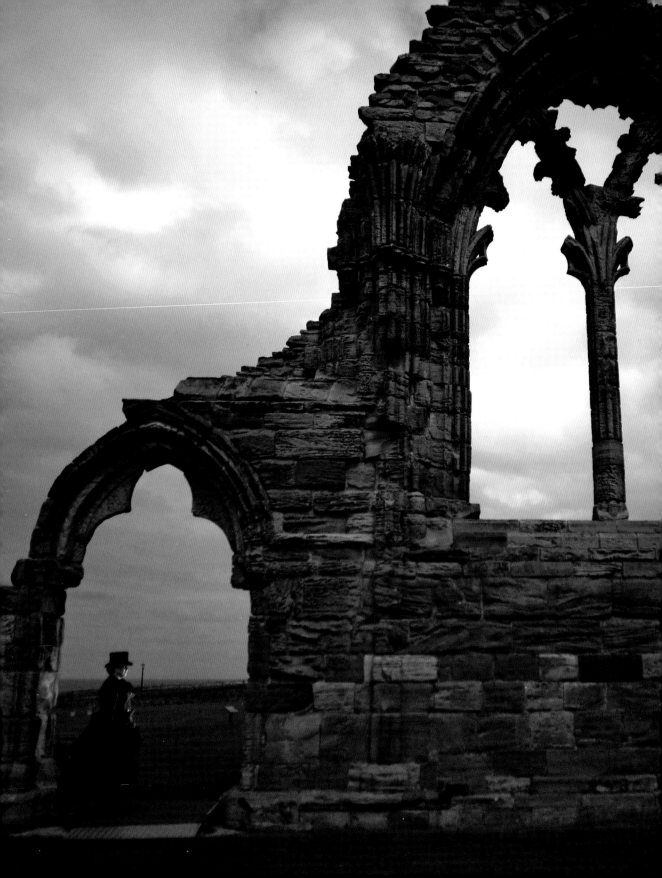

ETERNAL GOTH

EXPLORING THE WORLD'S MOST ENIGMATIC CULTURAL MOVEMENT

EMMA MADDEN

castle

CONTENTS

it? But you know who that sounds pretty great to, all that darkness and coffin-rotting? The Goths. While the rest of us idiots enjoy life, or at least pay taxes and rent to be here, the Goths spend their entire lives preparing for the inevitable.

To just about everyone but Goths, death and decay are locked up and secluded in places we'd rather not enter: hospitals, cemeteries, the local GameStop. We typically deny the fact of our slowly rotting bodies and mortality, but every now and again, when it gets really dark, we might allow ourselves a little indulgence. We stare the shadow of death in its face during sleepless nights. We dress up as skeletons once a year. We might watch horror movies or true crime documentaries because there's something about that pile of bones that fascinates us, makes us lean in closer.

Polite culture tells us to look away. But the Goth is a rude interruption, a dark inverse to the world that fools us into thinking that we'll live forever. No other genre or tradition has inspired as much rumination on death as the Gothic. From the Visigoth tribes to the birth of Gothic literature in the eighteenth and nineteenth centuries; from the late Victorian obsession with vampires to the vampire-dressing rock stars of the 1980s—a time when Goth became a subculture—the Goth has haunted the imagination of the civilized. But no matter how much we try to hide it, even inside the preppiest of the preps and the jockiest of the jocks lies the truth. Underneath perfectly coiffed hair is a skull. Underneath spray-tanned flesh is a stream of blood. And underneath L.L. Bean clothes is a skeleton. Hide it however you like, the Goth truly lives inside of us all.

RIGHT: Siouxsie Sioux and Peter Fenton of Siouxsie and the Banshees perform on stage at punk club The Roxy, London, 1977.

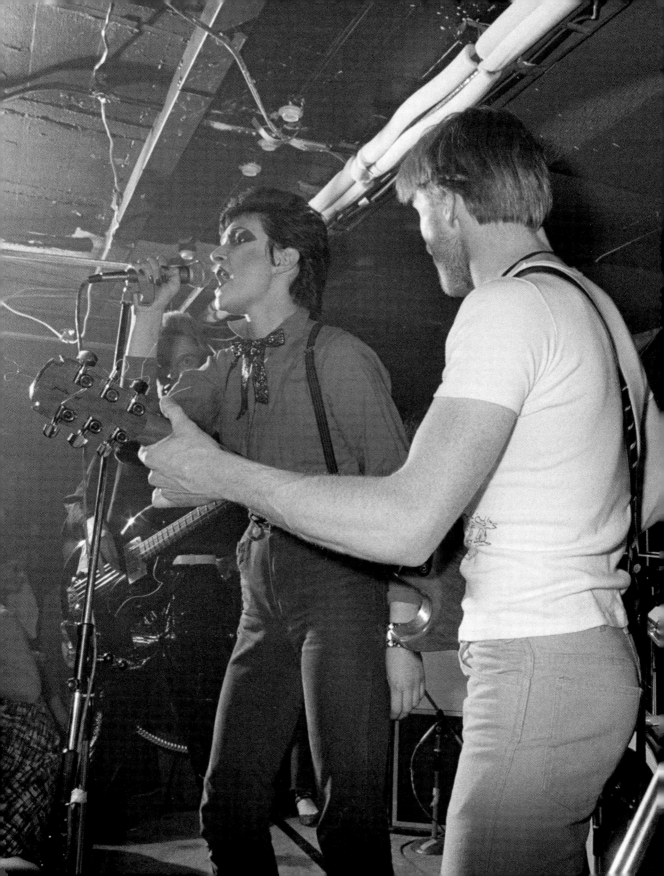

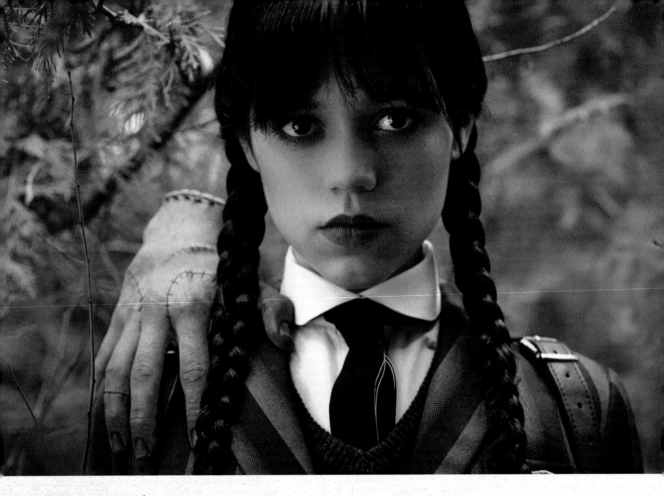

No matter what form they've taken throughout history, Goths have been cast away just as readily as most of us cast away thoughts of death. The reason the word "Goth" immediately brings to mind images of death, darkness, destructive tendencies, and your moody cousin Deborah is because "Goth" began as a collective term for a group of barbaric tribes who could have come from just about anywhere—more on that later. The term has since expanded so far in meaning that it's almost easier to say what Goth *isn't*. Goth isn't Abercrombie & Fitch, for instance. And it's certainly not a cucumber sandwich.

Goth *is* sex, Goth *is* death, Goth *is* telling the woman who birthed you, clothed you, and fed you, "Shut up, Mom!"

The fact that Goth is *so much* speaks to its undead status. Goth will always survive, and it will always haunt us, because the meaning of Goth mutates over time. The Goth is both as vague and pervasive as the darkness, a shadow, or a ghost. It is immortal.

Goth is also what you think it isn't: It's a sense of humor, a kind of campiness. It's horror with a twinkle in its eye. It's a strategy for coping with illness and mortality by either laughing at them or beautifying them, or both. Goth is the darker side of life, the lighter shade of death. And we need it now more than ever. Life has never felt so uncertain, its meaning so scrambled. The Goth—which began as a destroyer of civilization—is now the glue that could pull us back together.

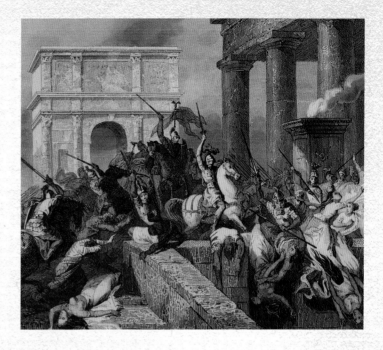

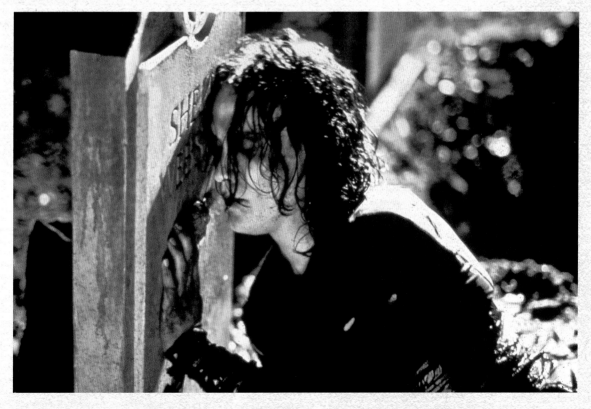

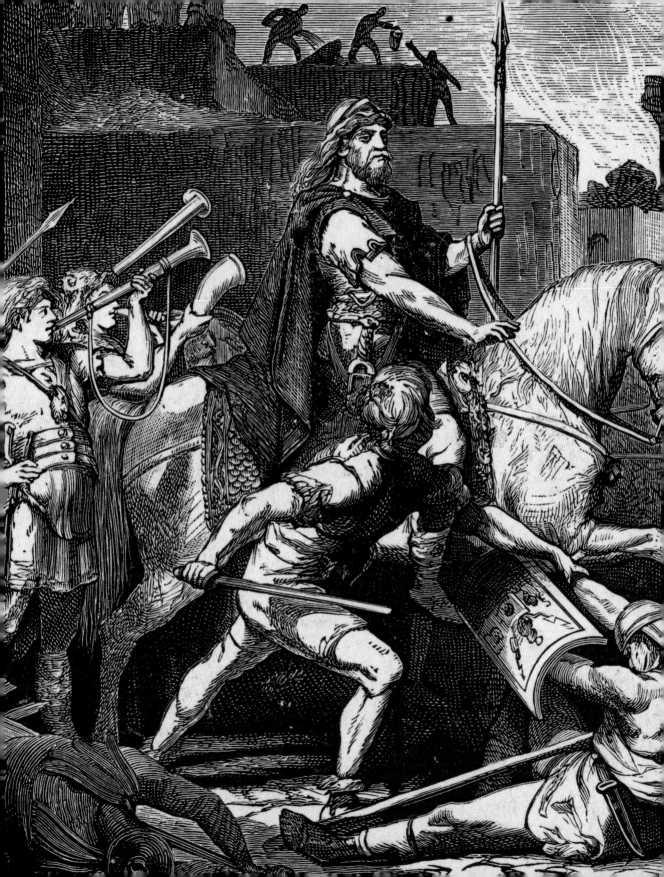

GOTH'S BAD REPUTATION BEGAN WITH THE FALL OF ROME

August 24, AD 410 began like any other day in Rome. Market traders opened their stalls, the sportsmen entered the stadiums, and the Romans, er, you know, did their Roman thing. One of them probably woke up, yawned, stretched, and said, "Ah! Today's going to be a good day." That fictitious person would be sorely mistaken. This was going to be a very, very bad day. If the mood hadn't already soured by mid-morning, surely the series of terrible omens felt throughout Italy would have done the trick: street dogs growled like werewolves while birds screamed in the sky.

An engraving of Alaric the Goth as he leads the attack on Rome in AD 410.

Just as twilight turned to uncivil dusk, the Goths—more specifically, the Visigoths—announced themselves at Rome's doorstep. Alaric, the Visigoths' brooded and foreboding leader, had led them to the breaches while the hot summer sky paraded its final bursts of red. Then, darkness. The Goths barged in through the doors and portcullises, sending a rumble through the city while howling so hard their throats could have bled. Their terrible announcement was so loud and tremorous that it overtook the roaring of the sports stadiums. And, for a moment, the games ceased while the dogs, the birds, and the city of Rome fell totally silent.

Then, the sound of terror resumed, redoubled. The Goths smoked the citizens out of their homes with fires that burned away any last sense of safety the Romans clung to. The city's paltry fire brigade tried fruitlessly to combat their attack with ladders, blankets, and wooden buckets full of water. The city's eight hundred thousand citizens pleaded for their lives and land. But it was no use. The Eternal City was made mortal by the Goths. The Roman Empire was no more, its libraries, temples, and stadiums burned to the ground.

The sheer devastation the Visigoths left in their wake would be incomprehensible to the modern mind, but to give it some kind of perspective: draw a circle around a good third of the globe, from Scotland all the way

SPOTLIGHT ON ALARIC

Alaric grew up on the Roman border—often referred to as the "backwater"—around AD 370 and cultivated his Gothic broodiness from a young age. Although born into a different tribe (possibly the Thervingis or the Greuthungs), Alaric eventually got a taste of the dark side when the Gothic soldier Gainas mentored him in military strategy. From there, Alaric joined the Roman army. After defeating the Franks, then Rome's enemy, Alaric didn't receive any kind of kudos and got real mad about it. He became a Gothic menace, rising through the ranks of the Goths before becoming the first king of the Visigoths in around AD 395.

around Russia to the base of Africa's Atlas Mountains. That was essentially the Roman Empire. It was an absolutely crucial nexus of communication, exchange, and knowledge. And it was no more.

In the following centuries, history looked unforgivingly upon the Goths. Their name became a byword for the barbarous, savage, and unchic. They'd be known forevermore as harbingers of darkness; the journey between the Visigoths and Sisters of Mercy is a straight line (as we'll soon learn).

The history of the Goth begins sometime around the first or second century AD, though it's shadowy, to say the least. Very little is known about the Goths prior to their Roman invasion. Really, the only verifiable history we have of the Goths is from Roman accounts, and since they didn't exactly regard the Goths in the highest favor (understandable), history came to accept the Goths on the Romans' terms: as merciless disruptors and destroyers.

The few versions of the Goth origin story differ wildly. Some say they came from Scandinavia, others say Poland. Save the Romans, the main source we have is Jordanes's *Getica*, a text that should be taken with a Sisyphean rock of salt, since it's highly questionable whether it contains any semblance of historical truth or is just a document of Goth propaganda. Many scholars have outright rejected it, deeming it the stuff of myth, the equivalent of Goth sponcon.

While there's not much we can accurately say about the Goths, what we do know is that they were surely a Germanic people who were hell-bent on spreading themselves far and wide throughout Europe and breaking the rule that Rome had enjoyed for centuries. We also know that sometime between the late 200s and early 300s AD, they split themselves into two primary tribes: the Visigoths, who settled in the west of the continent, and the Ostrogoths, who took the east. Together, they gradually moved southeast, inching their way toward Rome and its riches.

Since they hailed from colder climates, they were pale in complexion. While the Romans went around bare-legged, the Goths covered their ankles with long, flowing garments. Those in the Empire considered those strange, ankle-covering folks from chillier climates to be cold in personality, too, and thought of Goths overall as disorderly brutes. The Goths didn't speak so much as stammer. They didn't observe religion so much as consign themselves to the whims of superstition. To the Romans in particular, they were barbarians,

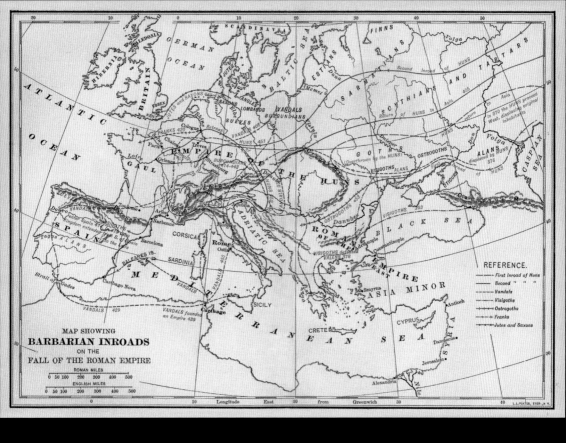

a word they derived from Greek to mean anyone outside the Roman Empire. For as long as they've existed—and still today—the Goths have been observed as agents of mystery and terror.

Prior to their invasion of Rome in AD 410, the Goths had launched a series of attacks across the continents we now know as Europe and Asia. Their first took place in AD 238, in what is now modern-day Hungary. In 251, they slayed their first Roman Emperor. By AD 320, they'd conquered so many territories that the Lower Danube came to be known as the "Gothic bank." They were undeniably good fighters, though certainly not invincible. In AD 376, they were forced out of their Central and Eastern European colonies by nomads from Central Asia known as the Huns. With arrows pointed to their chests, the Goths crossed the River Danube and settled on the Roman Empire's riverbank, before invading Rome shortly thereafter.

The Goths found Rome in a depleted state. Several provinces had been wrestled from the Empire's rule; Rome's trade networks were ramshackle; hot water rarely ran as it once had. For two long years, the Goths preyed on the Romans' insecurities before confronting them once again during the Battle of Adrianople in AD 378, a battle the Goths won, and which helped fortify them for their ransacking of Rome thirty-two years later.

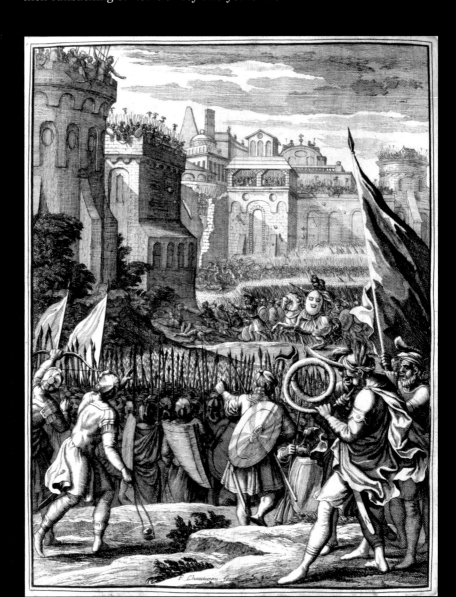

François Chauveau's engraving of the sacking of Rome.

In the years before the sacking of Rome, the Romans and Goths lived side by side. Having proved themselves to be militaristically skilled, the Goths were enlisted in Rome's imperial army. The Goths sort of adapted to Roman life—though one can only begin to imagine the passive aggression exchanged between the two. On the surface, it was a fairly peaceful coexistence. Truthfully, the Goths didn't have any of it. As the years passed, they grew increasingly weary of living under Rome's religious and cultural control.

So, on that summer's day in AD 410, the Goths finally fought for their freedom. Taking Alaric's lead, they spent three days pillaging Rome and holding the city hostage. How exactly did they manage to defeat one of the most illustrious empires the world has ever known? Well, remember Russell Crowe in *Gladiator*? It was sort of like *that*, except, in your mind's eye, give Crowe a pale complexion, dark robes, and an overall more emo disposition, and you might have a somewhat accurate vision of what went down on August 24, AD 410—total carnage, slaughter galore, the unrestrained violence of barbarians.

After their attack, the Goths moved swiftly southbound to Sicily, hoping to make a quick escape to the African cape. Too bad. Alaric died suddenly during the early months of 411, his cause of death most likely malaria. His tribe buried him under the riverbed before retracing their steps and taking a walk of shame through Spain and back toward Italy. The Visigoths headed north toward what would now be Luxembourg and spread across the Iberian Peninsula, while the Ostrogoths carried on westward toward Italy.

While the Ostrogoths' rule over Italy lasted barely more than a few generations, the Visigothic rule held for just short of three centuries, before falling to Muslim Arabs in AD 711. The Goths left no historical accounts of their own, no literature of any kind. All they left was a sense of unease and mystery that would mark the beginning of Europe's medieval period.

Moats, Murder Holes, and Mayhem: The Dark Ages and Barbaric Architecture

ith their hand in the destruction of the Roman Empire, the Goths had sealed their eternally bad reputation. Wonder why the Goth cousin who comes to the Thanksgiving table wearing fishnet sleeves gets such unfriendly stares? Well, it all started here, in AD 500, a time when *Goth* first became synonymous with darkness and destruction.

No thanks to the Goths, there was little to be salvaged from Rome's collapse. A substantial portion of Europe's culture and resources was concentrated there, and so with the fall of Rome came the fall of civilization. Superstition ran rampant and rationality fell to the wind. Science and technology regressed. Witches were a thing. All in all, a very Gothic time.

York Minster, prime real estate for a Goth pigeon.

which is just as well, because these were the Dark Ages—a time of paranoia and decay which lasted several centuries.

The "Dark Ages" was a metaphor that the fourteenth century poet Francis Petrarch—a great admirer of Roman classicism—applied to the period spanning roughly AD 500 to late AD 1000, deeming them years of torpidity and decline. In these years, the Roman Catholic Church became a means of social cohesion and civility. At that time, the Church was an institution that looked skeptically upon the scientific advancements that Greece and Rome had made in the preceding centuries, all of which relocated to the Islamic regions of

FIVE DARK AGE TREATMENTS MORE LIKELY TO KILL YOU THAN CURE YOUR COLD

1. Trepanation, or drilling a hole in the patient's skull: Used to abate the pain of a brain injury; this, funnily enough, only exacerbated the anguish.
2. Cannibalism (yes, really): Many believed that by eating the flesh of a healthy youngster, one could accrue their vital spirit. Degenerative disease might be more likely.
3. Bloodletting: A standard medical practice across Europe, bloodletting was a one-size-fits-all solution to, among many other maladies, measles and gout. It required physicians to poke around at veins, a process that often went horribly wrong.
4. Binge-drinking alcohol: Some believed that getting absolutely pickled would restore them back to health. These people were probably already drunk.
5. Placing a cold-water plant under a pillow to keep the devil at bay: Before gym bros dunked themselves in cold plunges, many medieval physicians recommended keeping a plant plucked from a cold riverbed under one's pillow, so that the devil may not taunt their nervous system further.

Northern Africa, while Europe languished in total unreason. While Arabian doctors were finding cures for measles and smallpox, European doctors were concocting potions from opium poppies. Who needs science when you have imagination? As religious superstition reigned, people became so obsessed with their souls that they forgot about their ailing bodies. If you were physically sick, you were basically a goner. If you were mentally ill? Double goner. The depressed were burned at the stake, chained to walls, or simply starved to death in the mostly unattended madhouses.

All in all, medicine was a field more likely to kill you than heal you in Europe at this time. Medicine was totally absorbed into the rubric of religion, diagnoses and cures simply matters of destiny and sin. The Church spread the belief that ill health was God's way of meting out punishment and that if you wanted any chance at life, you'd have to pray your pain away.

Unsurprisingly, fear was the prevailing feeling of the time, and it took the shape of some strange beasts. While the Dark Ages may have been lacking in just about every other department, to its credit, it did develop a very rich culture of fantastical varmints (all completely imagined, of course). The French had their werewolves, the Norwegians their trolls, the Romanians their undead beasts (which later took the form of the vampire), the Irish their banshees. In a world run solely on spirituality and fantasy, rather than science and reason, the material world vanished in the fear-stricken minds of the people. Remember how you felt as a kid lying in the dark, staring at and making monsters out of the bumps in the ceiling? That was basically life in the Dark Ages. What you saw—or what you *believed* you saw—was your experience. It was wondrous. It was terrifying.

Magic and sorcery were, of course, commonly believed throughout Europe. As people felt powerless and submissive to the grim and unexplainable whims of the world, magic became a way to trick the mind into believing it had some sense of control. It was a fine grift too. A good way to scam people out of their petty cash in the Dark Ages was to present yourself as some kind of spiritual practitioner capable of magicking the bad stuff away. Although the Church disapproved of such practices, believing them to be products of Gothicism and paganism, these practitioners would cast spells and rituals with the language of Christianity to protect against hexes and rubbish vibes. But all that fun soon

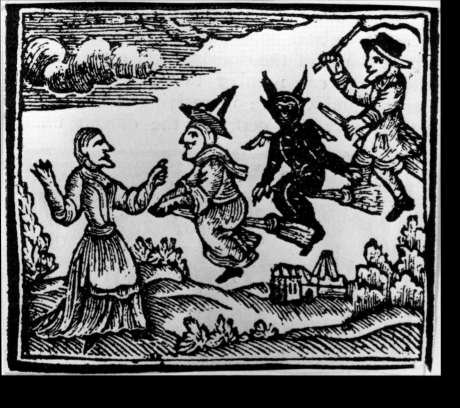

A seventeenth century woodcut depicting a witch on her broomstick, closely followed by the devil, of course.

came to an end with the publication of *Malleus Maleficarum* (often translated as the *Hammer of Witches*), an early Middle Ages text that decried magic and witchcraft as heresy. Totally not sexist or anything, but these heretic witches were almost always women. And women—I mean, *witches*—had to be exterminated.

So began the witch hunts. The infractions were so broad that it would have been very easy to accuse and then take to trial just about anyone for witchcraft. Hanging around in a group of women? That's the stake for the lot of you. Mole on your skin? You're donezo. Just slightly odd-looking? Be gone, witch!

All pretty dismal stuff, really. But if there's one saving grace of this period, it's the architecture. During the Romanesque period—around AD 1000, when the Dark Ages saw a pinhole of light—architects began fitting churches with small stained-glass windows, arches, vaulted ceilings, and gargoyles and demons, which they placed on the church's facade as symbols of expulsion. Demons and grotesque creatures then became regular fixtures in art across the

LEFT: An engraving in Mayen, Germany, 1937.

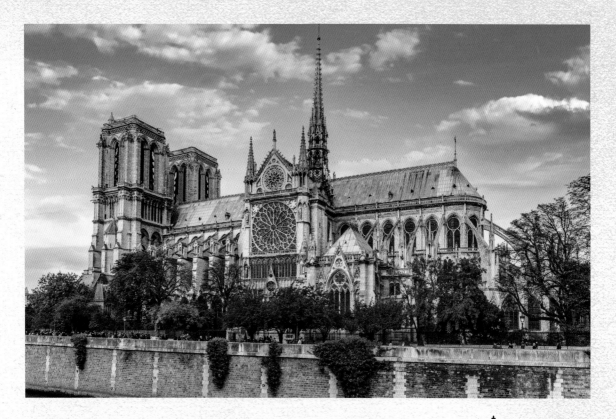

TOP: Notre-Dame Cathedral of Paris. Nope, never heard of it.

contributing to the creepy imagery that would later fall squarely within the bounds of the Gothic.

Gothic architecture, which first emerged in twelfth-century France, was an extension of the Romanesque style. It took Romanesque arches, ceilings, and demons to the next level, amplifying their features while multiplying the magnitude of their scale. It introduced a new era of architectural design, placing an emphasis on brightness and height, with the intent to climb as high as possible toward the heavens while drawing in as much light as possible—enough to kill off a modern-day Goth. The buildings were as skinny as they were tall—the supermodels of building design. Abbot Suger's Basílica of Saint-Denis, located just north of Paris, was one of the first demonstrations of this new style, with its lanky columns, intimidating beauty, and radiating light. Cathedrals made in a similar style swiftly emerged throughout France, each an attempt to rise above the other. The taller the spire, the closer to God.

LEFT: Saint-Denis, France's Basílica de Saint-Denis, a gargoyle hotspot.

These architectural ideals—which departed quite radically from Roman principles of symmetry and proportion—soon spread throughout Europe. While each country and region developed its own take on the Gothic style, the key features remained consistent throughout the continent: pointed arches, ribbed vaults, and flying buttresses. Also gargoyles.

Such elements were all innovations from the masons of the late Dark Ages, solutions to the problem of building upward when the heavy stonework was pulling the structure down. Pointed arches—a crossing of two circles at a sharp angle—redistributed the weight of the downward thrust. Ribbed vaults—an intersection of stone panels capable of supporting a vaulted ceiling—significantly reduced the building's weight. Flying buttresses—an arch that extended from the upper wall to a faraway pier—bore the load of the roof. Grotesques and gargoyles didn't help the structure in any way, but they *were* badass.

These Gothic structures, undoubtedly the cultural highlight of one of history's bleakest periods, have since become some of the most iconic and instantly recognizable buildings in the world. The example most likely in your mind right now is the Cathédrale Notre-Dame in Paris, an enduring masterpiece of Gothic architecture and surely the best in class.

It's now difficult to conceive that Notre Dame and the architectural style it represents were once highly disparaged. But public perceptions of flying buttresses, vaulted arches, and even

My ex ponders what went wrong over the streets of Paris from a perch on Notre-Dame.

gargoyles swung out of favor in the early sixteenth century, and all because of one word: "Gothic."

While those living in the early Middle Ages referred to this new architectural style as either French, Norman, or Modern design, in 1518, the Italian painter and architect Raphael was likely the first to name it Gothic, which he meant offensively. In a letter to Pope Leo X, whom he'd soon paint, Raphael compared the tall churches to the primeval housing of the Goths. In 1550, Giorgio Vasari, another Italian painter and architect, made the insult stick in *The Lives of the Most Excellent Painters, Sculptors, and Architects*, a landmark work of art history. Vasari clearly had a distaste for what he perceived as anticlassical design and aligned this new style with the perceived barbarity of the Goths, just as Raphael had done twelve years prior. By the time Vasari had thrown his shade, Gothic architecture had fallen out of vogue.

As the Dark and Middle Ages came to a close and economic balance was approaching restoration in Europe, those flying buttresses and gargoyles came to look uglier and uglier to the enlightened mind. During the onset of the Renaissance, when the merchant classes began to flourish and feudalism fell by the wayside, a taste for the classics reemerged. Sort of like that time in the early 2000s when everyone dressed like a music video from the '80s, the past was revivified.

Since relatively little was known about the Dark Ages, Renaissance historians cast it off, peddling the narrative that the Goths had destroyed the glory of the classical world and ushered in a centuries-long gloom. The period spanning AD 500 to 1000 was deemed completely at odds with the current moment, and the Dark Ages, which had by then become synonymous with the Gothic, represented everything the Renaissance was trying to counter. Those gangly cathedrals appeared pretty tasteless and kitsch compared to the simplicity of the Greco-Roman styles. Just as Gothic tribes were viewed as savages, Gothic architecture became an emblem of depravity.

Until at least the late eighteenth or early nineteenth century, history looked upon everything Gothic and Goth-adjacent as a vulgarity, a destructive force threatening to pull modernity back into the darkness. But toward the end of the Age of Enlightenment, when fantasy had hardened into reason, the Gothic cathedrals of the enchanted past set imaginations stirring.

Cathedral of Our Lady of the Assumption in Clermont-Ferrand, France. Catty name, no?

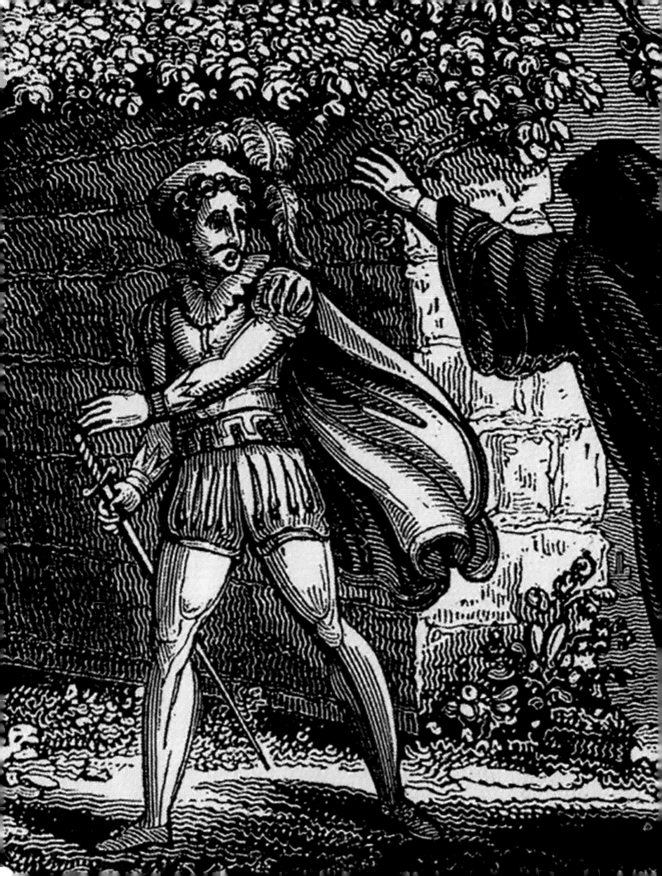

A SOPHISTICATED JOKE: THE BIRTH OF GOTHIC LITERATURE

aste and trends exist on a pendulum swing. One moment, skinny jeans are in, the next, they're out. One day, you're wearing a turtleneck and chain, the next, you find yourself on a rerun of *Fashion Police*. This has largely been the case with Goth—a back-and-forth swing between *hot* and *not* ever since it first came into vogue in the late eighteenth century.

The Gothic was the dark, sexy, fantastical counternarrative to the pragmatic Age of Enlightenment. With its ideals of logic, reason, and intellectual critique, the Enlightenment was a firm divergence from the savage, superstitious past.

A depiction of Montoni in Ann Radcliffe's *The Mysteries of Udolpho.*

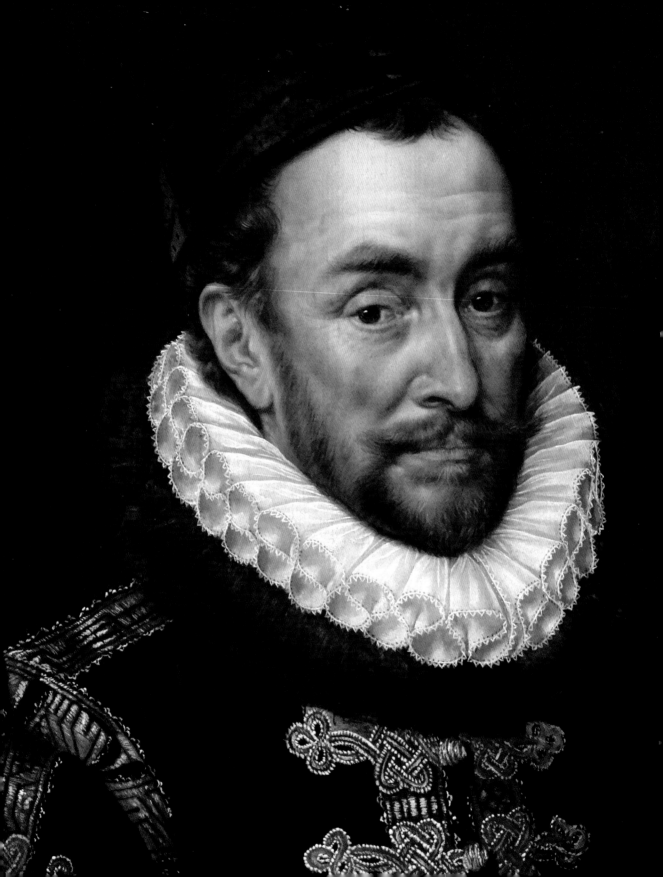

To an extent, all the early Gothic writers were responding to this abrupt loss of romanticism, and their fiction took the form of nostalgia for a medieval past that was exoticized in their minds. The Gothic was a form that indulged this nostalgia, and enabled feelings of mystery, fear, and bewilderment that were swiftly gaining their own kind of appeal.

As the appreciation for classical art and architecture reached its peak toward the mid-eighteenth century, the pendulum began to swing in the other direction. Those lanky cathedrals and gargoyles were even beginning to look kind of sexy. For the first time, and on a large cultural scale, Goth became a point of fascination rather than outright disgust. While the centuries immediately following the Goths' sacking of Rome had been defined by a condemnation for anything anticlassical—and therefore, pro-Goth—the further the fall of the Roman Empire fell into the past, the more romanticized it became in the minds of the present.

The Gothic Revival went hand in hand with the medieval revival, as historians and intellectuals began recharacterizing the period as one worthy of preservation. In England, the Gothic even became a point of patriotic pride, a sentiment that had been growing ever since William of Orange, the newly instated Protestant King of England, had defeated the Catholic King James II during the seventeenth-century civil war. During his reign, William minimized the power of the monarchy and raised the influence of Parliament, a model that historians of the time traced back to the Goths. While the sackers of Rome had previously been dismissed as barbarians, they soon came to be seen as brave protectors of liberty and democracy. In turn, the earliest Gothic writing was sneakily anti-Catholic, in an attempt to divorce English identity from its European and Roman Catholic past.

The Dark Ages came to be positively reframed, and darkness itself took on a broader meaning. Darkness, the proto-Goths realized, begat romance: The black sky brings out the moon and stars. Lovers tangle under sheets in unlit rooms. Darkness brings out monsters, too, but it's that fear that heightens the dark's erotic potential. Darkness is pregnant with both terror and romance in equal measure, and both forces work in tandem.

The provocativeness of this combination was formally realized by the philosopher and Anglo-Irish statesman Edmund Burke in 1757, when

LEFT: William of Orange, you old flirt, you.

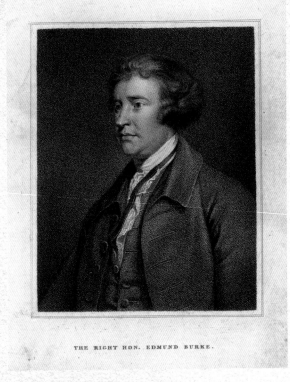

THE RIGHT HON. EDMUND BURKE.

Edmund Burke, please drop the haircare routine.

he published his widely influential text *A Philosophical Enquiry into the Origin of Our Ideas of the Sublime and Beautiful.* In it, Burke infused classical texts once solely associated with the ordered and virtuous past with a touch of terror. He referenced the *Aeneid*, Ancient Rome's epic text, drawing attention to Book Six, in which the protagonist faces the Underworld. Burke pointed to the Underworld's play of light and shadow and proposed the idea that flickering and fading light was scarier than total darkness (shadow play has haunted Gothic literature ever since).

This fear, Burke reckoned, was just as powerful as beauty. Seeing the sun rise over a mountaintop aroused just as much intensity of emotion as a scream in the dark. He attributed both feelings to the "sublime," the highest form of feeling a human being could possibly experience. That terror could be thought of as sublime was a groundbreaking—and Goth-making—notion. It articulated what most do not even dare think, let alone speak: how it feels to comprehend the entire life cycle, infinity, the dark mystery that is death.

Burke's theory of the sublime provided the temperament for Gothic literature and its overall reliance on mystery and heightened emotion. Gothic literature, a genre that emerged almost in tandem with the rise of the English novel, attempted to aestheticize that which terrifies us and to make romance out of fear. While the bestselling novels of the time, including Henry Fielding's *Tom Jones* and Samuel Richardson's *Clarissa*, were mostly mild-mannered and realistic portraits of the eighteenth century, Gothic novels were more like fantastical visions of history, filled with tales completely divorced from reality and plumbed from the deepest depths of the English psyche.

It's commonly asserted that the birth of this Gothic tradition took place on Christmas Eve 1764, when a little London-based publisher named Thomas Browne published a thin book titled *The Castle of Otranto*. *Otranto* was more

novella than novel, yet it set the conventions of the Gothic genre. Presented as a found manuscript written by a completely made-up medieval monk, *Otranto* begins with a young suitor being killed by a plumed helmet in a haunted castle. The ridiculousness does not let up. There are ghosts, skeletons, and stabbings aplenty; it is unmistakably Gothic. The novella was short yet stinging. It contained within it so many more tropes we now associate with horror, including bloody hallways, trapdoors, and bludgeoned innocence.

The concept came to Horace Walpole, the novella's author, in a dream, while he slept in Strawberry Hill, his Gothic home. Walpole, a keen lover of medieval history and the son of Whig prime minister Robert Walpole, was something of a Gothic tastemaker. Walpole's Gothic Revival style was gaudy, campy, and outrageous, and at that time not too dissimilar from the rococo style that had made a mark in France just a few decades earlier. His vision of Gothic was a meeting of rococo's frivolity with the gloom of medieval barbarity.

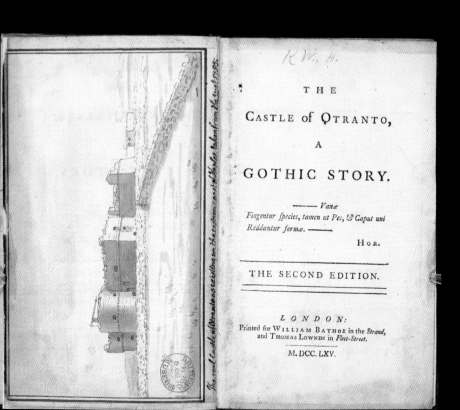

THE

CASTLE of OTRANTO,

A

GOTHIC STORY.

———— Vanæ
Fingentur fpecies, tamen ut Pes, & Caput uni
Reddantur formæ. ————

Hor.

THE SECOND EDITION.

LONDON:
Printed for WILLIAM BATHOE in the *Strand*,
and THOMAS LOWNDS in *Fleet-Street*.

M. DCC. LXV.

The frontispiece fo
Horace Walpole's
*The Castle Of
Otranto.*

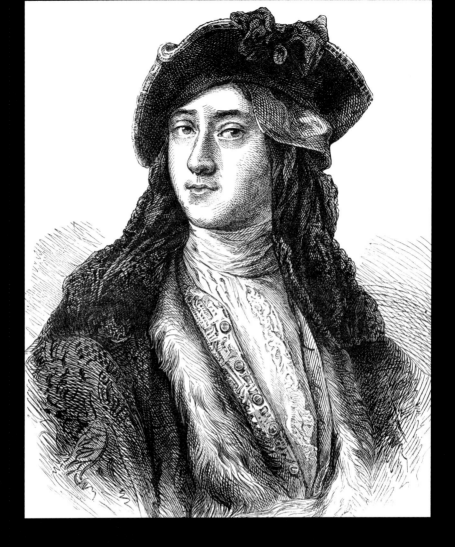

Horacio Walpole
absolutely serving,
as always.

He decided to apply this aesthetic to Strawberry Hill, the property
he'd leased in the spring of 1747. At the time of his purchase, Strawberry
Hill was little more than a very large, very British villa on Twickenham's
riverside. Three years later, he set about turning it into his own Gothic castle,
a renovation that would take some thirty years. He somewhat faithfully,
somewhat impressionistically followed early medieval designs, shaping his
property around his own half-informed, wholly romanticized vision of the past,
and used the Gothic as a way to express himself.

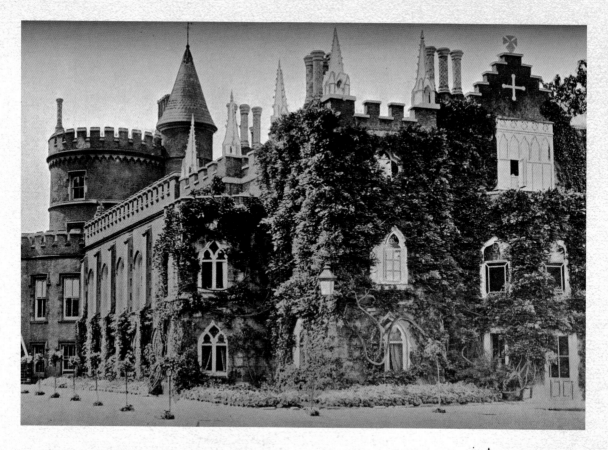

By the time renovations took shape, Strawberry Hill resembled an antiquarian's dream, or a theme park's vision of a Gothic castle: a magnificent white structure featuring towers, battlements, and stained-glass windows, the gloominess of its interior contrasting with the radiance of the garden. That's just the kind of juxtaposition Goths today still love to play with—here's looking at you, Tim Burton.

Walpole decorated the interior with the vast collection of bizarre trinkets he'd picked up over the years, including suits of armor, extravagant fireplaces, and antiques from far-flung countries. And when it finally came time to rest his head in the castle of his dreams, the nightmare that would inspire *Otranto* fell upon him. No doubt inspired by his surroundings, he dreamt himself climbing the staircase of an ancient castle and then suddenly seeing an enormous hand in armor. That was it—just a massive hand dressed in armor—but that was all it took to set a new literary tradition in motion. Upon waking, he sat down to

Strawberry Hill House in all its Gothic majesty.

THREE LESSER-KNOWN GOTHIC NOVELS OF THE LATE EIGHTEENTH CENTURY

Clermont **by Regina Maria Roche** follows Madeline, a pale and flighty Gothic protagonist, who is secluded from society alongside her father Clermont. While her father's past had always been shrouded in mystery, Madeline discovers why he's been so keen to conceal it when they're disturbed by a visitor one stormy night.

The Old English Baron **by Clara Reeve** tells the story of Sir Philip Harclay, who travels back to his hometown to find his dearest childhood friend dead by mysterious circumstances.

The Recess **by Sophia Lee** follows sisters Matilda and Elinor, the secret daughters of Mary Queen of Scots. Raised in an underground convent, they come up to the surface in their teenage years and soon learn a terrible truth.

write immediately. In less than two months, he'd completed the novella. When it came time to publish, Walpole remained anonymous, hoping his text would be read as a real-life medieval manuscript. But with its second edition, Walpole unveiled himself as its author and added a subtitle: *A Gothic Story*.

Until Walpole attached "Gothic" to his work, Samuel Johnson's *Dictionary of the English Language* had defined that word around two groups of meaning: as an all-encompassing term for the medieval period, as well as the barbarism associated with Germanic tribes. Walpole married those two meanings, forming his own brutal romance. With one small book, he shocked the English novel out of its meekness and expanded the potential of the form.

For this, Walpole was, like so many Goths in history, utterly despised. Artists and intellectuals at the time thought his writing contemptuous. He was largely cast out from the literary world. But Walpole held firm. He defended his novella endlessly, describing it as his bid to bring some fantasy to fiction.

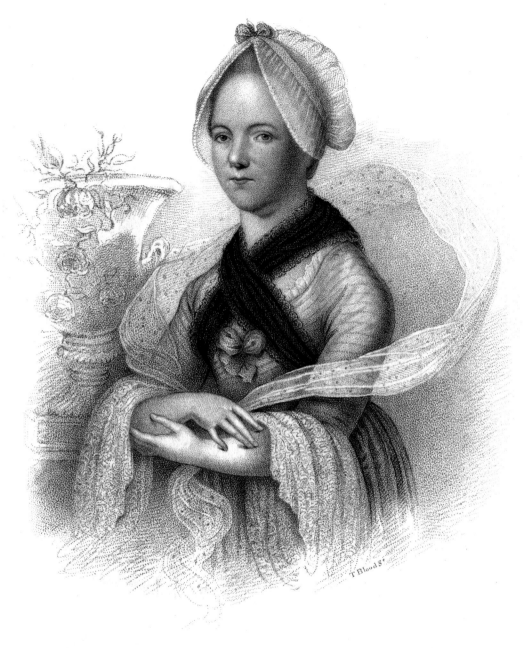

Miss Clara Reeve,

Author of the Old English Baron.

&c. &c.

to shake it out of the realist stupor it found itself in during the late eighteenth century. Walpole hadn't found much in modern literature that stirred him; he had to look to the past for excitement, to medieval tales and chivalric romances where creatures of the imagination roamed, and knights crushed on waifs so hard they'd slay dragons for them. Thanks to Walpole, others who felt the same lack in literature didn't have to look so far back. The romance of the past was brought forth to the present.

Otranto soon became a bestseller and was very quickly followed by a series of imitators. Like the Harry Potter or *Fifty Shades of Grey* of its day, Gothic literature was the biggest force in fiction. That watershed soon became a landfill, as innumerable books following Walpole's Gothic formula were published. Goth became a distinctive and easily recognizable genre that appealed even to first-time novel readers, luring them into bookstores and libraries. Since books were unaffordable to most in the late eighteenth century, most of these novels were borrowed from circulating libraries. Among the literature available, these early Gothic works, with titles like *The Necromancer* and *The Mysterious Warning*, stuck out and assured their borrower a good time. Almost all these novels were set in forests or castles in either ancient or medieval times and structured around the discovery of an old, barely decipherable manuscript. There were elements of the superstitious, too, whether that took the form of ghosts, wizards, or even a damned monk. Following Walpole's blueprint, these novels tended to receive a lot of press and turn an easy profit, and they were very likely to become bestsellers. With their quick translation turnarounds and heavy circulation, they also gained international recognition, and countries beyond England soon informed the Gothic genre too. While works of English literature had almost always taken place at home, in British manors or castles, the Goth of the late eighteenth century took the form abroad, placing dark fantasies in crumbling Spanish citadels or Italian palaces.

In his 1800 work *The Crimes of Love*, the French libertine writer Marquis de Sade put forth the theory that the rise of the Gothic across Europe in the 1790s was a response to the French Revolution. The Revolution, which caused tremendous unrest in France and stirred anxiety throughout the continent, could itself be considered Gothic. Not unlike the Goth barbarians of yore, the

supporters of the Revolution were fighting for freedom while spreading blood through the streets and toppling classical buildings.

Across art and literature in the late eighteenth century, strictly formalized romance and drama blossomed, offering an outlet for the overall sense of dread while keeping the drama contained within generic conventions. Early Gothic literature, perhaps more than any other form, was a way to subsume this terror while also shaping it into rigid conventions. It was a genre that gave a sense of control over fear, as well as a predictable sense of catharsis.

The fifth edition of Ann Radcliffe's *The Mysteries Of Udolpho*.

Mysteries of Udolpho.

Vol. 1. Ch. 1. P. 25.

THE

MYSTERIES OF UDOLPHO,

A

ROMANCE;

INTERSPERSED WITH SOME PIECES OF POETRY.

BY

ANN RADCLIFFE,

AUTHOR OF THE ROMANCE OF THE FOREST, &c.

ILLUSTRATED WITH COPPER-PLATES.

The Fifth Edition.

Fate sits on these dark battlements, and frowns,
And, as the portals open to receive me,
Her voice, in sullen echoes through the courts,
Tells of a nameless deed.

IN FOUR VOLUMES.

VOL. I.

LONDON:

PRINTED FOR G. AND J. ROBINSON,
PATERNOSTER-ROW.

1803.

SPOTLIGHT ON ANN RADCLIFFE

Hailed by the literati of the time as a female Shakespeare, Ann
Radcliffe was born an only child to Ann Oats and William Ward in 1764.
After the demise of the family haberdashery business, they moved to
Bath, where Radcliffe quickly established crucial literary contacts. In
1787 she married William Radcliffe, editor of *The English Chronicle*,
before releasing her first novel, *The Castles of Athlin and Dunbayne*
two years later. Although her earliest work received a middling
reception, the 1794 publication of her masterpiece, *The Mysteries of
Udolpho*, was one of the most famed novels of its time and turned
Radcliffe into the eighteenth-century Gothic It Girl. A feminist before
feminism was scarcely even a thing, she inspired innumerable women
in her wake, from Mary Shelley to Jane Austen.

A set of Gothic conventions began to form almost as quickly as they were
being written. Ann Radcliffe was among the most popular of these early
Gothic conventionalists, and perhaps the most important name among the first
generation of Gothic writers. Her most successful novel, 1794's *The Mysteries
of Udolpho*—the story of an orphan confined to a medieval castle and cast
away from her lover—followed Walpole's blueprint closely but reaped even
greater rewards than its predecessor. Radcliffe received a sum of £500 for
that novel (an unprecedented amount at the time) and £800 for her next novel,
The Italian.

Though commercially successful, these early Gothic novels were critically
panned. Reviewers considered them a lowbrow form that threatened the
reputation of England's high-collar literature. They looked upon Gothic
literature as the classicists had the Germanic tribes, as savages bringing
superstition and unreason to an enlightened age. But in a relatively boring,
mild mannered age, the Goths just wanted to have some fun.

Fig. 237. — *L'Italien, ou le Confessionnal des Pénitents noirs,* trad. de l'angl. d'Anne Radcliffe (1797).

An illustration from Ann Radcliffe's *Italian.*

THE VICTORIAN BLOODY: A GOOD TIME

n the early nineteenth century in England, visions of death were inescapable. Cracked necks hanged from guillotines. Pickled skulls littered the streets from public executions held days before. The Victorians were undeniably death obsessed. Their idea of a good time was watching the criminal and condemned come to very grizzly ends. Each week, criminals would be dragged from their prison cells to the gallows. During their journey through the streets, they'd be met with cheering and jeering from a crowd enjoying platefuls of food from the street sellers who quenched their bloodthirst with all kinds of meats. If they'd have any food left, they'd hurl it at the criminal. The spectators would also bring gross ammo from

It's getting lit at the Victorian séance, as depicted in an 1871 engraving.

home, including dead pets, animal entrails, fish bones, as well as their own feces. So, basically the Victorian equivalent of a Slipknot show.

The stench was unimaginable. The foulest scents filled the air, and that was before death added to the rotten perfume. And when the deed was done, the crowd would ogle the corpse before them, fascinated by the quick influence of death upon a body: the swelling of the ears and lips, the bluing of the skin, the snot dripping coldly from their nose. *That* was entertainment.

It wasn't just death that fascinated the Victorian masses so but the opportunity to see someone beg and curse for their life. It was one of the only times they could see someone act far outside the bounds of conventional behavior, throwing the nastiest insults they could think of at authority figures and even blaspheming against God.

Those disturbed by such a sight were initially in the minority. Among them was Charles Dickens, a man of feeling, so utterly appalled by the sight of a crowd thirty thousand strong that he wrote to England's then most famous newspaper, the *Times*, to file his lengthy complaint. Dickens's disgust prefigured a shift in mood away from brutality and toward sentimentality. Campaigns were subsequently waged against public parades of pain. The baiting of animals was banned. A dismissive eye was cast against the corporal punishment of in schools. Any enjoyment derived from such activities was increasingly

THE LAST EXECUTION AT NEWGATE.

The last public
hanging at
Newgate.

met with disapproval. Anyone still with a taste for another's pain would be considered a savage, associated with the barbarity of the Goths of the past.

Public executions were phased out of Victorian life in the mid-nineteenth century and legislation that banned public displays of torture came into play. But the curiosity for death and pain remained. The bloodshed simply transferred from the gallows to the page.

Violence was domesticated, privatized, and fictionalized. Pulp fiction and true crime began to circulate heavily throughout the country in periodicals and magazines. While the earliest Gothic writers worked within the longer novel form, the Victorians were looking for a quick thrill, a kind of Gothic lite for the masses. Penny dreadfuls—grizzly tales often serialized into eight parts—were just that, a source of fun and sensationalist literature that went straight to the scares. Penny dreadfuls were cheap, easy to come by, and made for everyone. Among the most popular series were rewrites of *The Castle of Otranto* and *The Mysteries of Udolpho*, as well as Gothicized adaptations of Dick Turpin's highwayman jaunts. The penny dreadful also

RIGHT: Edgar Allan Poe, the man, the myth, the edgelord.

BOTTOM: The OG *Sweeney Todd*, courtesy of a penny dreadful.

introduced Sweeney Todd, the Demon Barber of Fleet Street. Todd made his first appearance in an 1847 penny dreadful titled *The String of Pearls* and went on to become one of the most recognizable characters of the bloody Victorian moment.

Rather than providing a moral lesson or a rigorous character study, the penny dreadfuls simply aimed to terrify. Their only purpose was to make their reader feel a certain way, and there's no feeling more intense than fear. This is what Goth is and has always been: a mood.

One writer who avidly read penny dreadfuls and understood the importance of mood was Edgar Allan Poe. We cannot speak about Victorian Goth, or Goth at all for that matter, without mentioning this name, as Poe is considered by many to be the godfather of Goth.

Poe was born to Eliza Poe, an immigrant from London, and David, who left the family shortly after the birth of Eliza's third child. After his mother died of tuberculosis in 1811 and with his father still nowhere to be found, Edgar was sent to live with his uncle John Allan, a merchant, in Scotland. He received a fine education in London, and when he returned to America in 1826 to study at the University of Virginia, he brought with him a romantic European sensibility. He took to writing poetry, of course, first half-heartedly, then seriously. A year into his studies, he published his first little volume, *Tamerlane and Other Poems*, of which only fifty copies were printed.

Determined to make an income from writing, he briefly switched from poetry to fiction, a form more likely to turn a profit. Still, the early nineteenth century wasn't a great time to be a writer, at least not one hoping to survive in America. Since copyright laws didn't yet exist, publishers saw no need to invest in local talent when they could pirate literature from England without repercussions.

Americans then took another leaf from the British's book when they tried producing periodicals and penny

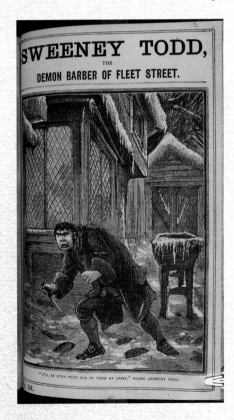

SWEENEY TODD,
THE
DEMON BARBER OF FLEET STREET.

"I'LL BE EVEN WITH ONE OF THEM AT LEAST," HISSED SWEENEY TODD.

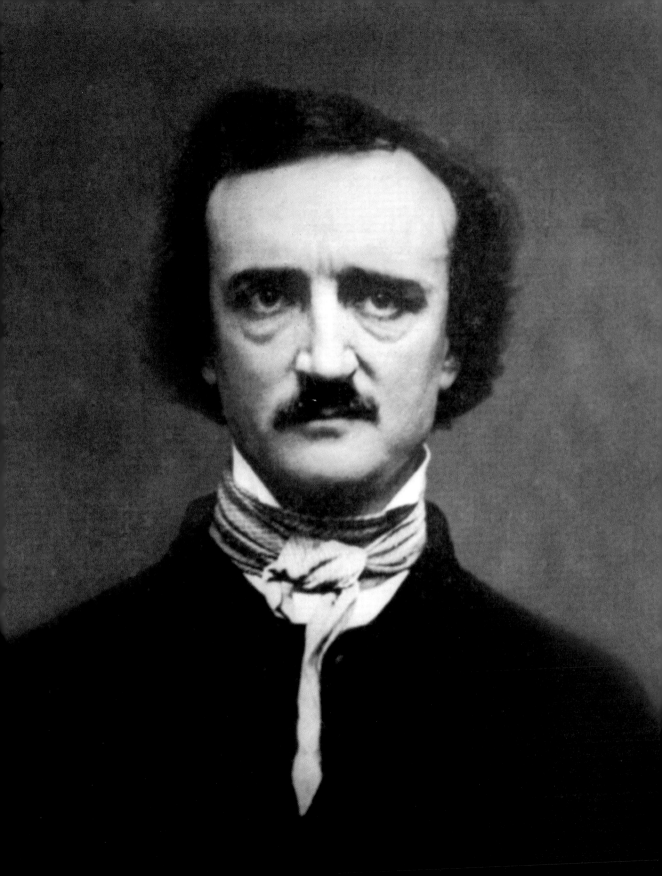

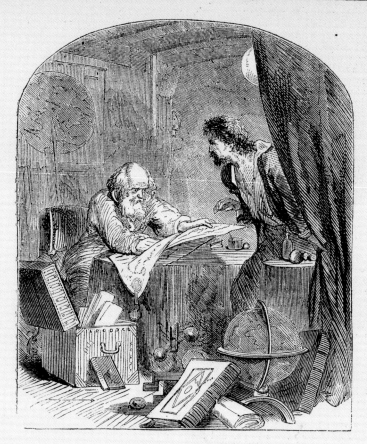

A MANUSCRIPT FOUND IN A BOTTLE.

BY EDGAR POE.

[THIS story (which here appears for the first time in England) is remarkable as being that which first brought the author, then in the very uttermost depths of poverty, into public notice. The proprietors of a Baltimore magazine offered a prize for the best story. Poe's beautiful caligraphy attracted attention; his story (the "MS. Found in a Bottle") was perused, and it was decided to give the prize to the "first of geniuses who had written legibly."]

Of my country and of my family I have little to say. Ill-usage and length of years have driven me from the one, and estranged me from the other. Hereditary wealth afforded me an education of no common order, and a contemplative turn of mind enabled me to methodise the stores which early study very diligently garnered up. Beyond all things, the works of the German moralists gave me great delight; not from any ill-advised admiration of their eloquent madness, but from the ease with which my habits of rigid thought enabled me to detect their falsities. I have often been reproached with the aridity of my genius; a deficiency of imagination has been imputed to me as a crime; and the Pyrrhonism of my opinions has at all times rendered me notorious. Indeed, a strong relish for physical philosophy has, I fear, tinctured my mind with a very common error of this age—I mean the habit of referring occurrences, even the least susceptible of such reference, to the principles of that science. Upon the whole, no person could be less liable than myself to be led away from the severe precincts

dreadfuls themselves, after seeing how successful the model had been abroad. Poe submitted a short story titled "MS. Found in a Bottle" to one such periodical, which won him first place in the *Baltimore Saturday Visiter* short story competition in 1832.

The judges immediately saw in Poe a wildly original talent, a writer with an inordinate imagination who drifted toward the dark stuff. His writing was as visceral as it was mentally tortured. Reading Poe, you almost feel trapped inside his characters' skins, claustrophobic within their endlessly recurring thought patterns. Indeed, so many of his characters, whether Baldazzar or the detective C. Auguste Dupin, are foundational Goths: moody shut-ins who prefer to remain under cover of darkness, burrowing so far into it that they lose their grip on reality.

The main character of Poe's work has always been death. From the onset, Poe carried into his work his nagging fixation with mortality. Perhaps writing was his way of reconciling with the inevitable truth, or rather keeping it at bay. But death trailed him, no matter how desperately he tried to trap it in his words. It had been stalking him since he witnessed his young mother's death. And so, many of his short stories made heroes of women who'd come to an untimely death, whether "Berenice" or "Morella." As a writer, Poe clearly had a thing for dead girls.

This dance with death is no better exemplified than in his long-form poem "The Raven," one of Goth's fundamental texts. Published in *The Evening Mirror* in January 1845 for the measly sum of $9, "The Raven" follows an aggrieved lover and his descent into madness as he realizes he will never find peace after the death of his love, Lenore. The protagonist's grief is rendered in Gothic symbolism—demonic birds' eyes, waxy black wings—that makes a darkly romantic and enduring picture of bereavement.

Poe held a fascination with death right up until his own on October 7, 1849. He'd been found in the streets of Baltimore four days earlier, delirious and destitute. Poe came to his end, as most of his characters had, in a state of lunacy.

That Poe had spent almost his entire life preoccupied by death wasn't so unusual for the time—in fact, Victorian culture had even encouraged it. The reminder that nothing was eternal and that you would someday die was

LEFT: An excerpt from Edgar Allan Poe's short story *A Manuscript Found in a Bottle.*

everywhere, from the crumbling castles that peppered the English countryside to the diseases—tuberculosis, cholera, scarlet fever—that ran through homes. Surviving death wasn't a possibility; the only option was to romanticize it or to make entertainment from it. That the latter was especially popular among the working class made a sad kind of sense. Living in terrible conditions, the working class's situation was made far worse whenever death arrived. With family members unable to afford storage for corpses, deceased relatives had to be hoarded in the home in the days between their death and their burial. In that time, their body would liquefy, the stench overpowering the house.

Every aspect of Victorian society was rank with death. The world as it had always been known was dying and a new one was being formed. The invention of the steam train fundamentally changed the nature of transportation. Swift urbanization caused millions to move from the countryside to the industrial city. Religious dogma gave way to scientific inquiry, as post-Enlightenment thinking and its prioritization of reason over feeling began undermining the Church. The hole that a certain God left behind made the afterlife a far more troubling reality to comprehend. There was nothing that could replace God in that regard, other than a ceaseless assembly line of question marks. Death was no longer a kind of salvation or religious remuneration, but a terrifying and certain eventuality. People started looking back to life before death, rather than ahead to the afterlife.

Just as the rapid changes of the eighteenth-century Enlightenment had caused culture to look backward toward the chivalry and sentimentality of an imagined medieval past, the revolutions of this new era caused the Victorians to dig into the more recent historical past, as nightmared up by Walpole and Radcliffe. The influx of the pulpish, quick-fix Gothic, as seen in the penny dreadfuls, coincided with the rise of scientific periodicals and technological innovations. The Gothic not only allowed its readers a cozy access point to the past, it also gave voice to society's anxieties about their increasingly uncertain futures.

Out of that uncertainty, there emerged a feeling of uncanny unease. Many Victorians felt themselves in a dreamy, in-between state which drew them easily toward the supernatural and occult. Spiritualism, the belief that the dead could communicate with the living, was an especially popular fad throughout the mid-nineteenth century, as traditional religious practices continued to decline.

RIGHT: Edmund Dulac's 1911 illustration of Edgar Allan Poe's The Raven.

Most historians agree that Victorian Spiritualism began with Margaret and Kate Fox, two teenage sisters who told *The New York Tribune* in 1848 that they'd communicated with the ghost of a man murdered in their home. The story spread around newspapers across Europe and America and introduced the idea that a gifted few could communicate with the dead. Spiritualism initially functioned as an American counterculture before a Bostonian named Maria B. Hayden offered her services as a medium when she traveled to London in 1852. For the price of a guinea per person (around $500 by today's standards), Hayden would connect the living with the dead. Soon enough, the practice of séances spread throughout London and a fascination with the practice emerged

Spiritualist organizations were founded, including the Spiritualist Association of Great Britain, as well as a press dedicated to all things spooky and séance-y. Spiritualism was the craze of the mid-century: Innumerable pamphlets were dedicated to it and several practices emerged from it, including automatic writing and even levitation. Florence Cook was one of the first major British spiritualists. After convening with a seventh-century buccaneer

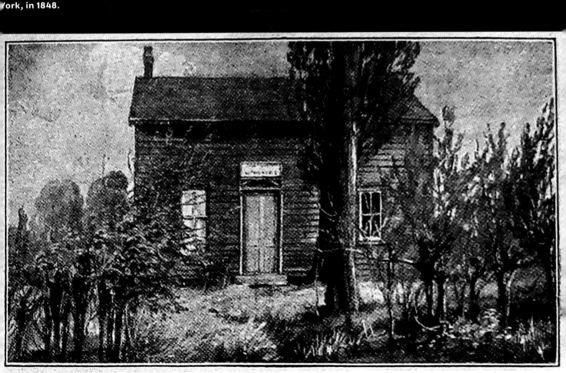

during a séance, she was invited into the drawing rooms of many upper-class Victorians. No longer just a fringe interest, a great many Victorians attended at least one séance, whether they took place in hospital theaters or in the privacy of a home. With their vast spread, they were enjoyed by just about every societal class and attended by the poor as well as by the queen.

Queen Victoria and her husband Prince Albert attended séances as soon as they came into vogue in London. They participated in ceremonies somewhat regularly, right up until Albert's death from typhoid in 1861. The Queen invited a thirteen-year-old spiritualist named Robert James Lees to hold séances at Windsor Castle shortly after. Together, they called out for Albert, who'd return messages to Victoria via Robert, addressing her by a pet name known only to the queen and prince.

How To Dress Like Queen Victoria in Mourning

WHAT YOU'LL NEED:

A choker (yes, for real)
A black bonnet with long, draping streamers

A black dress that's solemn in the front and a party (very poofy) in the back
A pout

INSTRUCTIONS:

1. Wrap the choker around your porcelain neck and don your bonnet.
2. Take your time changing into your black dress. Make sure it's appropriately mournful, and feel free to add a huge train if it isn't fun enough in the back.
3. Complete the look with the most miserable pout you can muster. Think dead goldfish face.

The queen was alone in her grief thereafter. She largely withdrew from public life and services, secluding herself from the world. When she eventually reemerged, she was extravagant in her grief. She dressed herself in black and never added another color to her wardrobe for as long as she lived. While Victorian etiquette stressed the importance of simple mourning dress, the queen overlooked this rule. Her simple black gowns soon turned into theatrical outfits of black lace, veils, and heavily draped cloaks. She floated through the halls of Buckingham Palace like a ghost, grief overtaking her personhood.

Following the queen's example, grief soon became the latest fashion accessory. While it was customary to wear mourning attire for just the week after a loved one's death, that period soon extended into months and even years. Magazines featured guides on how to dress like the queen in mourning. That she only wore black for the remaining forty years of her life was a sartorial choice that has become the bedrock for Goths even today. The origins of Goth style can be traced back to this moment of mourning. It was a time when shops dedicated solely to mourning dress were first opened (the proto-Hot Topics, if you will). Funerals became all the rage. The upper classes began to spend almost as much money on their funerals as they had their weddings, purchasing grand hearses and horses, jonesing for the largest gravestone on the lot. The middle classes tried to follow suit and bankrupted themselves in the process. Mourners at funerals did not hold back either. Wives jumped on their husband's coffins while they were being lowered into the ground, howling as they tried to go down with their beloveds.

After the most dramatic send-off possible, many lovers would take from their dearly departed a lock of hair, which they'd then weave into a wreath or brooch to place upon their dress. Victorians kept mementos of their lost ones for as long as they lived. No longer certain where they were headed to in the afterlife, the aggrieved wanted to keep their loved ones trapped on Earth by any means necessary. An emerging technology would enable them to do just that: the photograph.

In 1839, a Frenchman named Louis Daguerre invented the daguerreotype, a kind of camera prototype and one of the first machines capable of mirroring reality back to itself while creating an eternal present from

it. While painters were previously hired to commemorate dead relatives, postmortem photography became a far cheaper way to preserve a loved one's memory. Paintings tended to produce an idealized version of their subject, whereas photographs might have been a little too realistic. So, rather than just pointing a camera at a corpse, postmortem photographers staged death, taking photos of their subjects while they slept, dressed in funereal clothing. With one click, it was done. The Victorians came one step closer to cheating death.

An advertisement for Peter Robinson's Mourning Warehouse, 1894.

AT PETER ROBINSON'S
FAMILY MOURNING WAREHOUSE,
"REGENT STREET."

FAMILY BEREAVEMENTS.

Upon Receipt of Letter or Telegram, experienced DRESS-MAKERS and MILLINERS travel to all parts of the Country (no matter the distance) free of any extra charge, with Dresses, Mantles, Millinery, and a full assortment of MADE-UP Articles, of the best and most suitable description. Also Materials by the yard, and supplied at the same VERY REASONABLE PRICES as if purchased at the Warehouse in REGENT STREET.
Mourning for Servants, at unexceptionally low rates. At a great saving to large or small families.

FUNERALS CONDUCTED IN TOWN OR COUNTRY AT STATED CHARGES.

256 TO 262, REGENT ST., LONDON.

PETER ROBINSON'S.

BYRONESQUE VAMPIRES: THE KINKY ROMANCE OF GOTH

ow is it that bloodless husks with gaunt faces and sharp teeth are actually kind of hot? How did an unliving creature with rotting flesh and a penchant for bleeding people dry become a sex icon? Why did Bella Swan not file a restraining order against a centuries-old man who claimed he was seventeen? These are all questions that can be answered with just one look at the vampire, Goth's sexiest, and most irresistible, export.

A somewhat concerning illustration from Sheridan Le Fanu's *Carmilla*.

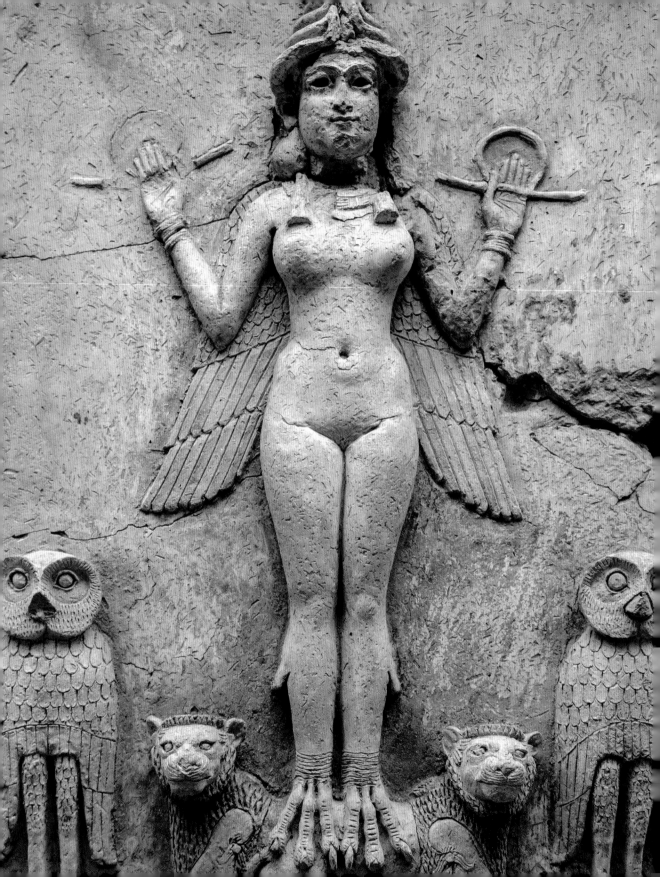

More so than any other monster, the vampire as we know him today always behaves with excellent manners. He is the most gentlemanly of murderers. He seduces, he wines and dines (*no* garlic, he wants to kiss you; plus, he's allergic). The actual killing isn't even *that* bad. Sure, he might poke a couple holes in your neck with his teeth and drain your blood, but he won't dismember you. He doesn't hack at you. He keeps it clean, and he keeps it chic.

The vampire has been through many makeovers throughout history, and each of these transformations reveals something about our own relationship with fear. Under different names, some iteration of the "vampire"—an undead creature denied eternal rest as punishment for his transgressive behavior, who preys upon the living—shows up in a good majority of mythologies around the world. Like Goth itself, the vampire is very supple as a metaphor and can be applied to just about any country or culture, simply because what it represents is so broad. Vampires are the manifestation of society's fears, as well as the meeting point between sex and death. It's just their sharp fangs, incredible dress sense, and confusing sex appeal that are relatively modern. These features don't appear to stretch back directly to antiquity, though they do have some close forebears in Mesopotamia and more so in Ancient Greece and Rome.

Around the seventh to fifth millennium B.C., during the Mesopotamian era, the vampire was almost always a kind of female goddess. In Babylonia, she took the form of Lilith, a naked, serpent-bodied woman who seduced men and seized immortality by stealing their sperm.

In Ancient Greece and Rome, people of all genders could be accused of vampirism. Those who had died by suicide or alcoholism and those who had died a virgin all qualified. The living also drew their own share of vampire allegations. If you were a sex worker, a raging criminal, or had birthed a deformed baby, you too could have been a vampire in the eyes of the ancient Greeks. The shifting criteria for what did or did not make a vampire revolved around the fears and insecurities of the ruling class, who envisioned vampires as societal pollutants, capable of destroying the world as they knew it, just as the Goths had in AD 520.

The significance of blood to the vampire was a tradition that also began in ancient Greece and Rome. In pre-Christian, pagan religion, blood was hailed

LEFT: A large, ancient stone monument depicting Lilith, now in the British Museum.

as one of nature's most divine properties. It became a precious commodity, one eyed up by thieves. This extended to menstrual blood, too. It was a time when, hard as it might be to imagine, men actually looked forward to Aunt Flow's visit each month. The vampire has always carried with it kinky associations, after all.

After the fall of the Roman Empire, the vampire was slow to take to European folklore and thought. The creature appeared in the enigmatic Anglo-Saxon poem "A Vampyre of the Fens" in the eleventh century, but didn't reemerge until sometime during the later Middle Ages. Then, when Europe was ruled by Roman Catholicism, the vampire unsurprisingly came with some religious trappings. He was transferred over from paganism to Christianity and came to be associated with Satan, damnation, sin. He gained a new weakness: The sight alone of a cross or crucifix could kill him.

Catholics believed that vampires were those who had lived a lecherous life: drunkards, harlots, downright scallywags. The theory was that these sinners had a hankering for familicide; they'd rise in the night and kill each family member by biting a good chunk of their flesh and draining them of their blood. Once these miscreants went to their eternal rest, they'd be denied burial rites—but even if they did somehow end up in a hole in the ground, they'd be promptly dug up, mutilated, and burned, just in case they felt like causing any more trouble.

The Christianized version of the vampire is the genesis of our sexy modern-day guy. With his holy trinity of blood, sex, and death, he was an inverse of the holy triumvirate. But who doesn't love a bad boy? As the vampire grew alongside modernization—a time when science and reason came to dethrone the religious superstition popularized in the Middle Ages—the vampire became more and more human (sexier, too). He developed the tastes and emotions of an upper-class man: velvet cloaks and bloody women. With each age, we don't get the vampire we need so much as the one we *deserve*.

Unsurprisingly, during the age of Romanticism, the people needed a hotter monster. And so, from the beginning of the nineteenth century, right on the cusp of the Romantic movement—just as the first wave of Gothic novels were being written—the vampire gained a more pronounced sexuality and a disposition, more likely to seduce than repulse. First used in 1803, "Romanticism" was a term

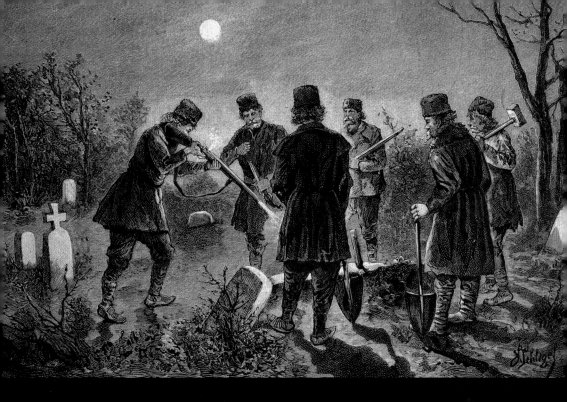

The lads digging up and killing a vampire. Go get 'em, boys!

hen synonymous with everything Gothic literature was in this age—primitive, strange, nostalgic, stirring—to the point that those words, Romantic and Gothic, became interchangeable. Vampires represented this confluence of meaning. Rather than haunting houses during the spookiest hours of the night, dragging with them the scent of their own rotten flesh, vampires became gentlemen of the evening, porcelain-skinned and smelling of cologne.

Vampires were no longer strictly associated with Christian sin, but with any desires that were both destructive and forbidden. They were Romanticism's idol: the dark, untamed part of ourselves that we're told by sensible society to overpower with manners and reason and boring, vanilla sex.

This vision of the vampire came into clearer focus when it fed off the flesh of a man named Lord Byron. Byron—most famously a man who was mad, bad, and dangerous to know and less famously a poet—exemplified masculinity at its sexiest. His lady-killer public persona and heavily introspective

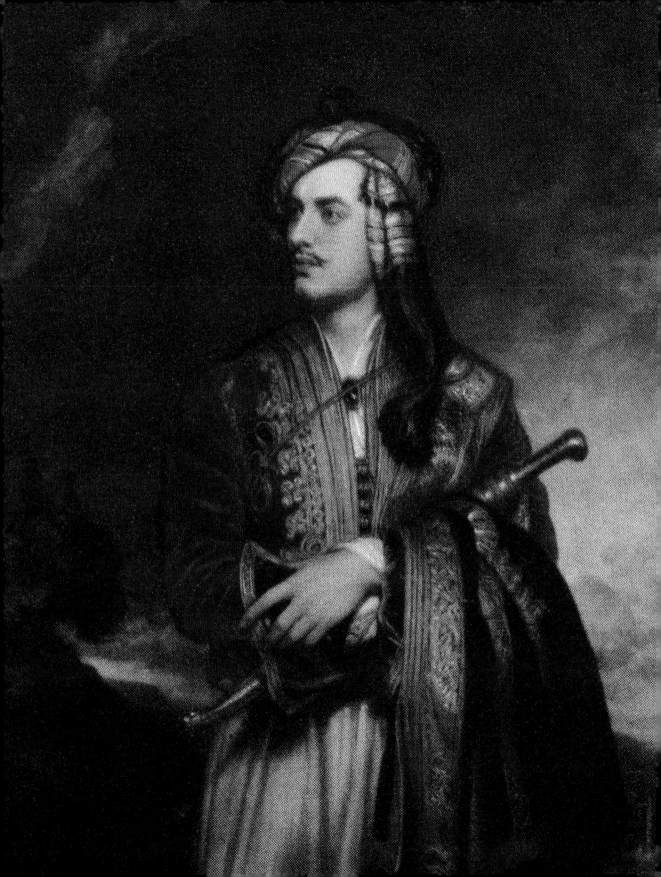

dark-side-of-the-soul poetry divided opinion throughout Europe. To some, he was the hero of the age. To others, he was a total reprobate. Byron confidently straddled this duality. He was a man of culture who also threatened to destroy the ethical foundations of society. Embodying both sensuality and danger, Byron posed to women a new erotic challenge: to find a fixer-upper, a bad boy you could spend the rest of your life trying to tame. You know this well by now, don't you, ladies? Byron was the James Dean of the Romantic Age.

Byron was often considered Britain's first celebrity, as well as the first model for what we now recognize as the modern vampire. The curiously good dress sense; the dark, princely cape and general aristocratic air—that's all Byron. As is his charm and wit, cursed heart, and fatal talents for seduction.

Romanticism may have reached its Gothic peak when Byron hosted a spooky storytelling competition at his mansion near Lake Geneva during the summer of 1816. In the spring, a few months earlier, Dr. John Polidori had been appointed Byron's personal physician, on account of the poet's dwindling health (the two were also rumored to have been lovers). On Polidori's recommendation, Byron traveled to Europe and quarantined himself in idyllic surroundings. Polidori came along, as did Byron's writer friends Mary and Percy Bysshe Shelley, and Mary's sister Claire Clairmont soon followed. They self-exiled themselves for a number of days in Byron's Villa Diodati, his mansion located near Lake Geneva. As a storm rolled in, Byron challenged his esteemed company to a storytelling competition. For three days, the party drank opium-tinged spirits and crafted their spookiest tales while the rain pounded outside.

Mary Shelley famously created what would become *Frankenstein* during this time, while Byron started—but never finished—a vampiric tale. At the end of the summer, when Dr. Polidori was relieved of his duties, he set about

LEFT: Lord Byron, history's greatest heartbreaker, as depicted by Thomas Phillips in 1813.

BOTTOM: A portrait of John William Polidori by F.G. Gainsford.

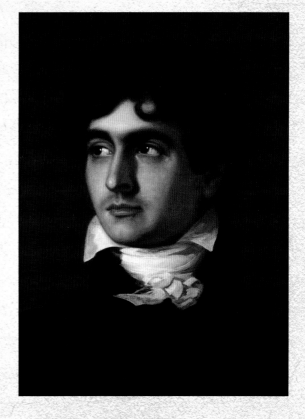

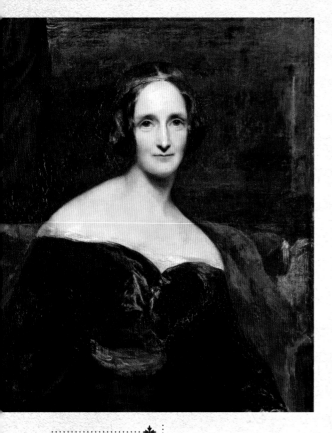

Mary Shelley, mother of a monster, in an 1840 portrait by Richard Rothwell.

trying to complete Byron's story. The result was *The Vampyre*, a work published in 1819 under Byron's name. It follows the fabulously wealthy and somewhat downcast Lord Ruthven and his traveling companion Aubrey. Ruthven is tempted by Aubrey's blood throughout the tale, trying desperately not to give his vampirism away. He eventually preys on Aubrey's sister instead before exiling himself to some far-off land. Nice.

The titular vampire was unmistakably Byronesque, a creature roaming around in self-exile, romantically melancholy, and irresistible to women. *The Vampyre* moved the needle further than ever before, casting out the vampire from his undead grave and into the flesh of an aristocratic dandy. It was the very first text that dressed the vampire in fine clothes and made his techniques of seduction so powerful that a woman would willingly present her neck to him.

This opulent creature was instrumental in shaping the most recognizable of all vampires: Bram Stoker's Count Dracula. Just as Ruthven had been modeled on Byron, Dracula was supposedly inspired by a real-life source too. In 1890, during a trip to Whitby on the Yorkshire coast, Stoker first learned of a fifteenth-century Romanian warlord and prince of Transylvania named Vlad Tepes, who infamously was later dubbed Vlad the Impaler, thanks to his barbaric treatment of Ottoman invaders.

It's possible—though unconfirmed by Stoker himself—that Dracula was envisioned as a blood descendant of Vlad. They certainly had a lot in common. Vlad's preferred method of murder was death by wooden stake, the very thing that would later vanquish Dracula. Vlad also enjoyed a post-murder aperitif: a goblet of blood. Stoker undoubtedly stole the name for his titular character from Vlad's family crest, the Order of the Dragon, or *dracul* in Romanian.

However, Dracula's sex appeal was an altogether modern twist. Published in 1897, Stoker's novel coincided with the rise of sexuality as a term and concept,

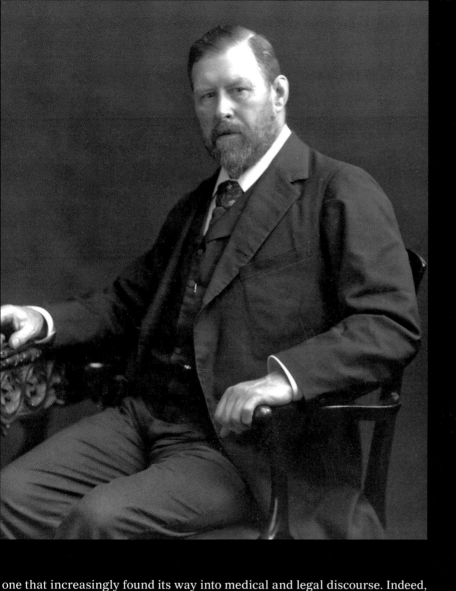

one that increasingly found its way into medical and legal discourse. Indeed,
Dracula was published the same year as Havelock Ellis's *Sexual Inversion*, the
first text from the field of sexology, an emerging science which had developed
out of late-nineteenth-century research. The biggest question in the field at the
time concerned the origins of sexually transgressive behavior: Was it the result
of a mental or physical defect or a clear-minded and intentionally criminal act?
In short, what makes a pervert?

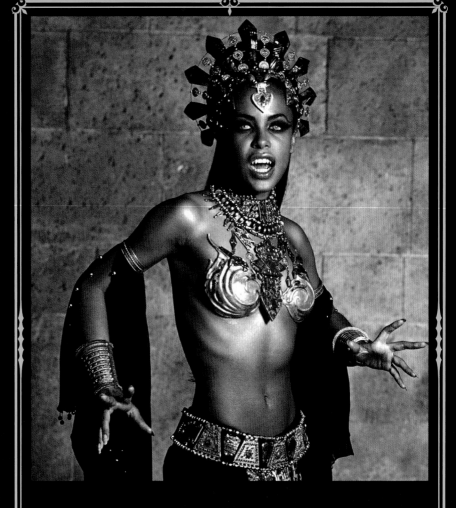

Aaliyah playing
Akasha in *Queen of
the Damned*. Hot.

THE TOP FIVE HOTTEST TV AND
FILM VAMPIRES OF ALL TIME

1. Christopher Lee as Dracula
2. Aaliyah as Akasha in *Queen of the Damned*
3. Wesley Snipes as Blade
4. James Marsters as Spike in *Buffy the Vampire Slayer*
5. Nina Dobrev as Katherine Pierce in *The Vampire Diaries*

Count Dracula could have told you. He may well have been modernity's first perv. The erotic aspects of vampirism are clearly pronounced in *Dracula*. That scene where Dracula baptizes Mina, his soon-to-be bride, in his own blood? Hot. I mean, ew! Gross. It's all fetishistic, blood replacing sexual fluids. A wooden stake penetrating a vampiric woman's body rather than a, you know, penis.

None of this would fall under the rubric of "normal" sexual behavior, though it might be just another Tuesday afternoon for a kinkster. At the time of *Dracula*'s publication, the threat of this transgressive sexuality upon the normal meat-and-two-potatoes sex between *a man and a woman who love each other very much* was one of the great fears of the time. And, since vampires manifest each society's nagging anxieties, Dracula took the form of a much more suave, much more bloodthirsty Christian Grey.

Premarital, extramarital, and promiscuous kinky sex were all encroaching fears at the time, since the threat of sexual liberation disturbed traditional boundaries of sex and gender. Homosexuality was a specter, though the Count's fangs don't even come close to a man's neck (pity). All of these forbidden desires were made more appealing—intentionally or not—by the sheer all-consuming nature of Gothic romance. If you were fortunate (read: doomed) enough to have a two-week-long romance when you were freshly teenaged, you might understand the unnecessarily grandiose nature of vampire-human relationships. The intensity of them, just like that one you had when you were fourteen, is torturous, codependent, and terrible for anyone who comes into contact with it. Romance that high—and disastrous—is all but an unsustainable fantasy, though you sometimes wish you could go back, bury yourself in it, and throw away the casket key.

FOUR TICKETS FOR NOSFERATU, PLEASE: EARLY GOTHIC CINEMA

hile visions of the vampire once only haunted our imaginations and mind's eye, with the advent of cinema, the vampire became undeniably real. Rotten-fleshed out on the screen, the image of the vampire was so severely stylized, so immediately iconic, that it became an image entrenched in our culture forevermore. Those plasticky capes and cheap plastic fangs you see at the Halloween store each October? Those span back to the first cinematic depictions of the vampire.

Cesare on the roof, from The Cabinet of Dr. Caligari.

Somewhere between the end of the nineteenth century and the beginning of the twentieth, cinema became the perfect successor to Gothic literature. The medium itself could be described as Gothic: In a dark room, images of a captured past are projected onto a white screen, drifting upon it and casting shadows on theater curtains like apparitions. Sat amongst others in the shared darkness, the audience enters a temporary trance, their reality briefly overtaken by the projections dancing in front of them. They are all participants in a kind of communal ghost sighting. For a window of time, no one questions what is real and what is not. Reality and fiction are blurred. The images on the screen are stronger, more vivid, and more arresting than any the audience has experienced in waking life.

Now, imagine being one of the very first to experience this. The camera was not yet a hundred years old. You'd only just become familiar with pictures, which you knew as static things that kept their subjects eternally in place. Now, imagine also that those pictures grew legs, began to jerk, and moved so fast that they filled your entire vision. Movies—moving pictures—left the impression of magic upon those who first beheld them.

Mom, something's in my cereal! Oh, honey, it's just Georges Méliès's *A Trip To The Moon*.

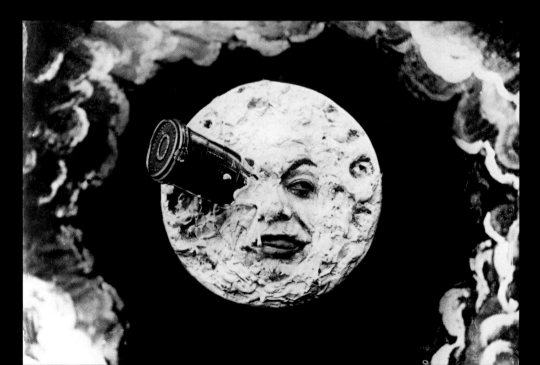

The very first movies really were just moving pictures—a snapshot photo that had come to life, with no narrative, just motion. They'd scarcely run for more than a couple of minutes and feature nothing terribly exciting by today's standards: a horse running through a field or a girl fetching a pail of water, for example.

It wasn't until the twentieth century that the Gothic trope, as made famous by the literature of the preceding centuries, found its way to the screen. Georges Méliès, a French magician and actor, might well be credited as the very first Goth cinematic practitioner. He saw film as an extension of magic, a way to play tricks upon the mind while engrossing his audience in a story. Inspired by Victorian spirit photography, he was a pioneer of both special effects and narrative cinema. As such, he was an early proponent of multiple exposure, stop-motion photography, and dissolving transitions. His tricks taunted and haunted his growing audience, confounding them with a new technology of illusions. His Gothic cinema of deception not only shaped the genre forever, but equipped the entire cinematic medium with a far greater vocabulary, filling its sleeve with new tricks.

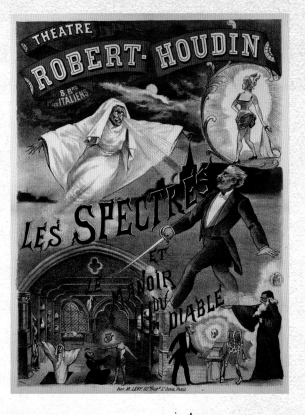

A poster for magician Robert Houdini's show "Les Spectres."

You'll perhaps know Méliès best for his 1902 feature *Le Voyage dans la lune* (*A Trip to the Moon*). Even if you've not heard that title, you've no doubt seen the image of a porridge-looking moon being hit in the eye by a spacecraft. The film was one of the first to combine live action and animation, and watching it now, there's an eeriness to the nascent technology. In its crackling noise and dotty picture, you can't help but form monsters in your own mind's eye.

Even still, *A Trip to the Moon* was not Méliès's scariest film by any measure. For those, you might want to venture back a decade to his shorts of the late 1890s, especially 1896, which was a banner year for the Méliès scaries. He started it off with *Une Nuit Terrible* (*One Terrible Night*), in which a

sleeping man is attacked by a giant bedbug that is swiftly squashed by a broom. Then he made *Escamotage d'une dame chez Robert-Houdin* (*The Vanishing Lady*), in which he plays the role of a magician who sits his assistant in a chair, covers her with a blanket, then lifts the blanket to reveal her disappearance. He proceeds to do this over and over, seeing the assistant return and disappear again and again, until at last, when he lifts the blanket, we see a skeleton.

For his final trick of 1896, Méliès made *Le Château hanté* (*The Haunted Castle*). Oft dubbed the very first horror film, it was three minutes and thirty seconds of pure spook. Bats, skeletons, and caped figures flitted darkly across the screen and crystallized the Gothic cinema aesthetic. In true Goth fashion, black and gray were the most used hues in Méliès's palette. He seemed to have an intuitive understanding of it, casting the viewer's eye away from the action bright enough to be seen and toward the intrusive darkness that gathered in the corners of his screen. He was a master of contrast, painting garishly white faces of makeup on his actors, which only accentuated the dark cracks in the thick paint.

Heightening the contrast between dark and light was a visual trick which carried over to the German Expressionist movement of the 1920s, one of the all-time greatest influences upon the Goth aesthetic going forward. With its Gothic-cathedral-esque set design, emphasis on shadows, and visual discombobulation, German Expressionism has influenced every Goth from Bauhaus's Peter Murphy to Tim Burton.

Emerging in the aftermath of World War I, when Germany found itself in a state of moral, economic, and governmental disrepair, German Expressionism was a dark mirror to the society that produced it. With this movement, the Gothic tradition was firmly transferred to the cinema.

Like all Gothic art, German Expressionism was an attempt to turn emerging fears into a point of catharsis. It was both an elegy to the Germany that was lost during World War I as well as a premonition of the unspeakable horrors to come.

The first omen arrived on February 26, 1920, in the form of a film called *The Cabinet of Dr. Caligari*. In it, the famous stage actor Werner Krauss plays Dr. Caligari, a corrupt hypnotist who takes advantage of a sleepwalker named Cesare, forcing him to commit obscene murders. Twenty-seven years later, and only two years after World War II's end, the art historian Siegfried Kracauer convincingly argued that *Caligari* had unknowingly predicted the rise of

RIGHT: An early poster for *The Cabinet of Dr. Caligari*.

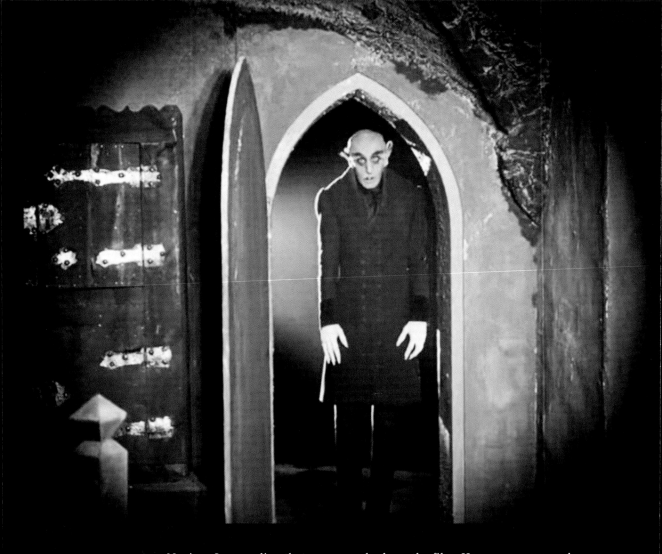

Max Schreck as
Count Orlok in
1922's *Nosferatu*.

Nazism. In a reading that now overshadows the film, Kracauer compared
Caligari to Hitler, and the German people to Cesare, somnambulists tasked to
commit terrible violence against their fellow men.

Of course, Robert Wiene, *Caligari's* director, could never have truly foretold
such a horror. He was inspired by literary expression—as made popular by the
plays of Eugene O'Neill and the novels of Franz Kafka—as well as the general
mood of the time, as an entire continent tried to grapple with postwar trauma.
The Cabinet of Dr. Caligari employed uneven camera angles, twitchy acting, and
brain-twisting set design to reproduce a world in disarray. Absolutely everything
depicted on screen is at least five steps out of order, a deeply troubling negative
image of reality. If you could peer into the German psyche at the time, it would
surely have looked a lot like *Caligari*.

The production design, as conceived by Walter Reimann, Walter Röhrig, and Hermann Warm, was one of the film's most inventive elements, as well as the most influential to the Goth aesthetic. Monstrous shadows and symbols of the occult were painted black onto whitewashed walls. Dark and narrow alleys led to staircases that wound around themselves like a snake eating its tail. Skinny buildings topped with pointed spires like Gothic cathedrals looked one breath away from collapse.

All of the above is the product of an artistic stream whose source begins in the unconscious. That people's inner worlds—and the parts of it buried so deep they could scarcely come to the light—were being visually depicted at all was helped in part by the growing influence of psychiatry. It's difficult now to watch a film like *Caligari* and not think of it as a psychiatrist's wet dream. Its high contrast black-and-whites resemble a Rorschach test. The entire film is carried by a mood that affects your subconscious on a deeper level.

Indeed, during *Caligari's* twist ending—spoiler alert—everything that viewers have just witnessed in the film is revealed to be the deranged ravings of an inmate in an insane asylum. Following *Caligari's* lead, many films of this era featured depictions of madness, insanity, and psychological affliction.

F. W. Murnau's *Nosferatu*, which followed in 1922, took the psychological tension of *Caligari* and magnified it. Often referred to as one of the greatest vampire films of all time, *Nosferatu* carries a deeply troubling mood into every scene. Even the more lighthearted sequences, in which characters are seen playing croquet, are haunted by an unsettling grimness. To be sure, the rat-toothed grin and bat ears of Nosferatu mark a level of monstrosity that didn't quite find its way to the vampire section of the Halloween store. When we think of vampires, we don't typically think of Nosferatu. That might be because we don't want to think of Nosferatu at all. He, or it, is one of the most truly horrifying of vampiric depictions of all, far away from the well-dressed dandy we now know as a vampire.

Murnau's *Nosferatu* was principally an adaptation of Bram Stoker's *Dracula*, one unauthorized by the writer's estate. Like Stoker's novel, the real protagonist of *Nosferatu* was its shadows. Even scarier than his half-rat, half-bat visage was Nosferatu's inhuman silhouette. Murnau knew, as Stoker did, that fear is fueled by the imagination, inside the loneliness of the mind.

That might be why one of the scariest and most iconic scenes in all of Gothic cinema portrays the killing of Nina, Nosferatu's principal victim, not in plain sight but through shadows.

In 1927, a director by the name of Fritz Lang, inspired by *Nosferatu* as much as he was by Gothic architecture, carried such heavy shadows into the global mainstream with his breakthrough film *Metropolis*. Set in the year 2000, in a dystopian world ruled by robots, *Metropolis* later caught the eye of Adolf Hitler. In 1933, when Hitler had been appointed chancellor and Lang had become one of Germany's most respected filmmakers, the Nazis tried in vain to recruit the director. That year, Lang was invited to the office of Joseph Goebbels, the chief propagandist for the Nazi Party. For a good hour, Goebbels tried to flatter Lang into producing films for the party. However, as soon as the meeting came to a close, Lang went to the nearest bank, withdrew all the savings he had, and escaped on a plane heading for America.

Lang was one of many German Expressionist filmmakers who fled Hitler's regime for Hollywood. The movement had reached the cinematic capital of the world, and Gothicized American cinema in its wake. Billy Wilder was among these expats, as was Karl Freund, who went on to direct the Bela Lugosi-starring *Dracula* alongside Tod Browning under Universal Studios.

A still taken from *Metropolis*.

Universal Studios had been adapting Gothic literature for the screen since the 1910s, with the 1913 cinematic rework of *Dr. Jekyll and Mr. Hyde* being an early example. Rather than adapting the source material, the studios borrowed from the adaptations of Gothic literature that were made for the stage at the beginning of the twentieth century. It was a process they repeated in the 1930s, though this time with greater success, for it was then that they transitioned away from silent movies to talkies. *Dracula* finally came equipped with the added terror of sound.

Even though Universal had managed to secure the *Dracula* rights from Stoker's estate, their film deviated vastly from the novel and edged closer to the more sympathetic portrayal of the count as seen in the stage version written by John L. Balderstone and Peggy Webling in the late 1920s. That production provided inspiration not just for a single film but for an entire model of filmic depictions of the monster going forward. No longer was he just a threat; the monster could also be seen as a misunderstood outsider.

It was a duality that a Hungarian émigré named Bela Lugosi played perfectly in both the stage and film adaptations of *Dracula*. Lugosi, who hardly spoke a word of English, naturally embodied the foreign exotica so intrinsic to the character of Dracula. He acted in a language he scarcely understood, applying a very warped take on English words and thus turning the common strange.

SPOTLIGHT ON BELA LUGOSI

Bela Lugosi was possibly cinema's most iconic portrayer of Dracula. Born Béla Ferenc Dezső Blaskó in the aptly Goth month of October in 1882, fifteen years before Bram Stoker published *Dracula*, Lugosi was born to play the role. He got his first taste of the stage when he volunteered to join the Hungarian army's cast of players during World War I. After a failed revolution forced him to emigrate from Hungary, he landed in New York City in 1920, where he struggled to secure more acting roles. His big break came in 1927 when he landed the starring role of a Broadway production of *Dracula*. He was almost fifty when Universal's execs came calling.

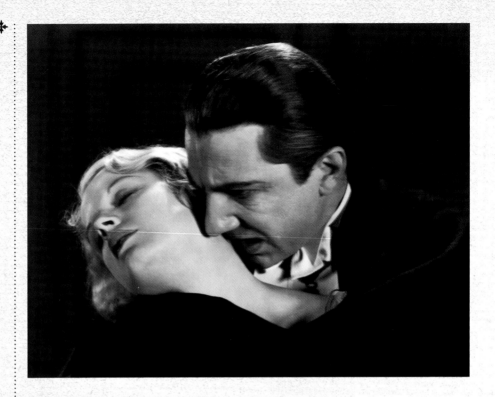

Bela Lugosi as Dracula feasting on the neck of Helen Chandler's Mina.

Universal bought the rights to Balderstone and Webling's script in 1931 and secured Lugosi to reprise his role. Lugosi was so convincing as Dracula that it may always be his performance that we associate with the vampire: his vaguely upper-class attire and Eastern European drawl.

Marketed as the first major horror film of the sound era, *Dracula* became one of the genre's all-time success stories, securing its status as a global phenomenon while turning an unprecedented profit for Universal. Wishing to quickly repeat the success, the studio searched the Goth section of the library in hopes of finding their next hit. Enter Mary Shelley's 1818 novel, *Frankenstein*.

Frankenstein was clearly one hell of a story, but it was still a risk compared to the surefire hit of *Dracula*. By this point, *Frankenstein* was well over a century old, and it had already been adapted to the screen. Thomas Edison's Edison Studios had tried their hand at the property in 1910, and it had flopped. Determined to avoid the same fate, Universal closely followed their *Dracula* model. While they brought on a new director, an Englishman named James Whale, they once again took more material from a sentimentalist

stage adaptation than from the original source material.

Rather than sheer terror, Whale's monster inspires in the audience a mix of pity and fear. The viewer is encouraged to see him as a tragic figure. Indeed, Boris Karloff portrays the Monster as a kind of bumbling bulldog, too goofy and dumb to harbor any actual evilness. Karloff's performance was just as impactful as Lugosi's; we think of Frankenstein and see him: greenish, deep-browed, heavy-lidded *him*.

Frankenstein was released in December 1931, shortly following *Dracula*, which had just been released in February of that year. *Frankenstein* found even more success than its predecessor, becoming the highest grossing film of that year. The combined profit between the two bolstered Universal to become one of the most influential and robust movie studios in the world. The money talked, and it said that people wanted more on-screen Goth icons.

While that was all well and good, soon came down the hammer of censorship. The notorious rollout of the Hays Code—a strict set of movie restrictions that banned everything from light making out to soft spook—in the mid-thirties put a very blunt and unwelcome end to Universal's season of Gothic monsters. Universal found a way around the code in the 1940s, when they rolled out a bunch of paint-by-numbers formulaic horror, but by then the need for more horror had long been satiated.

After almost a decade of horror indifference, the pendulum was due to swing back to Gothic monsters again in the mid-'50s. As profits for their monster movies slumped, Universal ceased making them in the mid-'40s. A decade later, cinemagoers were already nostalgic for their striking aesthetic

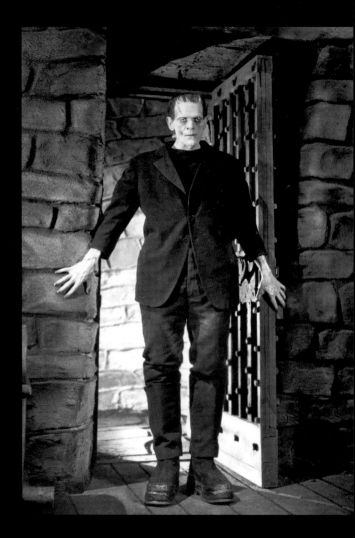

Boris Karloff as Frankenstein's monster.

and strong production values. It was just the right time for the rise of Hammer Horror, a relatively small British movie studio that specialized in low-profit, campy B-movie takes on Gothicism.

Founded by film producers William Hinds and James Carreras in 1934, British Hammer Film Productions first made their name with a series of adaptations of the works of Gothic granddaddy Edgar Allan Poe. They took the Gothic tropes of German Expressionism and Universal monster movies and turned them into camp fancams. Just as the inaugural Gothic literature of the eighteenth century had been a rosy look back to the medieval past, Hammer Horror looked back lovingly on its cinematic forebears. There was a charm to the studio's pairing of lo-fi production with high ambition. Its gore was cheap, its horror Technicolored. It was tacky, it was glam, and just about all their films made very liberal use of a fog machine, perhaps none more so than their 1958 adaptation of *Dracula*.

Starring the excellent Christopher Lee as Dracula and Peter Cushing as Van Helsing, Hammer Horror's *Dracula* had a leg up on its predecessors. While Universal's take was monochrome and mostly stone-faced, this 1958 production had color on its side. It dripped with ultrabright hues, winking humor, and a horniness that would have made Lord Byron proud. Name a hotter Dracula than Christopher Lee and you'll be lying.

It was another fabulous time with British Gothicism, the waves of which soon floated over to the States. But the pendulum never stops swinging. The flamboyant Goth associated with Hammer Horror fell out of favor and was soon tapered down to the more sober and raw terror of '70s films like *The Exorcist* and *The Texas Chain Saw Massacre*.

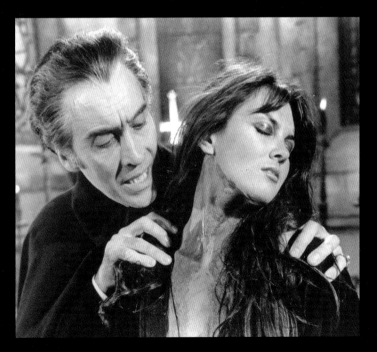

Christopher Lee as Dracula and Caroline Munro as Laura Bellows in a Hammer Horror classic.

Today, "Gothic" doesn't so much serve a classificatory function as horror, comedy, or sci-fi does. Instead of representing a genre, it represents a mood and a set of aesthetic features. You can see it displayed more whimsically in the films of Tim Burton. You see it more severely in the recent adaptations of *The Crow* and *Nosferatu*. Robert Eggers, who directed the latter, has become one of contemporary cinema's greatest Gothic formalists. It is he who has put in motion a revival of this cinematic form, tapping into its anxieties both universal and particular to this moment. In his films, he traces the very lineage of the Gothic genre, a feat that he is particularly suited to undertake. Born in 1983 in New Hampshire—trademark American Gothic Appalachia—Eggers incorporates the forests and abandoned colonial houses of his childhood into his work, just as the expressionist masters had. His early life had all the trappings of a Goth prodigy in the making. Tim Burton was one of his first cinematic obsessions, as was Nosferatu, which he watched for the first time when he was nine. He later codirected and starred as the count in his high school stage production of *Nosferatu*, a performance that caught the attention of a local theater director, who invited Eggers to restage the play for his company.

He went into film shortly after, releasing his debut film in 2007, a take on the Brothers Grimms' *Hansel and Gretel* (goth: strike one). He released his next one year later, *The Tell-Tale Heart*, inspired by Edgar Allan Poe (Goth: strike a million). He would spend the following years in the industry creating a historically accurate and reverent Gothic cinema, whether it was the Southern Gothic of 2015's *The Witch* or the updated German Expressionism of 2019's *The Lighthouse*. But it was on Christmas Day of 2024 that he released his ultimate paean to Gothic cinema: *Nosferatu*. In Eggers's version we find all the typical Gothic ornamentation—a grisaille palette, vaguely kinky sexual power play, extreme unease—refracted through the female gaze of Ellen, the doomed bride who falls prey to the vampire.

As Eggers knows, it is this gothic framework that best expresses all the day's anxieties and unrests. No matter what form it takes, Goth keeps coming back to haunt cinema. There's no mood better suited to the form.

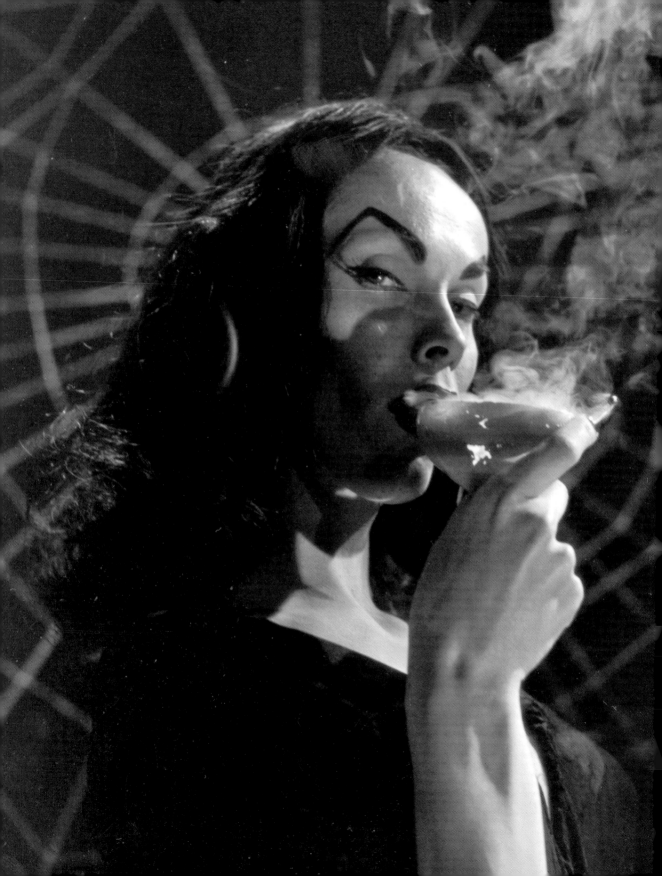

The Female Gothic: From Damsel in Distress to Femme Fatale

Before he dressed like a high-end pickup artist, the vampire was first a woman. She was Eve. She was Lilith. She was the sexy origin of all evil. Her power was in her beauty and her ability to weaken men's moral codes—a bargain they willingly struck in hopes of getting it in. She made her introduction early on, perhaps first appearing in pagan mythology, as an icon of excessive sexuality and wickedness right from the start. The femme vampire, daughter of Eve, Lilith, and the Sirens of Greek mythology, was above all a threat to patriarchal order.

Vampira bringing back "eyebrows on fleek" in 1956.

She was one of the very first depictions of the female Goth—a gorgeous Venus flytrap of a creature who drew men in like flies and spat them back out from her deep-red lips. For the established order, it was a terrifying image, the vision of a world in which women did not only not need men but also made mincemeat of them. Unfortunately, this vision hasn't always endured.

Historically, the female Gothic has swung between two extremes: from this man-eating goddess to her counterpart, a damsel in distress whose only salvation comes from her marriage to a man. These women are trembling victims, hardly anything more than reflections of men and women's relations to them. It was this character who defined the female Gothic of the eighteenth and nineteenth centuries. In her 1976 work *Literary Women*, the literary scholar Ellen Moers appointed the term "female Gothic" to describe this tendency among early female Gothic novelists who encoded their own anxieties about their sexuality and marital isolation onto the figure of the damsel in distress. Though she wasn't the most empowering of female archetypes, the Gothic damsel in distress spoke deeply to a growing audience of women.

Since at least the birth of Gothic literature, women have been integral to Goth's consumption and production. Ann Radcliffe, the writer who made the most bank out of Goth lit's first wave, caused a kind of crisis among trad men

when she became the Goth doyenne of the 1790s. No woman had yet earned £500 for a single novel as she had for 1794's *The Mysteries of Udolpho*, an amount that was double the annual income of her husband William. That women were able to find so much success in the rising genre caused concern for anyone trying to protect male supremacy (read: basically all men). Radcliffe earned so much money and fame from the genre in part because the rise of her literary star coincided with the rise of female literacy in the late eighteenth century. For men, this was the true Gothic specter of the time: the literate woman who threatened to rebalance the power between the genders.

Radcliffe used the Gothic to express her discontent with her own subjugation. As such, her female protagonists were often trapped, cast away, muzzled, and mostly prisoners of their own husbands. In *The Mysteries of Udolpho*, ghosts are merely the product of the heroine's flighty imagination. Her supernatural nightmare can only be ended if she learns to control her own neuroses. Fail to do so and she will be locked up forevermore in a convent or castle turret. Succeed, and her reward will be marriage (just another form of imprisonment, at least to the female Gothic mind).

Despite the fairly disempowering narrative Radcliffe was presenting, many women were inspired by her real-life success to venture into their own storytelling. Radcliffe had not only provided a novel set of tropes for the female Gothic going forward, but a model for women to follow to earn money themselves and gain some semblance of independence. Radcliffe had almost single-handedly created a new female class.

Throngs of female writers followed Radcliffe's lead, including Goth sentimentalists Regina Maria Roche and Eliza Parson, two women bolstered by William Lane's Minerva Press, a publisher that sought to capitalize off women's literature and redirect it back into a man's pocket. (Unlike Radcliffe's hefty sum for *Udolpho*, these women typically earned around £20 to £30 per three-book deal.)

This early canon of female Gothic writers reinforced the Gothic heroine as a victim imprisoned within crumbling castle walls. Unable to cast their ghosts aside, these heroines frequently exhibited the symptoms of madness. They spoke in tongues and throttled themselves against the walls in which they were trapped.

An illustration from Eliza Parson's *The Castle of Wolfenbach*.

This early wave of madwomen were precursors to the popular Victorian trope of the madwoman in the attic, as made most famous by Charlotte Brontë in her 1847 novel *Jane Eyre*. Bertha Mason was the madwoman in question, one of Romantic literature's most iconic characters. In the novel, Mason is the first wife of Jane's soon-to-be-love Edward Rochester. After she exhibited signs of madness shortly into her marriage, Mason was locked away in the attic of Thornfield Hall, Rochester's estate. She remains there as Jane enters the picture, making the ceiling creak at night and howling between the floorboards.

The trope of the madwoman in the attic was rewritten over and over in the late nineteenth century. It was indicative of a new wave of female Goth, one that had moved from faraway castles to somewhere closer to home. While Radcliffean Gothic heroines were sent elsewhere—typically to convents or castles—in the Victorian Gothic, the horror is contained within the upper-middle-class home, which by then had become a site of entrapment. The Gothic edged closer and closer to reality and even began to impose itself upon the reader's world.

The madwoman in the attic became pathologized, a figure that inspired scientists to document the rise of so-called female hysteria. She was, according to the likes of Sigmund Freud and Josef Breuer, a woman unable to conform to standard female propriety. She expressed frequent rage when she shouldn't have been expressing herself at all. Mental illness—especially when it pertained to women—was considered not just an affliction of the mind but a kind of moral sickness. Many women, disappointed by the reality of marriage and the domestic isolation it entailed, were cast away like Bertha Mason.

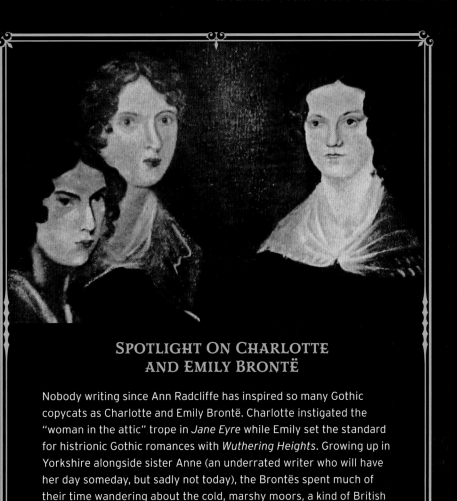

Portrait of the
Brontë sisters
from 1890.

SPOTLIGHT ON CHARLOTTE
AND EMILY BRONTË

Nobody writing since Ann Radcliffe has inspired so many Gothic
copycats as Charlotte and Emily Brontë. Charlotte instigated the
"woman in the attic" trope in *Jane Eyre* while Emily set the standard
for histrionic Gothic romances with *Wuthering Heights*. Growing up in
Yorkshire alongside sister Anne (an underrated writer who will have
her day someday, but sadly not today), the Brontës spent much of
their time wandering about the cold, marshy moors, a kind of British
wilderness in which they'd set many of their spooky novels. While
Anne was more of a realist, Charlotte and Emily were Gothic fantasists
from a young age, daydreaming up supernatural fantasies that would
go on to become some of the most famous in English literary history.

With the widening criteria for insanity came an influx of patients admitted
o asylums across England. A lunacy panic across England ensued and in
859 many of these inmates were sent back home. The Parliamentary Select
Committee Inquiry into the Care and Treatment of Lunatics, an influential
ocument that sought to crack down on the wrongful admittance of sane

people to asylums, was published that same year. Around the same time, Wilkie Collins, a staunch supporter of asylum reform, released his fifth novel, *The Woman in White*. *The Woman in White*, which follows the discovery of a woman who escaped from an asylum, can be read as a condemnation of female imprisonment. As such, while *The Woman in White* has the trappings of a classic Victorian ghost story— the haunted and haunting woman, the mood of terror on every page—it closes the door on the madwoman in the attic trope. By the novel's end, the reader comes to understand that the woman in white has been wrongly cast away, not because of her purported insanity, but simply because she wasn't content with her marriage.

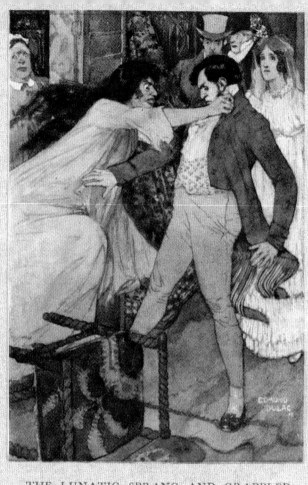

THE LUNATIC SPRANG AND GRAPPLED HIS THROAT VICIOUSLY

Illustration from Charlotte Brontë's *Jane Eyre*.

With the advent of cinema a few decades later, we witnessed the swing back from the damsel in distress to the femme fatale. Curdling wartime fears were rechanneled into carnal horrors. The fear of death was glamorized. Women of the screen ate men for lunch (only sometimes literally). As the movie screen naturally romanticized fear, Goth's female victims became sexy villains.

Theda Bara was one of cinema's first sex symbols, as well as Goth's first cinematic femme fatale. Bara, with her bat-black hair and dark-lidded eyes, quickly made an impression upon the New York theatrical scene when she moved there from Cincinnati in 1908. She made her Broadway debut soon after, landing in the city in a play aptly called *The Devil*. Six years later, in 1914, she

was discovered by Fox Studios' Frank Powell, who proceeded to turn her into a female vampire of the screen.

Bara made her screen debut a year later in the William Fox-directed *A Fool There Was*, in which she played a vampiric temptress, a woman who seduced men out of their money and dignity. She was typecast as a Gothic femme fatale from thereon and even established a new female archetype for the screen, that of "the vamp," a term that became interchangeable with femme fatale. The vamp just had the extra Goth edge.

Until 1920, Bara starred in some forty films, and always played the role of the vamp. Fox's publicity department marketed her as a real-life demon, which only added to her infamy. She was considered scandalous amongst many critics but an icon among the cinema-going public. Fans routinely proposed to her. Parents named their daughters after her. Many women began to dress like her.

Theda Bara being the absolute coolest in 1915.

Fashion designers took influence from Bara and began selling clothes inspired by her characters. Store mannequins were soon clad in black vamp getups: the clinging skirt, the blouse with the plunging neckline. Bara introduced a new vernacular to fashion, a way to dress both sexily and hauntingly at the same time.

These sartorial choices were carried over to Morticia Addams, the matriarch of Charles Addams's one-panel gags for *The New Yorker*, which he called *The Addams Family*. Appearing for the first time in 1938, Morticia was the spookiest, kookiest, and sex-ookiest of the bunch. A descendant of Salem witches, Morticia loved to smoke and make dark jokes about death. She held her family together with class, while exclusively wearing a long black velvety dress with a plunging neckline.

John Astin and Carolyn Jones in *The Addams Family*.

The Addams Family was conceived as a parody of the idealized suburban family. The gag was that despite being a family of Goths who very possibly possessed supernatural powers, they lived a normal lifestyle. They enjoyed little domesticities like trimming the garden's rosebush (though they kept the thorns because those were the best part). They were also the most functional unit on their block. There might not be a marriage in American popular culture more successful than that of Morticia and Gomez.

Addams's cartoon has been adapted into many TV shows and movies but its influence lived on most immediately through a woman who liked to call herself Vampira. Born Maila Nurmi, Vampira was a former pinup model who was discovered at a party in Hollywood in 1953 while wearing a Morticia Addams costume. The dance choreographer Lester Horton had invited her to his annual

Halloween bash, and Nurmi took it as an opportunity to try out a new character she'd been workshopping. Part Morticia, part Theda Bara, Vampira wore long black cocktail dresses and backless shoes and was every bit the vamp. Nurmi introduced Vampira to the party wearing a black wig she'd thrifted, her breasts bound together and her skin powdered with sprinklings of lavender.

At that same party was Hunt Stromberg, the director of programming for KABC (now just ABC). Stromberg was a pioneer of television, a form that was

HOW TO DRESS LIKE A VAMP

Number one: big cahungas, that's a nonnegotiable. But if you're not blessed with the breasts, consider stuffing two large balloons or watermelons underneath a plunging v-necked blouse. You'll also need very heavy, unsubtle makeup, smoky eyes with a dark-red lip. Over accessorizing is a must. More is more. You'll want to be dripping with jewels, preferably ones imported from Egypt.

The icon that is Elvira, circa 1988.

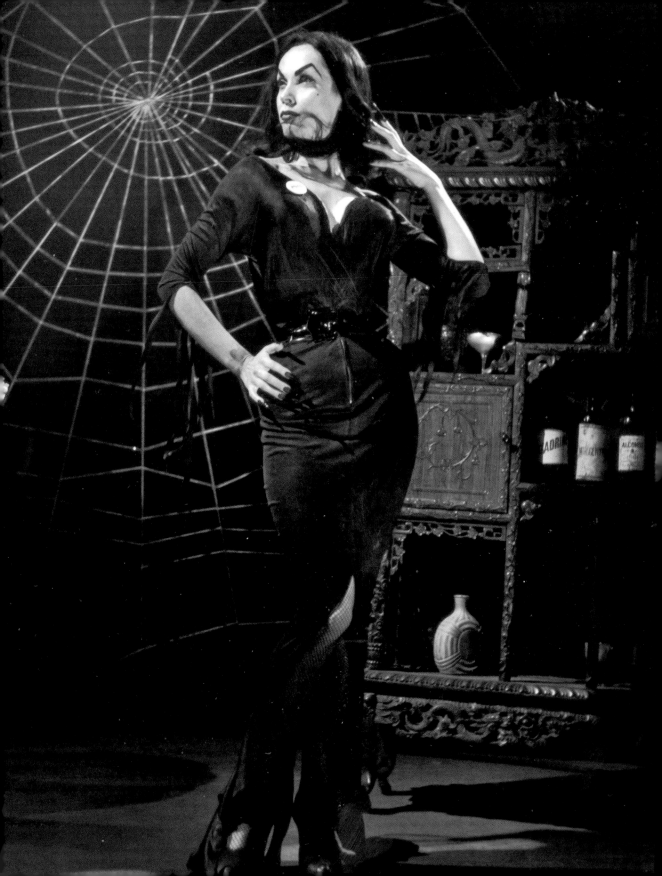

still in its infancy. His eyes were drawn immediately to the woman in black, and the two were introduced. Nurmi told him that she had a stash of low-budget, independently produced horror films back at home that she wanted to find a way to present. Stromberg told her he might have just the gig for her. He wanted her to become the first late-night horror hostess.

Together, they drew up a mood board for who or what Vampira, the late-night horror hostess, would be. Nurmi brought in images of American culture, a collage of Great Depression icons like Mae West and postwar Beat poets like Allen Ginsberg. She took clippings from Disney films like *Snow White*. She wanted to become a Frankensteinian monster of American iconography, while disturbing everything people thought they knew about celebrity in the United States.

In her schlocky underworld, Vampira turned the ultra-glam vision of the vamp to something kitsch and shifted straitlaced sensuality into parody. Like Morticia, she was a comedic counterpart to the archetypal suburban housewife. During a time when women were expected to remain at home, Vampira rebelled against the ploy to keep women neat and contained. She leaked sexuality, power, and horror.

With the vision complete, Vampira first slow-walked on to TV in 1954, a year after Horton's party. Her piercing scream announced the name of the show: *Dig Me Later, Vampira*. On it, she sipped cocktails—spiked with poison, of course—while she spoke in a sultry drawl about death and hinted heavily at her kinky sex life away from the cameras. Vampira was the introduction of a new phenomenon.

Right up until cable TV killed off local independent channels at the beginning of the 1980s, just about every major city in the country had its own late-night vamp. Starting every night around 11 P.M., they'd burst onto the screen in a cloud of smoke and introduce films from Universal Studios' *Shock* collection—the series of films covered in the previous chapter, from *Dracula* to *Frankenstein*. Vampira set the standard.

For a good year, Vampira was hailed and celebrated. Her show became an instant hit in Los Angeles, ratings shot through the roof, and Vampira swiftly became the It Girl of the moment. She had large spreads in *TV Guide* and *Life*. She transcended local television to appear on *The Ed Sullivan Show*. She hung

out with James Dean at late-night spots throughout Hollywood. She met Elvis in 1954 and told him he'd someday be a star.

During the height of the show's success and shortly after the death of James Dean, KABC unexpectedly canceled Vampira's contract. Her show lasted only a year. Nurmi died alone in 2008 and almost no footage remains of *Dig Me Later, Vampira*. Yet none of this changed the enormous impact she'd have on the Gothic culture.

Vampira lived on through her successor, a Valley Girl named Cassandra Peterson, just about the largest chested woman in show business (for anyone who speaks meme, she was the origin of the *big tiddy Goth GF*). Peterson, the daughter of a costume shop owner, created a character she called Elvira in the early '80s.

Elvira was a mix of Vampira, Priscilla Presley, and a '70s porn star. She was the ultimate postmodern Goth, a hyper-referential reflection of all the Goth gals who had preceded her. Following Vampira's lead, she took Goth to even kitscher places.

Just like Vampira, Elvira got her start introducing horror B movies on television with super sexual jokes. When *Elvira's Movie Macabre* first aired on KHJ-TV in September 1981, Elvira became the horror hostess of the cable era. She brought Gothic ephemera to the masses, spooking them out while making them laugh at the same time. She was knowingly ironic and self-deprecating, but she did not take any bull—especially not from men. She was sexy for her own sake and for that reason drew in a larger female audience than she did men trying to get off late at night. Right from the get-go, Elvira was an influential figure for young girls and women who lived simply to make themselves happy, never conforming to anyone else's expectations.

Unlike the Goth Girls of yore, Elvira never played the damsel in distress. In her 1988 film, *Elvira, Mistress of the Dark*, she escapes being burned at the stake with ease and single-handedly defeats an evil warlock. Her power and winning foolhardiness set the template for the Goth girls of today. Whether Jenna Ortega as Wednesday Addams or *Adventure Time's* Marceline the Vampire Queen, the female Goth has swung firmly away from damsel in distress to femme fatale. Wrong her and she *will* crush you with her enormous black combat boots.

RIGHT: Elvira in a promotional poster for her film *Elvira: Mistress of the Dark.*

WE'RE DYING TO HEAR IT: THE BIRTH OF GOTH ROCK

f you want to hear what Goth sounds like, listen to Bauhaus's "Bela Lugosi's Dead." If you want to know what Goth *feels* like, listen to its entire nine minutes and thirty-six seconds, and feel the goose bumps rise on your skin, the urge to laugh giving way to that eerie, suspenseful, disconcerting pit in your stomach. If you want to see what Goth looks like, close your eyes. *This* is Goth.

"Bela Lugosi's Dead" was recorded on January 16, 1979, during Bauhaus's first ever studio session. The song's funereal lyrics, themes of the undead, and overwhelming atmosphere, as well as Peter Murphy's

Bauhaus photographed at the Waldorf Astoria in New York in 1981.

roody lead performance and androgynous self-presentation, set the tone, emplate, and standards for what Goth would become.

When the song was released in the summer of 1979, Margaret Thatcher ha recently become Britain's prime minister. Her election was tied to a swift rise unemployment, street violence, and racism, in the face of which pop music had he blood sucked out of it. The spread of industrial technology brought jobs, dentity, and purpose into question too. Dark, dour, uncertain: it was the perfe breeding ground for Goth's next incarnation.

Emerging from this gloom, Gothic rock began to cohere into a recognizabl style and sound in 1979. It became a sensibility, too, a way to sublimate the surrounding darkness by aestheticizing it, making it exotic and beautiful. Thi s what the Goths have always done best: transform the tragic inevitabilities o ife into something not only bearable but beautiful.

Although Goth didn't become an identifiable style of music in the United States until this moment—the gloomy and sticky summer of 1979—a decade before, its seeds had already begun to sprout. It's commonly asserted that Joh Stickney was the first writer to ascribe the "Gothic" label to rock music. In 967, after seeing the Doors play in a dingy wine cellar, Stickney wrote in his student-run newspaper, *The Williams College Record*, that it was "the perfect room to honor the Gothic rock of the Doors."

Formed in 1965 by four too-intelligent dropouts, the Doors added a brooding ntensity to rock's bedrock of blues. Jim Morrison, the band's singer, was a

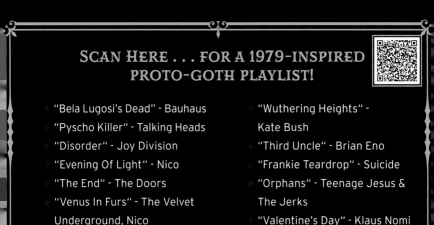

SCAN HERE . . . FOR A 1979-INSPIRED PROTO-GOTH PLAYLIST!

"Bela Lugosi's Dead" - Bauhaus
"Pyscho Killer" - Talking Heads
"Disorder" - Joy Division
"Evening Of Light" - Nico
"The End" - The Doors
"Venus In Furs" - The Velvet Underground, Nico

"Wuthering Heights" - Kate Bush
"Third Uncle" - Brian Eno
"Frankie Teardrop" - Suicide
"Orphans" - Teenage Jesus & The Jerks
"Valentine's Day" - Klaus Nomi

voracious reader of occult esoterica. His lyrics, highly literary and referential, were a reflection of his bookishness as well as his morbid fascination with mortality. Through performance, Morrison turned the darkness he encountered in his search for knowledge into something sensual and erotic. Dancing shirtless and slow, Morrison lingered on every note as though he were trying to kiss the life out of it. As a group, the Doors leaned into somber and dreamy atmospherics, prefacing Gothic rock's prioritization of aura, ambience, tone, and texture.

Back in Britain, the optimism of the 1960s was coming to a close. In the new decade leading up to Thatcher's instatement, national esteem was at an all-time low, the unity felt in the postwar years fractured and replaced by a sense of alienation and isolation. The punk scene arose as an aesthetic rebellion against

The Doors photographed in Hollywood, circa 1968.

LEFT: David Bowie
as Ziggy Stardust in
June 1972.

the Conservative establishment. Bands like the Sex Pistols and the Damned—the latter transitioning into Goth rock some years later—expressed the working class's grievances through a jugular, angular, bare-bones sound, galvanizing the youth to find unity once again in one another. The kids thrifted. They danced like pogo sticks. They grew a disdain for mass culture and marketing.

Aesthetically, punk favored the spiky and sharp. The uniform, almost military in appearance, was typically a leather jacket stabbed with an unsparing amount of safety pins. The punk scene was characteristically rigid, hypermasculine, almost sexless. It was a strict image to uphold, and so punk soon became *post*-punk. Post-punk ventured into more experimental territories and each band entered the scene with a distinctive vision and style. With anarchic darkness left in punk's wake, sensuality indexed itself to this new strain of punk and the post-punks dressed up in New Romantic garb: lace, frills, poet's blouses.

By the summer of '77, pure punk was beginning to lose its hold on the culture entirely. Dance floors cleared when Sex Pistols tracks played. The pendulum swung from the spare and spartan towards the excessive and fanciful. Hardnuts became Dandys. Cue: glam.

Goth drew as much—if not more—inspiration from glam as from punk. While Goth took from punk its sense of lawlessness, Goth took from glam its theatricality. Prior to glam, rock had been a vehicle for perceived authenticity. There was little actual *show* behind the show. With glam, anything outside the show was nonexistent. What you saw was what you got, and what you saw was too dazzling to look away from anyway.

No one's glam phase was more influential upon Goth than David Bowie's run from 1972 to 1974. In those years, he embodied his alter-ego, Ziggy Stardust, a character who spoke to anyone who felt like an outsider. In Bowie's vision, Stardust was an alien forced to observe a broken world. It was a concept that not only inspired the music and presentation of too many bands and artists to list—Boy George, Kate Bush, Gary Numan, the Pet Shop Boys, would just be the start—but the sensibility of the Gothic subculture in the decades to come. Bowie showed the lonely that they were not truly alone. There was a whole world of them. They could glamorize the sadness inside of them, and become one.

FIVE FACTS ABOUT BOWIE'S TOP OF THE POPS "STARMAN" PERFORMANCE

1. Bowie's "Starman" was a sleeper hit. It hardly made a dent until Bowie's *Top of the Pops* performance. Soon after, "Starman" entered at No. 10 on the UK Singles Chart and shot Bowie's latest album to No. 5 of the UK Albums Chart.

2. After Bowie's first run-through rehearsal, he met fellow performer and future girlfriend Lulu backstage for the first time.

3. The dandified hairstyle he sported on stage was the combination of three different styles he found while flipping through various hairdressing magazines. His mom's hairdresser was the one to cut him into shape.

4. Thursday, July 6, 1972—the night of the performance—is said to be the night that invented the '80s, as so many of the decade's biggest musical stars cited Bowie's performance as core inspiration.

5. Right after finishing the performance, Bowie and his band stepped off from the stage, put their arms around one another, and shrieked with glee.

Born to working-class parents in London in 1947, Bowie escaped the world early on through fantasy and dress-up. When his mother briefly left him unaccompanied at age three, Bowie took the opportunity to ransack her cosmetics bag. When she returned, she found him with her powder, eyeshadow, and eyeliner smudged all over his face.

Bowie developed a striking sense of style early on, occasionally showing up to school with dyed hair (something which would have been almost unthinkable in the '50s). When he eventually became Ziggy Stardust almost two decades later, his glamorous streak reached its peak. His striped, sherbert-bright jumpsuits were a rejection of the culture's hippie-ish quest for authenticity. While the first wave of proto-Goth bands like the Doors and the Damned favored introspection, glam artists like Bowie were more interested in extroversion, surfaces, dressing to the absolute nines. For Bowie, life and art were simply a game of dress-up.

While Bowie embodied multiple characters throughout his career, Ziggy Stardust was the persona that Goth took most influence from. Like Stardust, Goths were outsiders who presented themselves with extravagant attire to a world that couldn't quite understand them. Stardust also enabled the gender-bending and androgyny that Goth leaned into wholeheartedly, as they smudged the flimsy boundaries between masculinity and femininity.

All these elements were realized most boldly and in front of the most eyes in 1972. Bowie appeared on television, orange-haired with his arm draped firmly around his guitarist's shoulders, before a prime time Friday night audience and sang "Starman" on the *Top of the Pops* stage, shocking the realism out of rock and softening the rigidness out of masculinity.

A photo of a nineteen-year-old Kate Bush.

If not for that performance, Robert Smith of the Cure would have spent his career hidden away in trench coats. Siouxsie Sioux of Siouxsie and the Banshees would have been unrecognizable. Goth as we know it—and possibly even pop culture at large—would have looked a lot less spectacular.

The still-teenaged Kate Bush first heard David Bowie while submerged in a bubble bath. Soon, Bush would hear that song everywhere. She fell in love. She found a Bowie poster and tacked it to her wall, next to the sacred space she reserved for her greatest hero, Elton John.

Bush hadn't quite realized the extent of Bowie's beauty until she saw that performance of "Starman" on *Top of the Pops*. Those three minutes and thirty-three seconds impacted Bush as much as any other artist of the time, but it was she who formed the bridge between Bowie's ur-Goth moment and Goth proper.

Bush was by no means a Goth artist. She belonged to no scene, subculture, or class, and her music was far too varied to conform to a single style. What she did do was imbue pop cultural myths and literary characters (she was no stranger to a Gothic heroine) with a different point of view, often allowing them more interiority than the text from which they'd been lifted. This was the case with "Hammer Horror," a song from her second album about an understudy haunted by the actor who died on set and who he was forced to replace as

the Hunchback of Notre Dame. Released in late 1978, the song was Bush's most patently Gothic song, as well as her most Bowie-influenced. With its campy major-key, screaming horror movie strings, and exceedingly theatrical presentation, "Hammer Horror" added a dark yet tongue-in-cheek shroud to Bowie's proto-Gothic glamor.

"Hammer Horror" bore resemblance to the Gothic anthem that launched Bush's career at the beginning of 1978: "Wuthering Heights," a flirtatious take on Emily Brontë's novel of the same name. Bush's four minutes of condensed Gothica, which she performed with a banshee-like vocal, was an unlikely sensation and topped the UK charts. Bush, who shares a birthday with Brontë, wrote the song in appropriately Gothic fashion: sitting at her piano, the light from a full moon streaming through her window and a common cold rendering her mildly delirious.

Bush had been introduced to Brontë's *Wuthering Heights* a decade prior when she chanced upon a television adaptation of the novel. She caught the end of the program, drawing closer to the screen as the ghost of Cathy reached through her lover Heathcliff's window, terrifying his tenant—and nine-year-old Bush. The adaptation was part of a season of old horror movies that the BBC would broadcast throughout the winter, and another film from that season would go on to make British music history.

One night in 1977, the year before Bush released "Wuthering Heights," Bauhaus's guitarist Daniel Ash began playing a riff of fairly rudimentary chords with a haunted, minor twist. The melody reminded David J, the band's bassist, of a lyric he'd been turning over about Bela Lugosi's Dracula. J had caught Lugosi's 1931 version of *Dracula* during the BBC's horror movie season, and it had been on his mind ever since. As Ash continued playing the ominous riff, J said he believed Lugosi was the ultimate Dracula, the only actor who really brought a sense of the character's elegance and sexiness to the role. Together, Ash and J called Peter Murphy, Bauhaus's singer, and filled him in on their vampiric discussion.

That phone call not only shaped a song but set in stone the Gothic subculture's vision of the vampire as a sexy outsider. The band members summoned up the lush imagery of Lugosi's performance to articulate their erotic view of death, destruction, and decay. It was that vision of the vampire

LEFT: Bela Lugosi as Dracula in the 1931 horror classic.

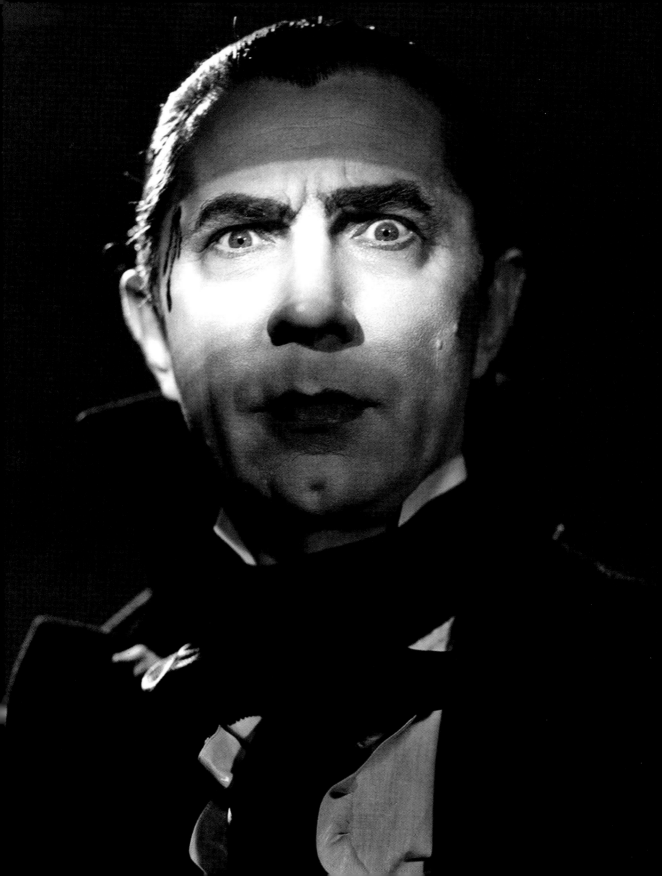

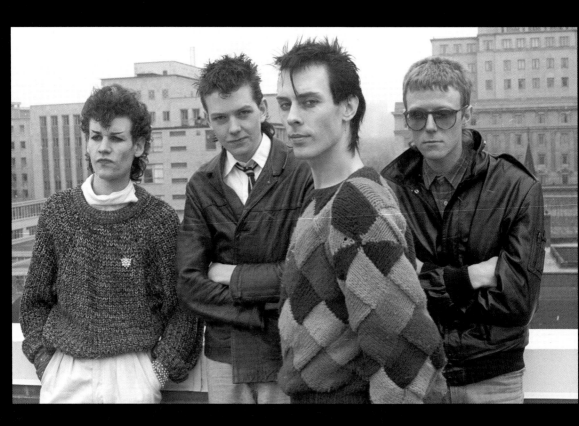

that would map perfectly onto the contemporary rock star: theatrical, sexy, dangerous—the broken promise of eternal youth.

The band brought a piece of paper with the lyrics they'd written to a rehearsal space. Kevin Haskins, the drummer, kicked the song into life (or rather, death) with a strange bossa nova beat, Ash came in with his haunting riff, J plucked a seesawing bassline, and Murphy entered like a lowing banshee, creeping slowly around the studio like a predator stalking its prey as he sang. The song came together like a spell, the tempo slow, the tone dour.

The band booked a session at Beck Studio in Northamptonshire right away, paying $11 for their first studio session. It was the first time Murphy had ever even sung into a studio microphone. As J and Ash played their opening riffs, Murphy felt a sense of dark beauty washing over him. The kitsch spookiness gave way to a kind of Gregorian sacredness. The band recorded "Bela Lugosi's Dead" in one take. What you're hearing when you listen to the track is the first thing Bauhaus recorded, ever.

Unleashed upon the unassuming public on August 6, 1979, "Bela Lugosi's Dead" cast a dark spell upon an unusually hot British summer. A fairly small label called Small Wonder released the track as a 12" on white vinyl, the sleeve art a print taken from *The Cabinet of Dr. Caligari.* The legendary DJ John Peel was one of the first to play the track, filling the airwaves with a sound unlike anything ever transmitted before: nine minutes of ghostly atmosphere-building that married the spiky melodies of post-punk with the ambience of dark dub (a style of music which originated in Jamaica and made liberal use of reverb and echo effects). Unlike any other music at the time, the song was initially hard to categorize. Some viewed it as a very arty contingent of the post-punk sound. But the magazine *New Musical Express* (*NME*) soon identified it as "Gothick-Romantic."

With its canonically Gothic references to bats, blood, capes, and dead flowers, "Bela Lugosi's Dead" was as deliberate as any Gothic novel in its generic set up. Murphy originally saw those on-the-nose lyrics as comic, a product of his dark humor. But his highly theatrical and intense performance of them gave the song a weight of seriousness. Listeners took "Bela Lugosi's Dead" very seriously too. It not only became one of the biggest alternative hits of the year but codified the tropes of Goth going forward.

Soon after its release, a young man named Ian Curtis caught a performance of "Bela Lugosi's Dead" at Bauhaus's residency at Billy's in London, a venue that would soon become the Batcave (more on that in the following chapter). After the performance, Curtis enthused the band about how much he adored their song.

Curtis was the lead singer of a band called Joy Division, an up-and-coming act from Manchester who had released their debut album, *Unknown Pleasures,* two months prior to Bauhaus's "Bela Lugosi's Dead." While Bauhaus's debut single continued to top the alternative charts, *Unknown Pleasures* very quickly reached cult status and became the standard just about every post-punk band in Britain aspired to. That summer, both Bauhaus and Joy Division built the groundwork for what Gothic music would become, though each in very different ways.

The "Bela Lugosi's Dead" single, 1982.

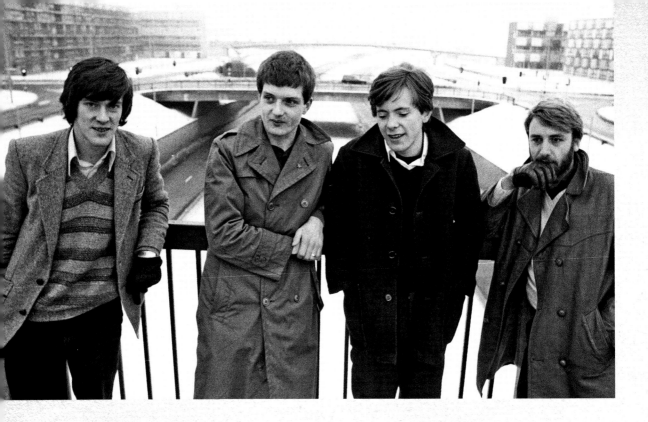

You can find traces of Bauhaus and Joy Division in every Goth band that followed. From Bauhaus, bands like the Sisters of Mercy, the Danse Society, Play Dead, and the Cult took their ritualistic atmospheres, as well as Murphy's Byronesque style. From Joy Division, they carried forward Curtis's droning vocal, Peter Hook's loud, melodic bass, Stephen Morris's motorik drum rhythms, and Martin Hannett's cutting-edge production. Joy Division practically laid the template for Goth rock, with focalized guitars and drums, distant vocals and guitars, echoey and slow-delay effects, and a soundscape so big it could swallow you. The pursuit to create not only songs but atmospheres was central to Joy Division's mission and Goth music onward. Joy Division's imperial and reverberate sound was even compared to Gothic cathedrals by the journalists who wrote about them early on.

But it was Anthony H. Wilson, Joy Division's manager—not the journalists—who first attached the word "Gothic" to the band's sound. Wilson referred to them as such while promoting Joy Division in an interview with the BBC in 1978, just as the band was gearing up to release *Unknown Pleasures*. Wilson was one of the first music industry players to refer to their own act as "Gothic." The writers who followed latched onto his bait.

The word "Gothic," by then a point of curiosity for music journalists and fans, helped Joy Division gain quick traction. In the September 1979 issue of *Melody Maker*, Joy Division was the central subject of Mary Harron's famous article on the rise of Gothic rock (how very typical of Goth, to self-mythologize itself in real time). Harron was the first to trace Joy Division's doomy music back to the sunny climes of the Doors' California, labeling both bands as "Twentieth Century Gothic."

Joy Division's twentieth-century Gothic was a specific image of England in disarray. Perhaps more than any other alternative British band of the late '70s, Joy Division was able to take the temperature of the time, reflecting the country's decaying post-industrial state in sound. Listen to a Joy Division song and you feel yourself transported into the dirty sprawl of the city at the time—the grayness, the loneliness, the emptiness, the scratch of footsteps on cold concrete. There was never any hope to be found in Curtis's lyrics and salvation could only be sought through death.

Curtis lived only twenty-three years.

Curtis played his final show with Joy Division on May 2, 1980. Sixteen days later, he hanged himself with a washing line in his kitchen, Iggy Pop's *The Idiot* spinning on his record player. Joy Division released "Love Will Tear Us Apart" to commemorate Curtis a fortnight after, one of music's few truly perfect songs.

Just like Goth, "Love Will Tear Us Apart" pushes us to face the reality of death and tragedy, inscribing it with a sad kind of beauty that we can, for the span of its three and a half minutes, not just tolerate but sink into. As Curtis sings, for just a moment, he is undead.

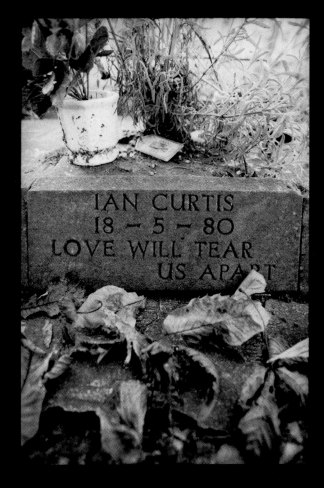

The memorial stone for Ian Curtis, circa 1985.

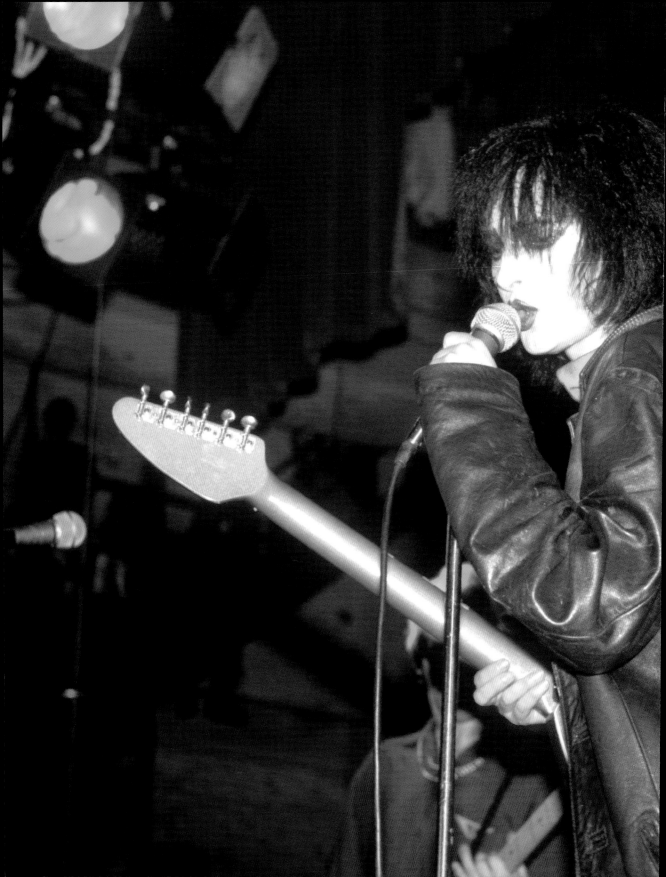

IT WASN'T JUST A PHASE, MOM!: WHEN GOTH BECAME A YOUTH SUBCULTURE

n the '80s, Goth became a lifestyle. Fueled by enormous hair, smudged eyeliner, slow dancing, and echoing guitars, it was a subculture that became the most legible and far-flung demonstration of Goth thus far. Pretty much every idea we have of what Goth is today—infrequent loads of all-black laundry, the most prolonged makeup routines imaginable—was formed in the '80s.

By then, "Gothic" wasn't applied just to music but to an entire generation of people who were aping the

Siouxsie Sioux and the Banshees perform, circa 1983.

style of their favorite bands and dancing sulkily under disco balls. Subcultures themselves—from skaters to New Romantics—also became a recognizable part of life in this decade.

Largely a reaction against Thatcherite and Reaganite Conservatism in Britain and the United States, respectively, subcultures were ways of navigating life outside mainstream structures. Members of these subcultures organized their identities around music, fashion, and style. Goth, in particular, required an intense level of participation. If you've ever tried and then given up on applying winged eyeliner, you might begin to have some understanding of the dedication that goes into maintaining the Goth look.

Goth was among the most insular of subcultures. Onlookers got the point of punk—it was overtly political, anarchic. They got the point of skaters, too; kids

SCAN HERE . . . FOR A PLAYLIST OF TOTALLY '80S GOTH SONGS

"Medusa" - Clan of Xymox

"Goo Goo Muck" - The Cramp

"Pretty Girls Make Graves" -
The Smiths

"Spellbound" - Siouxsie and
the Banshees

"Eighties" - Killing Joke

"Lucretia My Reflection" -
Sisters of Mercy

"Since Yesterday" -
Strawberry Switchblade

"The Killing Moon" - Echo &
the Bunnymen

"Pandora (for Cindy)" -
Cocteau Twins

"Black Celebration" -
Depeche Mode

"She Sells Sanctuary" - The Cult

"Release the Bats" -
The Birthday Party

"Sebastiane" - Sex Gang
Children

"Tainted Love" - Soft Cell

"The Host of Seraphim" -
Dead Can Dance

"Gecko" - The Creatures

"Charlotte Sometimes" -
The Cure

"Human Fly" - The Cramps

"Don't Fall" - The Chameleons

"The Shadow Of Love" -
The Damned

"Scary Monsters" -
David Bowie

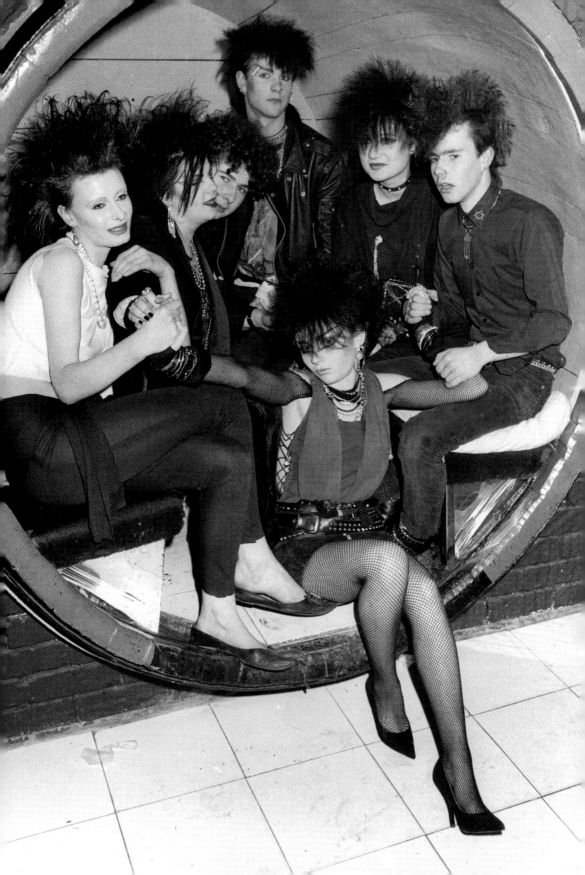

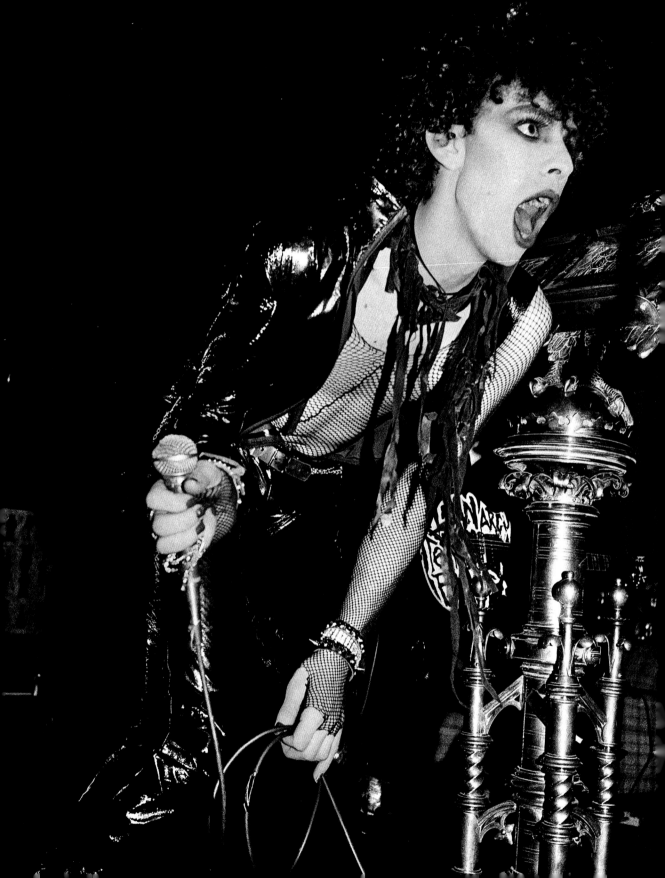

LOOK LIKE A GOTH: A HAIR TUTORIAL

YOU WILL NEED:

A fine-tooth comb Super-super-super hold hairspray

Patience and courage

INSTRUCTIONS:

1. Take your hair that you haven't washed in at least a week and douse in hairspray.

2. Sit on a coffin lid (or a chair, if you must) and tilt your head upside down. Take a strand of hair and backcomb the living daylights out of it. Do this to every single strand.

3. Coat hair in an extra layer of hairspray.

4. Take your fine-tooth comb and begin to futz together your backcombed strands.

5. Once your hair resembles a hissing cat, apply yet another layer of hairspray. This time, really make it count. Hold your breath, keep your finger pressed down on the can's button.

6. Voilá! Your hair looks terrifying. It's perfect.

ike going fast. But Goth was baffling and impenetrable to just about anyone outside of it. There was no obvious point to Goth—though that *was* the point of Goth. It was a feeling, not a purpose. Who would want to spend literal hours applying liquid eyeliner, backcombing their hair until it resembled an angry skunk, and making their appearance so outlandish that it would make the average person walk in the opposite direction? Someone who felt not of this world, or at least too dark or deep or romantic for it. In short, a Goth.

Subcultures are just as much a manifestation of everything their members want to be as what they certainly *don't* want to be. The Goths did not want to be mainstream. They did not want to be shallow. They did not want to dance to the disco music that was popular at the time. What they did want was to brood, to dig deep, to find romance in the dark corners of the night. They were—just as Bowie had envisioned them—outsiders.

LEFT: Olli Wisdom in 1983.

Subcultures also implied a degree of rebellion, which was perfect for the Goths. As we learned in the first chapters, Goths picked up a bad reputation fairly quickly. For many centuries, "Gothic" was thrown around disparagingly to describe society's vandals and villains. By the '80s, those people had taken a sexy, rebellious turn. Even so, there was still a fair amount of derision thrown toward the Goths, though that only stoked their rebellious fire. In the '80s, Goths doubled down and reached new heights (quite literally, with their hair and Doc Marten boots). They took the world by storm.

For a subculture to really take off, you need a breeding ground upon which the new species will hatch. For Goth, that space was the Batcave, a weekly club night that existed briefly between 1982 and 1985 in London's aptly named Gargoyle Club. Dreamed up by the social lightning rod that was Olli Wisdom, who was then the singer of glam-Goth band Specimen, and his friend Jon Klein, Specimen's guitarist and later a member of Siouxsie and the Banshees, the Batcave would go on to define the look and feel of Goth in the decade to come.

Prior to the Batcave's opening, London had been overrun with disco and jazz joints, with very few spaces dedicated to alternative or underground culture. With the Batcave, Wisdom and Klein brought a distinct aesthetic and vision, one that would offset the brightness of the disco balls hanging all throughout London's chintzy venues. "No Punk, No Disco" read the sign

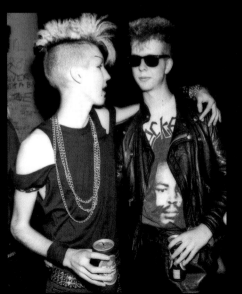

Revelers at the Batcave, circa 1985.

out front. The Batcave recoiled from the light—literally. It occupied a dank little corner of a Dickensian street in Soho.

To enter the club, visitors had to step inside a rickety elevator and climb two floors. When the doors opened, their eyes would have to adjust to a blackness even darker than the smog-filled sky outside. The first thing they'd see would be the cheap Halloween decorations, skeletons made from shoddy plastic, or possibly the coffin hanging from the ceiling. The walls were covered with crumpled trash bags and throat-tickling cobwebs. This sorry state is what they now call the "legendary" Batcave, but if we've learned anything about the Goths, it's that they can romanticize just about anything.

But beyond the cheap decor and projections, the Batcave truly earned its legend status. It was a multisensory world of darkness and sound. The music thumped while projections of Gothic bands and visuals played faintly on the walls. On the dance floor and by the bar, you'd regularly find A-List Goth clientele, including members of Bauhaus, Nick Cave, Robert Smith, and Siouxsie Sioux.

Every Wednesday night, the Batcave was the place to be. You'd never seen people dressed so decadently, and each with their own take on Goth, from fishnets aplenty to haunted opera gowns. It set the stage for artier, heavily costumed bands like Alien Sex Fiend, who were one of the Batcave's recurring acts. The club hosted a great many Gothic bands, including Sex Gang Children and the Guana Batz, who would go on to set the scene ablaze.

After the bands put down their guitars, Hamish MacDonald, the Batcave's resident DJ, would play a long four-hour set. The Goths moved to his throbbing beats with all the heaviness in their bodies at least twice as slow as their disco nemeses. The bodily music MacDonald played, with basslines so low they felt like they were shaking your bones, gave physical expression to the dancers' dark fantasies. Each Wednesday night, Goth wasn't just an idea or aura, but something you could actually feel in your body. Dancing as one obsidian mass, nights at the Batcave felt almost ritualistic, ceremonial. It was as though time slowed down while the attendees created a world even darker than the one they were trying to escape.

The setting was a point of fascination for the music journalists who spectated as often as they could, keen to sniff out a new scene in the aftermath of punk and glam. In the first years of the Batcave, the phrase "Gothic rock" became a regular fixture in the alternative music press. As it grew in popularity, "Goth" became a tag those within the scene tried to distance themselves from. For outsiders, "Gothic rock" was a convenient way to label and make sense of a new social and cultural phenomena. For the Goths themselves, it was just another coffin-shaped box.

Before the Batcave, Goth had been an insulated world. But as the word spread, outsiders wanted in. Record companies came snooping, knowing that they could whip up a quick buzz by signing a Goth or Goth-adjacent band. By that time, playing Gothic rock was a surefire way to get prime time radio play

and substantial press coverage. The BBC regularly broadcast Goth acts. *NME* and *Melody Maker*, Britain's biggest music magazines, covered the Goth music scene extensively and were largely responsible for the crystallization of Goth in the public eye.

One band whose popularity soared because of Goth's trending status was Siouxsie and the Banshees. While they'd been bubbling underground since their formation in 1976, the Goth tag brought them to the surface, and they would soon dominate what Goth would become. Like most bands who were labeled so, the band despised the Gothic branding. But even if it was unintentional, absolutely everything about the band was Goth, from their name—inspired by the Vincent Price film *Cry of the Banshee*—to their somber backstory.

Siouxsie and the Banshees photographed in 1977.

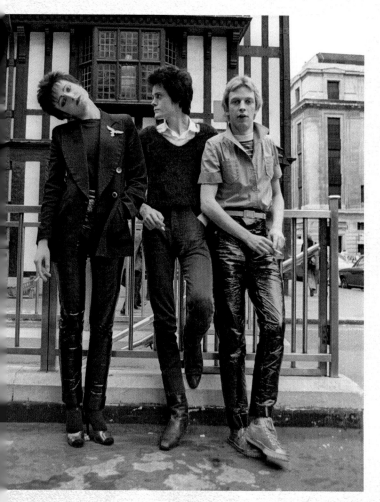

The band's leader, Siouxsie Sioux (born Susan Janet Ballion), was born to a Belgian doctor and a British secretary in 1957, the youngest of three children. She grew up an outcast in a middle-class suburb of London and fell even further into herself at fifteen when her father died in 1972 of an illness related to his alcoholism. In her grief, she lost a substantial amount of weight, grew physically ill, and ended up in the hospital. It was during her admittance that Sioux heard David Bowie for the first time. It was the same performance that had transfixed Kate Bush and so many others, the made-up man on TV blowing the young girl's mind.

That performance gave Sioux the courage, or at least the initiative, to become herself. She began taking the short train journey from her suburb to London, finding in the city a then

hriving punk scene. She darted in and out of venues across the capital, taking style inspiration from all walks of life. By the time she reached the latter half of her teens, Sioux donned a mixed assemblage of punk, cabaret, and S&M-inspired regalia, somehow fitting the mishmash into a coherent whole. When she returned to her little suburb, she got a kick out of the shocked faces from her neighbors.

While she went on to become one of post-punk's most compelling vocalists, Sioux was less interested in musical proficiency than she was creating a dressed-up vision. She'd taken a leaf out of Bowie's glam book in that way. She wanted to recreate in sound the goose bumps she'd felt watching Bowie on *Top of the Pops* or Anthony Perkins in Hitchcock's *Psycho*. She wanted to capture the shock of something new and to conjure an atmosphere filled with tension, suspense, and unease.

In 1975, during glam's faded afterglow, Sioux met a bassist named Steven Severin, with whom she shared a dark sense of humor and outlook on life. Severin was a diehard fan of Edgar Allan Poe and Vincent Price films (and yet he still didn't care to be called a Goth). At the time, the culture at large was beginning to reflect Severin's tastes. Stephen King's horror had a strong foothold on the literary market; the 1976 film adaptation of his first novel, *Carrie*, awash with (pig) blood, was representative of loose censorship and a growing taste for graphic horror.

The media being produced at the time may have suggested a more liberal mindset, but conservatism across Britain and America was just as stiff as

THE MOST GOTHIC BAND NAMES OF THE '80S

- Christian Death
- Southern Death Cult
- Dead Can Dance
- Ghost Dance
- 45 Grave

ever. When Siouxsie and the Banshees formed in 1976, they played to a very underground audience. Their first ever show at London's 100 Club in September of that year was one of their most confrontational and outrageous performances ever and soon became something of a legend. Borrowing the Sex Pistols' Sid Vicious on drums, the Banshees played a twenty-minute jam of cacophonous noise filled with mock covers of rock classics, as well as a twenty-minute improvised performance of the Lord's Prayer, just because. Such a performance transcended words, understanding, and labels.

Nevertheless, "Goth" found itself attached to the Banshees some two years later. Nick Kent, a music journalist who caught one of their shows in the winter of 1978, thrust them under the Doors' shadow, comparing them to the architects of Goth in his live review. After receiving a flurry of Goth-related press, the Banshees scored their first record deal with Polydor in the summer of '78. While they'd been on label heads' radars ever since their iconic performance at the 100 Club, those in the business had no idea where to place the band. Sioux was quite literally a fearsome performer, prancing around onstage as though she were looking for a fight—and they had no idea how to market that. "Goth" then became the perfect category in which to make sense of them and sell them.

With Polydor, the band released *JuJu* in 1981, considered by some to be the first Goth album ever. It achieved both critical and commercial success and enabled them to play a big national tour with a band called the Cure as their support act.

Robert Smith, the Cure's lead vocalist, joined the Banshees as their temporary guitarist, an experience that would fundamentally alter Smith and his band going forward. Before their tour with the Banshees, the Cure were outfitted like four polite young men with tidy haircuts, sensible button-up shirts, and Macintosh jackets, the kind of band that might play a distant relative's wedding. After the Banshees tour, they grew out their hair, backcombed the frizzy ends, and dressed in black. From thereon, the Cure took less influence from the brighter side of punk and ska and lost themselves to the dark forest that was Goth.

Aesthetically, Smith was very much Sioux's male analogue. He had the same bat's nest of hair, the same look of menace in his eyes, the same dark palette coating the lids. But the band's sound didn't quite mirror the ghoulishness of their image until their fourth album, 1982's *Pornography*.

While their first three albums conveyed a clear trajectory towards the increasingly dim and dirge-y, *Pornography* was the Cure's most deliberate attempt to create something truly frightening. They entered their recording sessions with the goal of freaking out their listeners and spooking themselves in the process. To aid in that mission, they each dissolved little squares of hallucinogens on their tongues and turned their sense-warping experience into sound. The result, as you can hear on *Pornography*, is almost overwhelming, great monoliths of noise, with stacks of guitars and synths piled tall as a turret.

Listening to *Pornography* from start to finish feels like walking through a heavy fog before falling through the trapdoor to hell. But what should have remained buried underground soon took to the surface, reaching the Top 10 of England's album charts and turning the Cure from a cult act into one of the country's most formidable bands.

One act who took the Cure's quasi-mainstream success and ran even further with it was the Sisters of Mercy, the most explicitly Goth of the bands on our timeline so far. Formed in Leeds, England, in 1980, the Sisters of Mercy, like most Goth rock bands, started as a joke that was then taken very, very seriously. Andrew Eldritch, the band's lead vocalist, originally saw the band as a project to marry the outrageous showmanship of American rockstarism

The Cure's
Pornography.

with the austereness of British post-punk, a combination he personally found hilarious. He especially got a laugh out of performing the Sisters of Mercy's ridiculously bleak cover of ABBA's "Gimme! Gimme! Gimme! (A Man After Midnight)."

Like just about everyone else from the scene, Eldritch had been enabled and essentially changed by Bowie's *Top of the Pops* performance of "Starman." Eldritch felt that Bowie had given him permission to become a larger-than-death version of himself onstage, a persona large enough to overpower the man who suffered from stage fright.

By the time the Sisters of Mercy had emerged on the scene, the tropes of Gothic rock had been thoroughly codified and made discernible on a mainstream level. To the culture at large, Goth had become as identifiable as punk. Goths—and their music—were everywhere, from the metropolis to the outskirts of England, in bars and clubs across the country.

Unlike the bands that came before them, the Sisters of Mercy didn't preexist this Gothic subculture, but were actively inspired by it. Their sonic, visual, and lyrical aesthetic was contingent on it and had a certain clarity because of it. They were unashamedly style-over-substance, dressing consistently in tight leather pants and pointy boots, with their faces covered by large shades and a shock of hair. They had a uniform and even their own logo before they ever released a single song.

When they finally released their debut album *First and Last and Always* in 1985, the Sisters of Mercy quickly achieved chart success—as well as a very nice record deal with Warner. The band's swift success signaled the mainstreaming of Goth and, therefore, the death of an underground subculture. The Batcave closed its cobwebbed doors, smaller venues shuttered in its wake, and bands like Siouxsie and the Banshees and the Cure began playing arenas. Goth was no longer a sensibility, lifestyle, or aesthetic shared among those on the fringes. Suddenly, Goth belonged to the masses. There are very few subcultures that have survived integration into the mainstream. Goth has not only endured but exists forever in its own state of perpetual undeath.

Sisters of Mercy in 1984.

LAUGHING MY CARCASS OFF: DARK COMEDY AND GOTHIC PARODY

hy did the chicken cross the road? To fall into traffic and die. Ha . . . ha?

This is the sort of thing we talk about when we talk about dark or black comedy, the comedic province of the Goths. Black comedy is the often inappropriate mixture of the tragic with the whimsical. It makes light of the darkness and the things we wish to cast as far away as possible out of fear. Death is, of course, a common subject of the Gothic dark joke. As the Goths know, there's really only two things we can do to live with the fact that we're all going to die: either make really edgy art

Tim Curry in *The Rocky Horror Picture Show*.

FIVE JOKES YOU PROBABLY SHOULDN'T TELL AT A FUNERAL

Why did Uncle Billy cross the road? We'll never know, he was hit by a truck . . .

He died doing what he loved. Falling from a roof and landing on a large spike.

[While holding an urn]: Your grandfather was a lot smaller than I remember.

Don't be sad. You're not losing a family member, you're gaining a guest room!

Well, Dracula's wedding turned out perfectly.

about it or laugh about it. So, in this case, we're going to die laughing to our graves. Ha, ha.

Black humor allows us to express the darkness and cruelty of our world from a detached distance. Unsurprisingly, it tends to edge closer to the cultural center during times of economic and spiritual hardship, particularly during wars or immediately after conflict. In 1940, a year into World War II, the French writer André Breton coined the term *l'humour noir* (black humor) to describe the turn in surrealist writing towards the deathly and macabre. It's a kind of humor that has grown alongside modernism. As our world grows evermore fractured and more and more difficult to comprehend, black humor allows us the opportunity to simply reflect on the absurdity of it all in a way that won't send us on a downward spiral. The world is full of nonsense. We're all going to die. Again: let's just laugh about it.

No one's better at laughing at these cruel facts of existence, or even themselves, than Goths. While mainstream culture often mistakes them for being overly self-serious—and sure, they certainly can be—they're also part of

a subculture prone to self-parody. That might be because there's no style so privy to parody as Goth. The Goth is so easy to mimic and poke fun at purely because it's so tropey.

Comedy has always played a part in the Gothic, even if only subtly. Radcliffe's novels were quick-witted and zippy, Walpole's self-consciously absurd. Very soon after the first wave of Gothic literature in the late eighteenth century, parodies of the new genre began to emerge. There was a good deal to laugh at. Those desperately trying to repeat the success of Walpole and Radcliffe wrote formulaic follow-ups, not caring whether their own imitation was good or not. And, of course, so much of this writing was laughably bad. Goth loved cliché as much as it loved bats and death and castles and virgins. It loved a heroine who stumbled upon a secret in a dark castle. It loved predictability.

No one took finer aim at this than Jane Austen, who may well have been the first to establish the link between Gothic and parody to a mass culture. In 1797, during Goth's watershed moment, Austen set to work on a novel that thoroughly roasted Goth and the reading habits it inspired. She called it *Northanger Abbey*.

Completed in 1803—though not published until after Austen's death in 1817—*Northanger Abbey* follows seventeen-year-old Radcliffe-obsessed Catherine Morland. Morland leads a fairly ordinary—one might even say "boring"—life; she is simply so unremarkable a person that Austen herself has to keep reminding us that she is the heroine of the novel. Yet onto her very normal life, Morland projects the grandiose displays of romance and emotion that she's learned about from Gothic literature. Those of us who like to pretend we're the main character in an overdramatic music video might recognize ourselves in her. When Morland is invited to stay in the very prosaic Northanger Abbey (the only vaguely interesting thing about it is that it has

✦ Photobooth images
of André Breton.

LEFT: Oscar Wilde, circa 1882.

"abbey" in its name), her overactive Goth imagination gets the better of her. She sees vast, endless mysteries in phenomena that could be explained away by the most basic science.

While some wrongly claimed that Austen's satire had killed the genre, in truth, Gothic literature had been in decline for a good while by the time *Northanger Abbey* was finally published. In 1799, two years after Austen started work on the novel, the poet Mary Alcock published the poem "A Receipt For Writing a Novel," a recipe of stock proponents found in Gothic novels, which included everything from young virgins to fainting fits. By the early 1800s, Goth's shocks and spooks had become predictable to even the most casual reader. The Gothic novel, as made popular by Walpole and Radcliffe, had grown old real quick. The tropes were simply so overworked that they became familiar to just about everyone. Think of it like that moment in a horror film when you see a girl venture down into the basement. You know exactly what's coming next.

In the Victorian era, when Gothic literature experienced its second wave with Poe, Dickens, and the Brontës, parody quickly followed once again. Goth came back stronger, finding its way off the page and into the bleak culture of the time. It would have been difficult for any novelist at the time not to have come into some contact with Goth and form a dialogue with it, no matter how unintentionally. One such writer, who self-reflexively parodied Goth's own influence on him, was Oscar Wilde.

In 1891, Wilde published his most famous work, *The Picture of Dorian Gray*, the story of a wealthy dandy who trades his soul for eternal youth, which combined elements of satire, melodrama, and Gothic themes of death and decay. *Dorian Gray* was a work of Gothic camp that followed on the heels of a lesser-known work of Wilde's, his 1887 short story *The Canterville Ghost*. Following a family of cynics who move into a house that is undeniably supernatural and filled with ghosts, Wilde's novella parodied the ghost story, an emerging form at the time. Recalibrating terror into laughter, Wilde turned each of the characters in *The Canterville Ghost*—including the haunted house—into Gothic caricatures. Each of them reacts to their supernatural surroundings with modern practicality. Really, it's the inverse of *Northanger*

Abbey: the family overly rationalizes the supernatural, to the point where absolutely nothing can spook them.

As *The Canterville Ghost* proved, what would have caused a scare in the past felt very quaint—and laughably so—in the present. This is part of what makes Gothic parody recur—each time we move on from a new era of spooks, they become fertile to parody. Parody has followed the Gothic every time it has reemerged into public favor, no matter what form it finds itself in. By the time it came to the twentieth century, the world had a broad-strokes understanding of Goth. Rather than referencing specific works, as Austen had done in *Northanger Abbey*, or specific conventions, as Wilde had in *The Canterville Ghost*, satirists needed only to gesture vaguely toward the Goth. It was a vibe that could be summoned just from a single thundercrack or high-flown emotional performance.

When Goth came to cinema, it carried with it such an excessive display of emotion that one couldn't help but laugh. Bela Lugosi's performance as *Dracula* was just so outrageously self-serious that nowadays it can hardly be taken seriously at all. Of course, this excess of emotion has always been a hallmark of the Gothic, which is another reason why it leans so easily into parody.

Gothic parody took as swiftly to television as it did to cinema. In 1964, ABC TV's chief commissioner David Levy secured the rights for Charles Addams's *New Yorker* cartoon *The Addams Family*. As we learned earlier, *The Addams Family* was irreverent from the outset. It was originally a comic strip, a form

that was bringing a new sense of drollery to newspapers. In Addams's vision, the ookiest family was essentially a satire of postwar upper-middle-class family life rendered through a Gothic lens. Addams clearly possessed a dark and risqué sense of humor, as well as a reverence for the Gothic. He originally envisioned *The Addams Family* as a lot more humorless and dourer than his final product. He drew his characters, which were as morose as you might expect a Goth to be, with a spidery hand. In one panel, he drew Wednesday Addams, the youngest of the bunch, beheading her dolls with a guillotine. In another, the children are seen being gifted a noose by a family friend.

In the decades between Addams's original comic and *The Addams Family* television pilot, the American public's relationship to spook had drastically changed. While the films that Vampira introduced to the late-night crowd

may have once genuinely scared its viewers—these were, to be fair, a pretty nervous bunch and even the growing genre of rock 'n' roll scared them—a decade later, they were laughably tame. The horrific monster villains of yore became like friendly comedic companions.

And so, in the mid-'60s, the gruesomeness of Addams's original vision was dialed down quite a lot for the television series. Despite all the trappings and signifiers of horror—the dimly lit house, the desolate graveyard, the wardrobes solely consisting of black—it was a safe, cozy show that was suitable viewing for the whole (not undead) family. *The Addams Family* TV show demonstrates the power of recontextualization that is fundamental

The cast of the original Addams Family TV show, circa 1964.

to the parody and black comedy genres. You can take all your regular horror fixtures and fixings but, so long as you add a sprightly theme song, you'll find nothing scary about it. In fact, *The Addams Family* is closer in tone to *Mork and Mindy* than, say, *American Horror Story*. The Gothic elements are used solely as points of parody.

Indeed, the original TV series took a lot of influence from the popular sitcoms of the time, if only to invert them. Aside from their own dark Victorian Gothic home, the street in which the Addams family live looks just as suburban cookie-cutter as any of the other popular family sitcoms of the late '50s and early '60s. But since the show unfolds from the Addams family's point of view, we come to see them as the "normal" ones in comparison to their über-normie neighbors. The Goths are no longer the strange outcasts, but an oasis of relative normalcy amongst their white middle-class neighbors, who are always the butts of the jokes.

Iconic inspiration: Gustave Doré's illustration of Poe's *The Raven*.

SPOTLIGHT ON CHARLES ADDAMS

Born in Westfield, New Jersey, in 1912, Charles Addams practically entered the world a Gothic rascal. He stirred up terror as a child, getting his kicks from pranking the neighbors and drawing gruesome cartoons during Sunday school. When he wasn't drawing, he was wondering what it was like to die. Eventually, his doodling and fascination with death coincided. He drew graveyards, skeletons and ghosts. When his cartoons were first published in *The New Yorker* in 1933, his macabre style drew plenty of critics. Addams was particularly inspired by the ghoulish engravings of Gustave Doré, who contributed illustrations to an 1883 edition of Edgar Allan Poe's *The Raven*. From that spine-chilling base, Addams eventually annexed levity and whimsicality to his drawings, balancing the spooky with the ooky and creating the *Addams Family* aesthetic that we now know and love so well.

Goth was the perfect vehicle for its satire, and many network heads began to agree. ABC's *The Addams Family* was engaged in a heated competition with CBS's *The Munsters*, another marriage of the family sitcom with elements of the Gothic, which soon became known as the "monster-com."

For at least the next decade, these monster-coms ruled the parodic Gothic. But in 1973, a little production called *The Rocky Horror Picture Show* turned the genre PG-13. Originally a stage musical that debuted in the small room above London's famous Royal Court Theater in June 1973, *The Rocky Horror Picture Show* was the brain harvest of unemployed actor Richard O'Brien and his friend Tim Curry. The show married '50s doo-wop culture with the friendly monster-com culture of the '60s, sprinkling it all with '70s glam. It was essentially bait for the proto-Goth David Bowie, who was of course an immediate fan, as was his friend Lou Reed.

O'Brien and Curry's show follows the hesitant footsteps of young couple Janet and Brad as they unadvisedly enter a castle-spaceship hybrid, the domain of a mad scientist named Dr. Frank-N-Furter, who subjects them to a series of events both so dazzling and so strange that watching it unfold feels like a fever dream. It's all very outlandish and, not to mention, very, very horny. The stage production of *Cabaret* had opened in London a few years before, kicking off a taste for camp sexuality—a sexiness so unsubtle that it ceased being sexy—and *The Rocky Horror Picture Show* became something like *Cabaret*'s less mainstream counterpart.

LEFT: The cast of *The Munsters* circa 1964.

BOTTOM: A still from *The Rocky Horror Picture Show*.

After some cult success, *The Rocky Horror Picture Show* transferred from its little attic theater across the street to King's Road Theater, and then later to Los Angeles's Roxy Theater. Soon enough, fans flocked to the theater dressed like the characters, fishnets on their legs and garishly dark makeup on their faces, and sang every single word. While the stage production enjoyed success on the West Coast, it flopped when it arrived in New York City in 1975, which only increased its cult allure. A bigwig at 20th Century Fox soon had the genius idea of adapting it to the screen, opening it at first to an exclusively post-midnight crowd.

As the Goth caricatures of *The Rocky Horror Picture Show* were blown up even further for the screen, fans gained a greater sense of familiarity with them, as well as a greater need to join in. While the stage version had encouraged crowd participation, the audience had to make their own fun when it came to the cinema. They easily did so, shouting lines and throwing props at the characters onscreen, a tradition that still continues at screenings today.

What makes *The Rocky Horror Picture Show* such a legendary example of black comedy is that it thoroughly understood the assignment: There should be nothing subtle about the Gothic parody because the Gothic parody is ultimately a parody of excess. As Susan Sontag said in her essay on the subject, camp—which we can use interchangeably here with "Gothic parody"—sees everything with exclamation marks. This is literally and spiritually the case with *The Rocky Horror Picture Show*, a film that screams in Goth.

Curtain call camp in *The Rocky Horror Picture Show*, 1998.

Like *The Addams Family*, the film is saturated with Goth cliches, stretching them as far as possible: the storm, the castle, the progressive gender identities. There is absolutely no subtext in *The Rocky Horror Picture Show*. Everything is placed right on the campy surface, taking advantage of Goth's propensity for melodrama to get some laughs from the audience. Everything in *The Rocky Horror Picture Show* is as ludicrously severe as Lugosi's *Dracula* performance and draws its comedy from the fact that what was once considered sublimely terrifying now appears as scary as a smiling pumpkin.

This has almost always been the formula for the Gothic parody—poking fun at Goth's extreme emotions and distancing ourselves from them—except for a brief moment in the '90s, when David Lynch and Mark Frost's *Twin Peaks* first came to the small screen. In it, an FBI agent named Dale Cooper relocates to the eponymous small town to investigate the murder of the beloved prom queen Laura Palmer.

Although not stylistically Gothic—there are no vampires or kohl-smudged eyes, and the cast tend to wear plaid rather than black—*Twin Peaks* contains some fundamentally Goth elements, like dark doppelgängers, unexplainable supernatural phenomena, and a scary forest at night. What's also Goth about the show is that absolutely everything about it is excessive, from its depictions of violence and fear through to its soap opera-like scenes of high school romance and whimsy—but it dares you to take seriously what would usually make you laugh in any other context. The Slovenian philosopher and theorist Slavoj Žižek referred to this affect as the "ridiculous sublime," the very thin line between intense emotional reactions and ridiculousness that Lynch deliberately blurs.

From the late '90s to the present day, Goth parody has often appeared in the form of bit characters in recurring series or sitcoms. Rather than showing up in haunted houses, castles, or any other Gothic cliché, they stick out like black-bruised thumbs in very common places, like a high school or Home Depot. These Goths are overly maudlin and excessive personalities who take themselves very seriously in a parochial world that is far too practical, sensible, and apathetic to do anything but laugh at them. The gag is in the fact that absolutely nothing in our modern world seems to encourage a Goth existence, yet the Goths themselves are almost comically intent on living a dark, brooding fantasy that exists only in their imaginations. For instance, one of *Saturday Night Live's* more obscure '90s skits was *Goth Talk*—an Elvira meets *Wayne's World*-inspired bit—featuring two teenage cable-access TV hosts who were desperate to present themselves as sunlightless vampires despite living in Tampa, Florida. They'd glumly hum "Bela Lugosi's Dead" and talk about *dark stuff*, their fantasy undercut whenever the jock brother of one of the hosts barged into the room.

Goth parodies have since shown up in many major comedies of the twenty-first century, including *South Park*, *The Simpsons*, and *Portlandia*. However, today, the joke is no longer coming from inside the haunted house like it had when it came from the Goth-glam minds of Richard O'Brien and Tim Curry or the black humor of Charles Addams but from somewhere outside of it—the normies in normie houses who used to be the subject of Goth's mockery. Now, Goths are at the butt of the joke. Ha. Butt. Get it?

So Much Fear, So Little Satan: Goth and Satanic Panic

n an unsuspecting day in April 1999, Eric Harris and Dylan Klebold, two high school seniors dressed in black, barged through the doors of Columbine High, a school of almost 2,000 students in the provincial town of Littleton, Colorado. Under their coats they held stolen shotguns, air guns, and rifles, which they engaged immediately after entering the premises and used to slaughter their schoolmates. They first targeted Columbine's star athletes, then their teachers. They killed twelve students, one teacher, and then themselves.

Metal fans throwing horns at a concert in 1990.

No matter where in the United States you lived and no matter the kind of family you lived with—left, right, religious, secular—if you were a teen at the time of Columbine, your adolescence took a sudden and dramatic shift after this moment. Everyone was desperate to make sense of the tragedy. They all needed something to blame. Immediately after, newspapers around the world were in a frenzy to answer one question: Why did they do it?

With very little to work from beyond the killers' appearance in security footage, one of the very first pieces of information leaked from the police to the press was the color of their clothing: black. Reporters soon heard from a source that Harris and Klebold were also supposedly members of "The Trench Coat Mafia," a quasi-Gothic group of outcasts at Columbine High who dressed in black and had murderous impulses.

The media took firm hold of the little information they had and made a meal of it. They warned parents to beware of trench-coat-wearing teenagers; this piece of clothing had come to be associated with Goth-rock shocker Marilyn Manson. Manson, perhaps the most recognizable of all '90s Goths, inspired his fans—often dubbed "The Spooky Kids"—to dress in all black, as he himself often had. Manson was a vision of everything conservative America despised: gender nonconformity and provocation. From the mid-'90s onwards, Manson had become the whipping boy of a nation. Soon, the Spooky Kids would follow. Anyone with even the most tenuous associations with Manson and Goth culture at large was now considered a national threat.

Mere days after the tragic event, this narrative had taken hold. Across mainstream media throughout the world, reporters described the school shooters as Goths. A week after, ABC ran an entire news segment on what they called "The Goth Phenomenon," in which they argued that Goths had homicidal tendencies, mutilated others as well as themselves, and were a general threat to life in America. These sensationalist claims were even bolstered by local authorities, including one Steve Rickard, a member of the Denver Police, who filed an official report which claimed that suburban areas in America were at risk of danger from teenage Goths. These late-twentieth-century Goths were confused with the Ostrogoths and Visigoths who had desecrated a nation thousands of years ago, their black outfits conflated with the supposed witches of the Middle Ages. The most unfortunate among the Goths were

LEFT: Marilyn Manson performing at Mile High Stadium in Denver, CO.

criminalized—ticketed, fined, or placed under surveillance. By the time it was revealed that the Columbine shooters weren't fans of Manson's nor members of the Trench Coat Mafia or of the larger Goth subculture, it was far too late. Fear of the Goth had sunken into America's subconscious and, in some cases and places, a harmful perception is still in place today.

The fear of Goths stretches back millennia, but it found new footing in the decade prior to the Columbine shooting, when satanic panic—the precursor to Goth panic—overtook America. Already morbidly fascinated with the occult following the highly publicized Zodiac and Alphabet Killer cases of the '70s, America truly went into panic mode in 1983 with the McMartin preschool trial in California. In a similar pattern to Columbine, the media created hysteria throughout the nation when they falsely claimed children as young as two had been privy to satanic rituals. It didn't matter that these were baseless claims. Parents immediately began to dig underneath the preschool, searching for secret tunnels.

Unsupported conspiracy theories and general hysteria spread throughout the decade and well into the next, as the white suburban middle class believed themselves to be under attack from unexplainable satanic forces. It was a self-perpetuating fire of fear. The media continued to spread fearful stories, and the growing panic only helped to fuel the continuing sensationalist coverage.

Parents grieve in the aftermath of the Columbine High School Massacre.

By the mid-'80s, evangelical Christians
commonly held seminars and tutorials for the police
and their local communities, educating them on the
satanic spirit and how to identify it. Toward the end
of the decade, teenagers—particularly ones who
listened to heavy metal and other music from "the
dark side"—became one of their biggest targets.

Ever since the emergence of the teenager post-
WWII, moral panics have often coalesced around
youth subcultures, whether the mods and rockers
of the '60s or the Xanax-affiliated SoundCloud
rappers of the 2010s. The Goths are just one of
many images of delinquency that have joined the
gallery of folk devils. However, more than any
other of these subcultures in recent decades, the
Goth has been charged for the most grievous—and
insubstantiated—offenses.

Damien Echols
during his trial.

Before Columbine, one of the worst judgements came in 1993, when three
teenagers were charged with the murder of three second-grade boys in West
Memphis, simply because they led a Gothic lifestyle. In May of that year, three
scouts were found dead in a muddy creek just outside of the small town in
eastern Arkansas. That they were bound in intricate rope patterns led police to
presume that their killers must have been satanic ritualists.

Damien Echols—a dark-haired teenager who listened to heavy metal and
read Gothic novels—was an immediate suspect. The evangelicals of West
Memphis had long cast a skeptical eye on Echols, firm in views of him that had
been fueled by several years' worth of satanic panic. His black wardrobe and
loud music caused them to suspect him of devil worship. Police brought him in
for questioning, but Echols was released on account of there being no actual
evidence yet gathered from the crime.

A month later and still with no evidence, the police called in Echols's friend
Jessie Misskelley. For twelve hours, police subjected the mentally-challenged
minor to relentless questioning, without his parents' permission and without an

he young man eventually gave them a confession. He told them that he, Echol nd Jason Baldwin, their mutual friend, were all responsible for the murders. ven though Misskelley's confession was contradictory, incoherent, and clearl ame as the result of police coercion and misconduct, Misskelley, Echols, and aldwin—who soon came to be known as the West Memphis Three—were rrested that day, June 3, 1993.

Their trial began on February 4, 1994. For weeks, an absurd excuse for vidence—for instance, that the boys had read and enjoyed Stephen King ovels—was weaponized against them. The whole trial was a shambolic farce f illogical reasoning and miscarriages of justice. Everything about it was eeply clumsy and unethical. But that didn't matter. The boys received the ver arshest of punishments: Echols was sentenced to death by lethal injection, aldwin and Misskelley to life imprisonment without parole.

While all three were locked away—with Echols in solitary confinement— oths around the world petitioned for their release. Celebrities like Henry ollins, Eddie Vedder, and the members of Metallica—all people who knew hat it was like to be the weird, gloomy kid in a small town—publicly called

for their release. The West Memphis Three soon came to be considered Goth martyrs, a terrible example of what panic and misjudgment can do. Finally, after new forensic evidence proved the trio had nothing to do with the crime, the now middle-aged men were freed on August 19, 2011.

Although America clearly hadn't learned its lesson by the time of Columbine, in the new millennium, Goth came back with a vengeance and even began to take over America's shopping malls (as we'll learn about later). But soon after in the UK, in 2007, one of the most tangible and tragic consequences of Goth apprehension came to pass.

On August 11, 2007, twenty-year-old Sophie Lancaster was the victim of one of the country's very first subculture-based hate crimes. Lancaster was a self-described Goth, and proudly so. She wore Slipknot tees with jeans so long they soaked up the dew on the ground. She wore her hair in multicolored dreadlocks. Piercings sparkled on her face. Her boyfriend, twenty-one-year-old Robert Maltby, dressed similarly. They stood out in a town that lacked alternative culture and were bullied mercilessly for it.

Although the assaults they'd received in the past had almost always been verbal, on that Saturday morning, walking together, they were subject to a brutal, unprovoked attack by a group of teenage boys, some as young as fifteen. They started on Maltby first, before Lancaster came to his aid. She too was attacked, and both were repeatedly pummeled until they were left unconscious and bleeding on the ground. While Maltby eventually came to after the attack, Landcaster never did, and she was pronounced dead thirteen days later, on August 24.

While the police initially treated Lancaster and Maltby's attack as a case of grievous bodily harm, they now had on their hands a murder inquiry, and the British media blew the case up even further. "GOTH" was the headline word, and it captured the country's imagination for several weeks.

It was a word that Goths in the UK were more determined than ever to redefine on their own terms, just as the Goths in the States had been post-Columbine. They emphasized their own unique sensitivity and sensibilities, their ability to laugh at a dark joke, and their capacity to find community and light amongst darkness, even when the world covered them in shadows. Ultimately, they proved that Goth is a cause for celebration rather than panic.

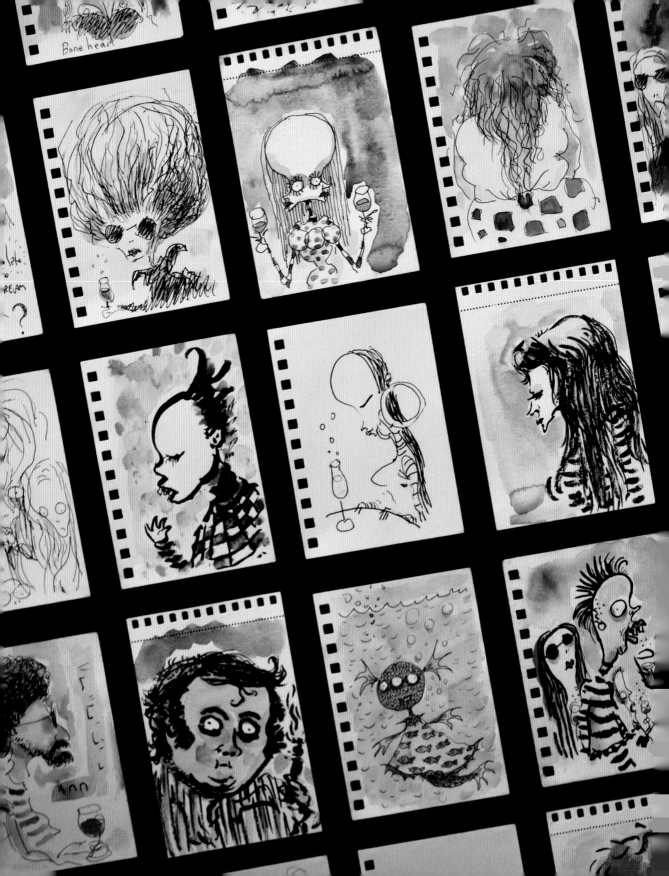

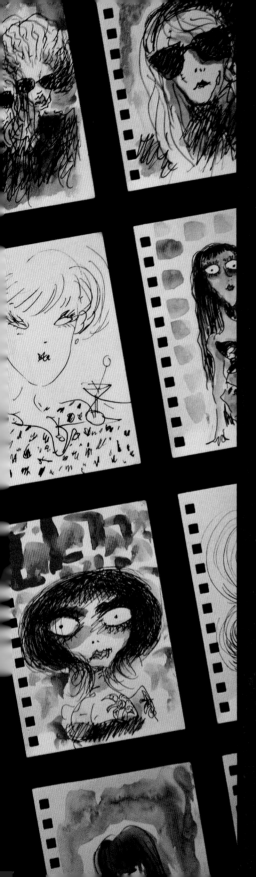

EARLY ONSET EXISTENTIAL CRISIS: KID GOTH

For the first years of our lives, our parents play the roles of guardians against darkness. It is their duty to lie to us, to protect our happiness and our imagination and to keep away the real facts of the world. Is Santa real? Yes. Is Uncle Keith a nice man? Yes. Where did Rover go? Off to the sunshine farm.

But behind the unicorns and the smiling family portraits and the happy farms, there was always that tiny underlying suspicion that our parents were full of it. And they were. We came to know that sometime around our fifth or sixth birthdays, when we were able to stay up late enough for the sunset, when, suddenly, the world became dark and terrifying. There were monsters under the bed and skeletons in our closet. Strangers were very dangerous. Candy was poison.

Illustrations by Tim Burton.

Art from the Night on a Bald Mountain sequence in Disney's *Fantasia*.

Kids and Goth go hand in hand. If you've walked into a bookstore lately, then you've probably noticed. Spooky skeletons and vampires and Frankenstein-like cats populate the covers. Fear is cartoonified, turned into something vaguely friendly. So many kids books today are Goth-lite. Why? Because it's kids' first opportunity to take comfort in fear, a feeling they will have to live with for the rest of their lives. Fear can either be very real or of the ooky variety. Better to try and make it the latter.

The greatest stories never leave us, especially not the scary ones. There may be moments in Disney or Dreamworks films that still raise the hair on your neck as an adult—and freak you out even more than an R-rated horror movie—purely because you remember how it scared you as a kid. When you rewatch them, you're six years old again, and terrified.

The kid's Goth-lite is usually our introduction to fear, as well as death. Ghosts and undead pets roam the pages. Smiling skeletons play their ribs like xylophones. The Kid Goth presents a friendly challenge to take that which scares us and not only befriend it but learn to grow alongside it. Succeed at this challenge and you will be forever equipped with one of life's greatest skills. While adults seek out these scary narratives so they can

briefly escape the terror of their own lives, for children, the Gothic story can be their life's road map.

Historically, children's and Gothic literature have been in dialogue with one another, and possibly even emerged alongside each other. In the Victorian era, when ghost stories became prevalent, nannies would share spooky stories with their ailing patients. Ghostly folktales became a point of nurturance and care, and this soothing spook soon found its way to children, whose parents treated them to tales of headless horsemen and sentient pumpkins to send them off to sleep.

Childhood itself became a topic of interest in the nineteenth century too. With the rise of the middle class, more children experienced a childhood that was genuinely nourishing rather than riddled with disease and decay. Childhood was more positive and might evoke a fond sense of nostalgia in the adults who looked back upon it. This time became a crucial building block in a person's life.

As such, child labor laws passed, making it possible for children to be children and not just small adults who had to help earn money for the family. Prior to the regulatory laws that were passed in 1803, children could be expected to work manual jobs for upwards of fifteen hours a day. Three decades later, in 1833, the Factory Act passed and ruled that no child under nine should work and no child between the ages of nine and thirteen could work longer than twelve hour days.

It was the Victorians who saw childhood as a discrete category, a state of existence distinct from adulthood. As such, they began idealizing childhood as a time of innocence and purity. Until the mid-nineteenth century, children's

An early "Kid Goth" illustration.

THE MINISTER TOOK RADICAL STEPS TO HALVE THE NUMBER OF PUPILS IN EACH CLASS!

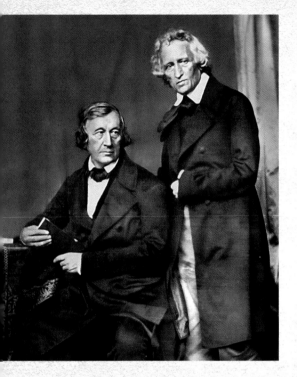

A portrait of
the Brothers
Grimm, 1847.

literature was still very rare. The only reading material kids were treated to was the Bible and educational pamphlets. Joy! But the shift in thinking about childhood later in the century necessitated the production of literature tailored to children and their growing imagination. Children's literature, which was at first strictly moralistic, was a way of keeping children on the track to happiness and incorruption, as well as teaching them good manners.

While today we try to put off teaching kids about the evils of the world for as long as possible, there was no delay for the Victorians. Parents made their nursery rhymes as gory as possible, with monsters and witches ambushing children in a bloody massacre or the fictional kids being flown away on a witches' broom, stashed away, and later eaten. The tales were downright bleak and unnervingly instructive: Don't talk to strangers, kids, because they *will* turn out to be a cannibalistic witch.

The aptly named Brothers Grimm were the kings of this grizzly kid's lit form. During their studies at the University of Marburg at the very beginning of the nineteenth century, the German brothers developed a deep fascination with European folklore. They scrounged around their university's library for myths and then retold the old tales to their peers in a contemporary voice. They quickly gained a reputation across campus for being master storytellers and soon focused their talents on the fairytale form, a kind of story that revolved around horror as much as it did magic and which often served to moralize children. There has always been an uncanny sense of fear to these kinds of tales in a way that bears a strong resemblance to the literary Gothic forms. Crumbling castles, witches, magical forests are key components of each, as is the threat of violence.

German fairytales particularly emphasized the violent part. In the nineteenth century, German fairytales and Gothic horror fully coalesced and soon became infamous across the globe. Horror writers across England and the United States would even begin to subtitle their novels "a German

story," so you *knew* you were in for something ludicrously scary. The Brothers Grimm's first collection, *Grimm's Fairy Tales: Children's and Household Tales*, had a distinctly German flavor. In some cases, it even made the *Saw* movies seem tame.

Grimm's Fairy Tales was so grim that the stories within have had to be heavily sanitized in the centuries since their release. In the first edition of *Grimm's Fairy Tales*, for instance, Cinderella's stepsisters hacked off parts of their feet so they could fit into the slipper. In *Little Red Riding Hood*, the grandma died a long, painful death rather than being eaten in one gulp by the wolf. In *Rapunzel*, the princess was raped and impregnated by the prince. It's not exactly *Little Bo-Peep*, though if the brothers had written that, I'm sure the sheep would have been taken straight to the slaughterhouse.

In the second and third editions of their tales, the brothers removed the allusions to sexuality and added some Christian references for good measure, but still put their foot down when it came to the violence. In fact, they even doubled down on the brutality, subjecting Cinderella and her sisters to even more torture, including a scene in which they're forced to dance while

Household Stories from the collection of the Brothers Grimm, 1882.

burning hot irons encase their feet. Just another reminder: this was all meant for children.

Cinderella was perhaps the most Gothic of the brothers' fairytales. The titular character, hidden away and surrounded by supernatural elements, was much like the Radcliffean damsels in distress. She was every bit a figure of beauty hidden away in captivity, except, rather than being tortured by her husband, as one of Radcliffe's heroines would have been, she was tormented by women, her stepmother and stepsisters. Was there anything children could learn from this lurid tale? Well, just pray that your parents won't get a divorce, I guess.

A man who brought all the Brothers Grimm's violence and depravity into twentieth-century children's literature was Edward Gorey. Although, something curious happened when the writer and cartoonist died in 2000. His obituaries argued amongst themselves: Did Gorey intentionally write for children or not? One camp argued that he was Edward Gorey, the children's author. The other contested that he was Edward Gorey, the man whose work was certainly not suitable for children. In this case, both things could be true at once. Edward Gorey was the children's author whose work wasn't suitable for children.

THE TOP FIVE MOST HORRIFIC BROTHERS GRIMM MOMENTS

1. The realization that *The Girl Without Hands* was in such a predicament because her own father cut them off.
2. The moment when the woman in *The Goose Girl* got thrown into a barrel of nails.
3. The *Game of Thrones* vibe all throughout *All-Kinds-Of-Fur* which features a king hell-bent on marrying his daughter.
4. Knowing that Snow White was only seven years old when the Evil Queen tried to have her killed.
5. Finding out that the Frog Prince wasn't actually kissed but thrown against a wall.

A descendant of freezing cold Depression-era Chicago, Gorey showed his parents his first drawing and first taste of his zany sense of humor with "The Sausage Train"—a train track, train, and train wheels drawn in the shape of sausage—at just eighteen months old and taught himself to read by the time he was three. He carried the drollness of "The Sausage Train" well into adulthood, and when he began self-publishing his antiquated, Victorian-inspired illustrations in the 1960s, he was an obvious counter to the Pop Art movement of the time. Rather than finding an audience amongst adults who had more modern tastes, he was a favorite of children's book writers who eagerly wanted Gorey to illustrate their books. Even as an adult, Gorey had a remarkable ability for recreating the imagination and naivete of youth, and he rode the Sausage Train all throughout his life as a professional children's book illustrator.

In his adult life, he sported a magnificent white beard and dressed almost every day in the same outfit: a large fur coat, white tennis shoes, rings on each finger, and a large chain hanging from his neck. If you were within a two-mile vicinity of him, you'd know that Edward Gorey was nearby. You might have heard the clunking of his jewelry or smelled the cat fur that covered him from head to toe. Like all good Goths, Gorey loved cats more than just about anything.

From a frighteningly young age, Gorey was a fan of the Gothic and quickly worked his way through all the canonical texts and authors of the genre, from Radcliffe to Poe. He brought their melodrama into his own work and then stretched it to the point where it became comic. As with all the good Gothic parodies we learned about earlier, Gorey took the already hyperbolic elements of Goth and pointed toward their absurdities with a fleshless hand. Gorey was a

Edward Gorey, circa 1977.

practitioner of the goofy Gothic. Throughout his career, he handled the darkest material with the lightest, most whimsical touch. It was this consistent tone that lent his books the kids' lit classification.

In his seventy five years of life, he authored and illustrated some hundred darkly farcical picture books, the titles of which included things like *The Curious Sofa*, *The Wuggly Ump*, and *The Beastly Baby*. Gorey's writing style was a mixture of nonsense literature, surrealism, dadaism—all of the literary movements associated with the downright weird—and the Gothic. His cartoons leaned more into the latter. Inspired by nineteenth-century engravings and penny dreadful illustrations, his crosshatched cartoons recaptured the Gothic past; he even set many of his stories in his imagined version of Victorian-Edwardian England.

The book you're most likely to know him for is 1963's *The Gashlycrumb Tinies*, an ABCs of children's death that poked fun at the overly moralizing tone of post-Victorian children's literature. From A—for Amy who fell down the stairs—to Z—for little Zillah who drank too much gin—Gorey's alphabet teaches children about death in a comedically unfiltered way. In doing so, he not only prepares them for death, but equips them with the black humor necessary for tolerating it. There is no redemptive arc, no saving grace, no cathartic moment. There are no heroes, only victims. And this is all very funny, by the way.

In the '80s, a man named Tim Burton took the whimsy of Gorey's bleak fancifulness and moved it closer to the cartoonish kids' Goth we're surrounded by today. Heavily influenced by Gorey, Burton too had a fascination with childhood and the overlap of horror and mirth it entailed. In a way, all of Burton's work argues for the sanctity and celebration of the child's imagination. But, like Gorey's, Burton's work also parodies the overly sentimental and moralizing tone of post-Victorian children's literature, by way of blunt depictions of death.

Burton's most Gorey-indebted work is 1997's *The Melancholy Death of Oyster Boy & Other Stories*, a picture book of poems populated by characters like "The Boy with Nails in His Eyes," "Stain Boy," and "Voodoo Girls." Drawn in a similar antiquated and chicken-scratched style as Gorey's illustrations, the kids of *The Melancholy Death of Oyster Boy & Other Stories* are all plagued by some unfortunate case of supernaturalism. However, unlike Gorey's, Burton's children tend to have some Disney-fied hope amongst their bleakness. In both

his books and films, Burton helps us sympathize with the dark, the gloomy, and the outcasts. The characters—his Frankenstein-esque monsters or the man with scissors for hands—draw compassion when they'd ordinarily evoke fear under anyone else's hand. The characters who are easiest to identify with are the ones who differ most from the norm, and through them we come to understand monsters not as threats but as merely huge-hearted and misunderstood.

As a boy Goth, Burton tried his best to shelter himself. He grew up in far-too-bright Los Angeles, the manufactured housing of his suburban neighborhood at odds with the Gothic cathedral of his heart. He tried to avoid it all by retreating into Universal's old monster movies, the salve to his youthful alienation. Watching James Whale's *Frankenstein*, he felt a keen tenderness toward the monster. As a lonely child who couldn't quite fit into the hum of the world, he saw himself in movie monsters. He felt about his suburban neighbors how the monster must have felt about an incoming pitchfork-wielding crowd.

While the kids on his street rode their bikes up and around the cul-de-sac, he discovered ever more niche media: Hammer horror, sci-fi B movies. The

Tim Burton with a slightly sunnier disposition during a 2014 exhibition.

The Most Goth Moments in The Disney Film Canon

The darkwave acid trip Snow White experiences once she takes a bite of the red apple.

Fantasia's Chernabog, the gargoyle-like demon who shrouds himself in shadows and then watches pleasingly as a menagerie of evil creatures dance around him.

The Skeleton Dance in *Silly Symphony* that is exactly what it sounds like.

The ultra-adolescent Goth vibes of Kovu, the emo-fringed cub of *The Lion King II: Simba's Pride.*

Every single one of Violet Parr's hair flips in *The Incredibles.*

only times he willingly went outside was to haunt the local cemeteries and wax museums with a Super 8 camera. He filmed his outings from a young age, trying his best to find the creepiest spots in his saccharine neighborhood. When he was a teenager, he began submitting the results to local art contests, and usually took home first prize. It was around this time that Burton mailed an illustrated children's book to Disney . . . who subsequently rejected it.

In 1976, Burton found another way in when he joined the newly minted animator program at Disney Studios. He studied and created alongside the future director of *The Lion King*, Rob Minkoff; his future collaborator on Disney *Tim Burton's The Nightmare Before Christmas*, Henry Selick; and overall Disney behemoth Glen Keane. Burton found inspiration in the group of cartoonist-weirdos and began to develop his style and technique among their company and friendly criticisms.

At the program, he reproduced on the story reel all the spooky pop culture references he'd absorbed throughout his childhood and adolescence, giving them his own whimsical and sympathetic twist. He etched out skinny, spindly characters with jet-black shocks of hair and big, bulging eyes. His style clearly

owed a lot to Gorey, as well as German Expressionism. It's strange to think that—at least by his own admission—Burton didn't see *The Cabinet of Dr. Caligari* until later in his career, since his style has always resembled that film more than any other.

At Disney, Burton crystallized what would go on to become one of the late twentieth century's most distinctive cinematic aesthetics and put into development some of his greatest successes, including *The Nightmare Before Christmas*. The studio initially rejected his efforts, describing his films as a waste of the company's resources, since they considered his off-kilter Gothica too dark for children. What they didn't originally understand was that Burton was attempting to introduce a new level of innocence to the Gothic, one that was even Disney-friendly. Although his films were full of skulls, ghosts, and other images of death, they were about as scary as a bunch of trick-or-treaters at Halloween. If kids are allowed to dress up as skeletons and vampires once a year, Burton reckoned, why couldn't they watch them on the big screen?

Disney eventually saw this vision and greenlit his and Henry Selick's *The Nightmare Before Christmas*—a stop-motion animation film that follows Jack Skellington, the Pumpkin King of Halloween Town, and his plans to overtake

A still taken from *The Nightmare Before Christmas.*

Christmas Town—at the beginning of the '90s. During that decade, Burton sealed his reputation forevermore as cinema's Gothic master, carrying into his films the most recognized tropes and images of the Gothic, while replacing their horror with childish delight.

While he might have been best known during the '90s for his extra Gothic twist on the already Gothic *Batman* series (more on that in the next chapter), the film of Burton's that feels most archetypically Goth is 1990's *Edward Scissorhands*. Watching it feels like peering inside the mind of a young Burton, the one who grew up in those sundrenched suburbs and looked toward the Gothic to escape the bright artificiality of his LA neighborhood.

True to Burton's inner child, the origins of Edward Scissorhands—an affectionate character with fingers made of blades, who wants to touch but cannot—was a drawing he'd composed as a teenager. An expression of Burton's adolescent angst, Scissorhands spoke for Burton when he felt he couldn't communicate with the rest of the civil world. In the decades since its release, *Edward Scissorhands* has become a token of alienated Gothic youth, an idol and friend to anyone who desperately wants to be a part of the world but doesn't know how.

Today, drawing on the works of the Brothers Grimm, Edward Gorey, and Tim Burton, a swathe of Kid Goth writers including Neil Gaiman, Tonya Hurley, and Sharon Gosling are teaching children to not only find joy in fear but to treat every day like it's Halloween. Death might be the conclusion to the story, but at least it's a spooky ending.

A Graphic Sense of Style: Comic Book Goth

So, there's this dude who has a dark past, lives in a city called Gotham, and literally dresses like a bat each night. Does Goth get any more on the nose than Batman?

Introduced toward the end of the 1930s, The Batman was the most emotionally complicated superhero yet. He was real *deep*, man, the Gothest of the Goth—and yet it's strange that he's hardly ever acknowledged as such. For almost a century, Batman has been trading in Gothic angst for heroic redress.

Created by writers and animators Bob Kane and Bill Finger, Batman was sartorially inspired by the 1920 film *The Mark of Zorro* as well as the 1930s silent film *The Bat Whispers*. He made his debut comic book

A still from the 1994 film *The Crow*, featuring, well, a crow. How apt.

appearance in the twenty-seventh edition of Detective Comics (later shortened to DC) in May 1939. Batman introduced a darker side to superhero comic books. Dressed like an antihero with his bat-winged cape and black mask, Batman appeared as nefarious as any of the villains he was fighting against. While the uncomplicatedly good Superman who debuted in Action Comics the year before, fought the city's corruption with wholly charitable motives, The Batman came looking for retribution.

Even all these decades later, Batman has remained the darkest, edgiest, and most morally ambiguous of just about all the famous superheroes. With him, Kane and Finger introduced a childhood trauma plot which has forever darkened the winged vigilante's crime-fighting motives. Batman's Gothic backstory was introduced early on in the DC comics: He was Bruce Wayne, the orphaned child of two wealthy parents who were murdered by the criminal Joe Chill during a robbery, all of which young Bat witnessed when he was only eight years old. As soon as he came of age, he swore that he would fight against Gotham's crime, even if it meant breaking some laws himself. Adaptors of The Batman have changed many facets of his lore over the years, but this one has largely stayed put. Without it, it wouldn't be Batman.

A comic fan holds an early edition of The Batman.

BATMAN'S MOST GOTH MOMENTS

When Batman finds the literal bat cave below his mansion in *Batman Begins* and practically dances with glee when bats orbit him.

The young Bruce Wayne menacingly holding his hand above a flickering flame in the TV series *Gotham*.

Journaling while a Nirvana song loudly plays in 2022's *The Batman*.

Coming right on the red-booted heels of Superman, an immediately successful franchise, Batman was clearly conceptualized as Superman's dark double, as well as a more visually striking and emotionally fuller version. While Superman was sort of emotionally flat, Batman contained multitudes: He was a loner as much as he was a team player, as erudite as he was a hunky himbo, as prone to dark severity—particularly in Christopher Nolan's twenty-first-century depictions of him—as he was frivolous camp, which is how we saw him in the 1960s.

The Gothic overtones of this superhero story—even when dressed up in a campy outfit—have been one of Batman's major through lines. One of his first major villains—so major that the storyline extended across months' worth of installments—was the red-robed Monk. Inspired by Matthew Lewis's classic

Batman and Robin in The Batmobile in 1966.

Gothic novel of the same name, as well as Bela Lugosi's *Dracula*, the Monk was a vampire who also happened to have the shape-shifting powers of a werewolf.

All of Batman's foes from thereon resembled characters out of a German Expressionist film, all of them marked by some physical deformity, bold makeup choices, and a touch of psychoticism, from the Joker to the Penguin. The backdrop for their duels looks particularly German Expressionist, with the buildings of Gotham City winding, off-kilter, and filled with dark shadows and silhouettes.

This was largely due to the wiggly drawing style of Kane, who was still in his early twenties when he cocreated Batman. Still a relative newcomer to comic books—and drawing in general—Kane's early illustrations had a skewed perspective and odd proportions. He was a poor realist but a natural pairing for the Gothic. Further into his career, he sustained and stylized the amateurish look of his early drawings to create bizarre, *Caligari*-like atmospheres. The jerkiness of his drawings of the Joker, for instance, perfectly mirrored the villain's unhinged mental state.

That Gothic tropes lent themselves so naturally to Batman isn't particularly surprising. Goth and comic books have gone claw in claw since the very beginning. The penny dreadfuls, as we covered earlier, could well be seen as proto-comics. Even well before that, in fifteenth-century Britain, carpenters carved wood scenes of famous executions that they mass-produced for sale.

The very first *comic* comics took inspiration from the fantastic lore of all the Goth masters, particularly Poe, possibly because the comic book, at least in the form we know it as now, was an American invention. The creation of the modern comic book began toward the beginning of the twentieth century, when Victorian Gothic tropes, like ghost stories and hysterical women (gasp!) began appearing regularly in short story magazines and cheap dime novels. Like the penny dreadfuls which preceded them, these magazines and books were conceived as quick-fix entertainment, the sort of thing you could consume in one train commute, then dispose of when you arrived at your destination. They inspired the rise of comics in newspapers in the 1920s, but it wasn't until about the 1950s—after the boom of vampire/vampira TV horror hosts and hostesses—that the Gothic reached comic books, drawing from more traditional Gothic tropes than *Batman*.

RIGHT: Bob Kane posing with his drawings of Batman characters just before Halloween, 1979.

Just like the Goth's first introduction to cinema, the earliest Gothic comics were adaptations of the most iconic texts in the canon, like *Frankenstein* and *Dracula*. These soon gave way to Gothic anthologies, one of the most popular being 1950's *Tales from the Crypt*. Published by EC Comics, *Tales from the Crypt* borrowed from Universal's monster movies and Hammer horror as much as it did eighteenth-century Gothic literature. They were gruesome tales that featured an assortment of supernatural demons, from good ol' ghosts to mutilating mummies, and were known for their elaborate plot twists. They were also what any good Goth comic should be: sexy and violent.

Of course, not long after the rise of horror and Gothic comics into mainstream popularity, when copies of such comics were selling upwards of sixty million copies per month, conservatives began petitioning against their depictions of graphic violence and sexual content and argued that they were encouraging degeneracy and illiteracy. Their criticisms successfully led to the creation of the American Comics Code in 1954, which restricted the subject matter of comic books for decades after. For the first few years, when the Code was at its most stringent, comics without a Code seal of approval on their cover could not be sold in stores. In order to get that approval, comics had to refrain from any depictions of sexuality or violence or anything even remotely spooky at all: no vampires, no zombies, and *certainly* no bloody ghouls. Titles couldn't even have words like "horror" or "terror" in them and there *had* to be a happy ending. Good *must* triumph over evil—if there is any very sanitized version of evil at all.

In these years of censorship, the Gothic Batman became real camp real quick and so came the arrival of Robin, his new goofy sidekick. Instead of fighting vampire-werewolf hybrids, they had low-stakes run-ins with petty criminals. This Batman rebrand brought such a negative reaction from the fanbase that they began buying fewer comics. The huge popularity the series had once enjoyed slumped.

But just like Goth itself, the character has been resurrected over and over again and tends to come back stronger with each rebirth. With the relaxing of the American Comics Code in the late '60s, a bevy of Gothic comics began to reappear. DC published anthologies in abundance, including the *House of*

LEFT: A 1950s copy of *Tales from the Crypt*.

Mystery and *House of Secrets* series. *Batman* course-corrected its camp direction—though it wouldn't be Goth without at least one camp era—by going darker than ever. The Joker inched closer to the genuinely disturbing and psychotically deranged villain we know him as today. Batman brooded as much as he solved crimes. The following decade, with the creation of *The Dark Knight Returns* series, he became morally questionable, a hero as prone to corruption as the villains he was facing.

This new era of *Batman* attracted Tim Burton to the franchise, who made one of the highest grossing films of 1989, as well as Batman's darkest incarnation yet. In Burton's vision of Gotham, the city's modern skyscrapers were replaced with sixteenth-century Gothic architecture, all spires and gargoyles reaching toward the dark sky. Burton provided the dark bridge to Christopher Nolan's 2000s reboots of the character on screen. In *Batman Begins*, the first of Nolan's *Dark Knight Trilogy*, we see a less fantastical and grittier, more realistic depiction of the Gothic superhero. Nolan made good on the promise of Batman as one of the very first brooding and self-confessional superheroes, with Christian Bale playing Batman to his full emotionally tortured potential.

A swathe of horror comics came out of the violent and emotionally disturbed traditions that Batman had set for the form, including Alan Moore's *Swamp Thing*, which was published in 1984 and is the absolute high-water mark of the American Gothic in the comic form. It gives you all the usual suspects—ghouls and werewolves and such—but its philosophical ramblings on the nature of being and existence elevate it to a higher level, its somber takeaway lifting a wing out of Batman's bat cave. While Batman still remains the understated Gothic king, in the 1990s and 2000s, a range of explicitly Gothic comic books began to emerge. Speaking directly to the subculture, comics like Roman Dirge's paean to Poe *Lenore*, Jhonen Vasquez's deranged *Johnny the Homicidal Maniac*, and Neil Gaiman's lyrical *The Sandman* took a dip in the Y2K malaise, a time when cynicism was on the rise and dark overtook the light. At your local record store, you could pick up a beanie, a Nirvana vinyl, and a Gothic comic in one fell swoop—the Goth starter pack.

Copies of James O'Barr's *The Crow* and Neil Gaiman's *Sandman*.

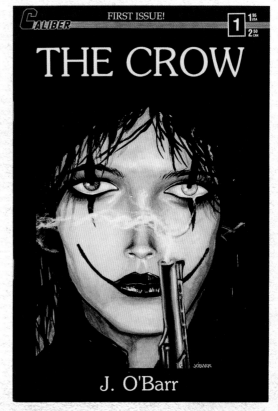

One comic that encapsulated the overcast era best was James O'Barr's *The Crow*. First published independently by Caliber Comics in 1989, *The Crow* was a hit with angsty Gen X Goths who wore studded belts and whose parents just didn't get them. It was gloriously self-serious and almost masturbatory in its depictions of pain: Eric Draven, its main character, is almost always shirtless, his pants hang low, and he tends to stand in a Christlike formation, his muscly arms stretched out on either side of him. The words LAMENT and PAIN are printed across the pages. The comic screams every word. There's no room for subtlety; *The Crow* is an emergency.

But there's an unfortunate reason why *The Crow* is so emotionally overboard. The story, which follows a couple who are killed by a gang after their car breaks down, parallels the creator's own. After proposing to his high school sweetheart, O'Barr's fiancée was killed in a crash by a drunk driver. O'Barr has often said that he wrote *The Crow* as a way to transmute his grief. The comic, a trauma narrative in graphic-Gothic form, is O'Barr's fictional enactment of vengeance. And vengeance, from *Batman* to *The Crow*, is one of the Gothic comic book's main motivations.

Like Batman ridding Gotham of crime to avenge his murdered parents, *The Crow* was O'Barr's fictional revenge scenario. After Eric and his fiancée

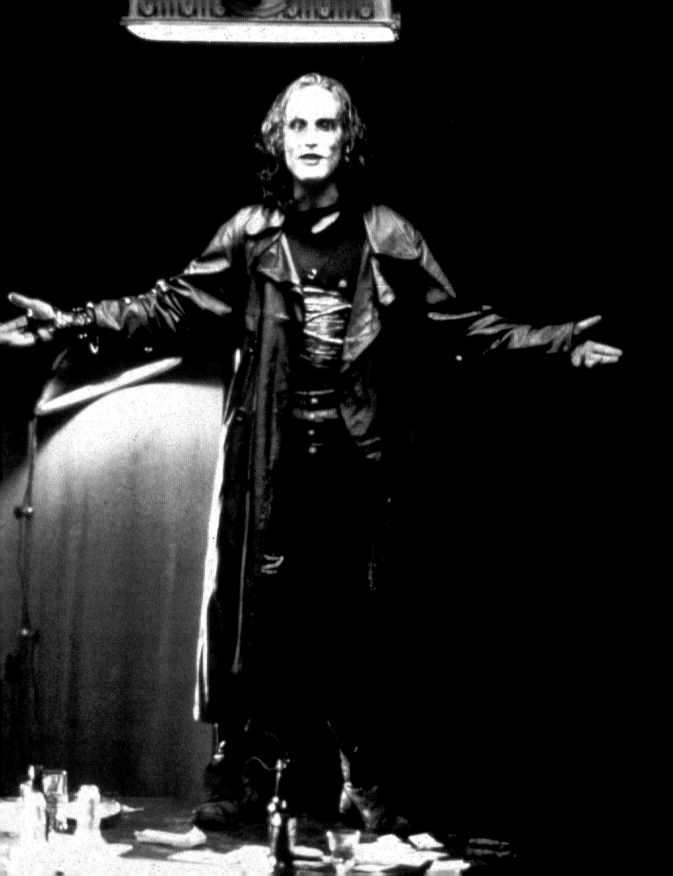

are killed in *The Crow*, Eric is resurrected by a crow who tells him to stalk and kill while chastising him for wallowing in grief.

The Crow belonged in the Goth section of the store more than any other comic, largely because its musical references were fundamental to the text and overall aesthetic. O'Barr was part of a new generation of Goth creatives who had actually lived through the Goth subculture of the '80s, and so brought to his Gothic art a thorough, lived-in perspective. Draven is built upon the bones of Gothic rock originators: to Bauhaus's Pete Murphy, he owes his ample black locks and severe face; to Iggy Pop, his six-pack and gym bod; to the Cure's Robert Smith, his masculine sensitivity; to Joy Division's Ian Curtis, his sacred pain.

Later adapted into a movie of the same name in 1994, followed by four standalone sequels, a television series, and a second film adaptation in 2024, *The Crow* has, like so many other Gothic intellectual properties, become a multimillion-dollar franchise. As Eric Draven and Batman have proven, there's nothing so enduring and regenerative as darkness.

LEFT: Brandon Lee as Eric Draven in the original 1994 *The Crow* movie.

PANIC AT THE HOT TOPIC AND MALL GOTH

t's a rainy Sunday and you're staying at your mom's house. There's nothing good on TV, no one's calling you up, and so you remember, for the first time in a long time, what it's like to be truly bored. It's been a while. You like this feeling now. It makes you go and explore. You figure you'll go up to the attic. You pull down the rickety ladder, and as you climb, you imagine your body slamming to its death with each step. But you don't die, you never do. You make it to the attic, smell the dampness, and hear that drip, drip, drip that sounds so close yet so far at the same time. You find the light and pull on the single piece of string. *Click.* Right in the furthermost corner, you see a box with your name written on it. You inch towards it, imagining yourself falling through the fragile floor with each step, and blowing the dust off the box. You open it. You gasp. You slowly remove the object from the box,

You can practically hear the clink of the metal from these Hot Topic belts.

handling it with both reverence and bewilderment. You hold in your hands a pair of counterintuitively large pants, the ends ripped and frayed, D rings on each side, zips dripping down the legs.

Your Mall Goth life flashes before your eyes. You think back to all those hours spent in food courts, bowling alleys, parks, and parking lots. You smell the stinging scent of nail polish. You feel the dull itch of your knee-length pink-and-black-striped socks. Your eyes still burn from all the neon. Your feet still ache from the cumbersome boots.

These were all staples of what we once called the Mall Goth. A term that demonstrated Goth's transition from a politically motivated subculture to an aesthetic marked by consumer habits, Mall Goth, which experienced its heyday during the '90s and into the early 2000s, wasn't a stance but simply a look that could be purchased. Nancy Downs—the combat-boots-and-spiked-collar-wearing character played by Fairuza Balk in 1996 teen movie *The Craft*—was the proto-Mall Goth. Nancy didn't seem to have any affiliation to the Goth subculture aside from the clothes she wore. Dressing in studded wrist cuffs, ankh necklaces, jelly bracelets, and *Nightmare Before Christmas* long-sleeved tees enabled you to enter the social sphere of the people wearing the same thing. It democratized taste. It Gothicized afterschool hangouts at the mall. It even girlified Goth. Skulls collided with glitter. Pink was patterned with black. Indeed, the main Icons of Mall Goth were mostly young women: Avril Lavigne, Janice from *Mean Girls*, Evanescence's Amy Lee, and probably you, if you were asked why you were dressed for a funeral at the local low-priced chain sandwich store. *Ma'am, this is an Arby's, not a wake.* Ring a bell?

That Goth was suddenly so popular was a problem for the older generation, who'd come from a subculture that was largely a reaction to a normie, consumerist world. Goth suddenly began to split into factions, with the main division being Trad (traditional) Goths against Mall Goths. There was

much animosity between these two tribes, particularly from Trad's end, who perceived Mall Goths as posers who knew nothing about Goth and simply wanted to try it on for size.

That all subcultures eventually transition from the underground to the mainstream is Cultural Theory 101, but it's a particularly rich journey for the Goth subculture and one that is expressly anti-commercial. Beginning in the late '90s onwards, teenage alienation and edgy resistance to the norm could be purchased from The Mall, one of the most normcore institutions you could possibly imagine.

To go to the mall today is to walk through an undead crypt. It stays at the same sickly warm temperature, the kind that gives you a headache. It plays music you haven't heard in fifteen years through its sooty speakers. Its stores sell trends fifteen years out of date. Yet still, it lives—half-dead, yes, but it lives.

The mall first surfaced in Midwest America in 1956 to cater to a new consumer class with a distinctly suburban shopping experience. With the increase of leisure time after World War II, retailers were looking for ways to seize all that spare time and keep people in their shops longer. Soon enough, the mall became a place where consumption and identity went hand in hand. It wasn't simply a matter of milling about in a shop for an hour or two; the mall allowed us to meticulously design the person we wanted to be. It split us into factions: The preps dominated one side of the mall, the Goths the other. The mall was even more than this, though: not just a lifestyle but a rite of passage, the place where so many of us scored our first job, had our first kiss, and saw our first R-rated film.

It's almost impossible to believe now, but the mall once carried tremendous power. It could make alternative subcultures alluring instead of alienating. As such, the mall fundamentally transformed Goth, lifting it toward the mainstream.

Avril Lavigne playing her Hot Topic punk.

Goth style became a consumable trend in the '90s, when entrepreneurs began selling alternative lifestyles to teens. The king of this model was a man named Orv Madden, a young, high-level exec and founder of a store named Hot Topic. In the last surviving Goths of the '80s, he saw an opportunity to not only cater to an ignored crowd but to create a new market out of them.

Coming off the satanic panic, no retail company with mainstream ambitions dared to step anywhere near the dark alt side. But Madden saw this as a gap in the market—and as angsty teenager bait. In 1988, he opened the first Hot Topic in his garage in California and sold a bunch of rock band merch he'd accrued throughout the years. Intent on expanding this business model, Madden flew to independent Goth stores throughout the United States for inspiration and returned to California with the idea to mass-market teenage rebellion to the mall crowd. The following year, in the fall of 1989, he opened a Hot Topic store in Westminster, California. As the Goth aesthetic began to soar in the '90s, with the introduction of Goth characters and cartoons—including, as mentioned, Nancy Downs, as well as *Daria's* Goth characters and the *South Park* Goth kids (who even visited a Hot Topic in one episode)—Madden opened hundreds more stores throughout the country.

Goth stores once existed solely in the downtown areas of America's major cities and style hubs. They were hard to come by, and the Goth aesthetic drew its power from that inaccessibility. Madden turned this model on its head when he brought Goth to small towns and suburbs throughout the United States, making it available to everyone. And *everyone* wanted it. Their band merch, spiked collars and bracelets, and even their crucifixes practically flew off the shelves.

Hot Topic made it considerably easier and far more comfortable to be a Goth. While the subculture once required a bunch of daily hazing rituals, like wearing PVC in 100 degree weather, dousing yourself in hairspray to the point of deep wooziness, and walking in platforms the size of a small infant, all you needed for the Mall Goth look was about thirty minutes of your time, nail polish, an armful of bracelets, a bunch of tees, and a couple pairs of cargo pants.

Within Hot Topic's first year, the chain broke even and scaled up to a national level. Every store across the country drew a healthy profit, luring in private investors who enabled Hot Topic to become an even more dominating force in malls throughout the country. By the time *The Craft* was released in

1996, Madden had opened 800 Hot Topic stores—and was, you won't be surprised to learn, a very, very rich dude.

The overall aesthetic of the store was a major upgrade, too. No longer did it feel like simply stepping into a store at the mall as much as it did taking an elevator down a thousand levels to the underworld. As you walked through Hot Topic's damnable gates (yes, *gates*), you were immediately thrust inside its dark universe. Even darker than

The Goths of
South Park.

an Abercrombie & Fitch, Hot Topic's lighting was as low as a pair of sagging cargo pants. The music was unreasonably loud. The staff looked like members of Satan's unholy assembly. And *that smell*—how on Earth to describe that Hot Topic smell? "If you know, you know" is really all you can say about that specialty stench. For so many young American suburbanites, many of whom had grown up in evangelical families, this was their first look at teenage rebellion. It was a sensory overload. It was everything.

Hot Topic cultivated teenage tastes across the country, not only helping to develop dress sense but the type of music the youth liked too. The chain regularly solicited opinions from their trendiest clientele. They had a feedback box in their stores, where shoppers could mail their suggestions on a postcard to Hot Topic's corporate office. They also had a clipboard in stores where customers could write the band merch they'd most like to see stocked. This in turn allowed Hot Topic to create supply for a demand no one else was covering. They even sold CDs from relatively niche, indie labels that no other store in the mall was likely to have in stock.

Hot Topic's general impact upon music in the late '90s and early 2000s was a phenomenon in itself. It undoubtedly aided in the success of Goth-lite bands who were aesthetic-forward and mirrored the Mall Goth style themselves. One of these bands was Evanescence, a Goth-rock outfit from Little Rock, Arkansas, fronted by the Mall Goth poster girl that was Amy Lee. Lee, with her porcelain skin, dark braids, eyebrow piercing, and Victorian doll look, was the talk of the mall. In one of her first ever major profiles, she told a *New York*

Times reporter that the only place she was recognized in public was in the mall, where she was regularly accosted by teenagers who tried desperately to style themselves after the "Bring Me To Life" singer.

Lee had been posted up on the bedroom walls of Mall Goths ever since they first saw the album art for *Fallen*, Evanescence's multiplatinum-selling debut album. Lee stares out at the viewer with her piercing husky-dog eyes, her black dreads and eyebrow piercing silhouetted. The album, with its mix of sentimental balladry and nu-metal flourishes, pretty much defined the sound of Mall Goth in the early 2000s. A classically trained pianist who sang ballads about suicidal ideation and romantic codependency, Lee was one of hard rock's first female stars. She was positioned as the anti-Britney, a counter to the overly manicured pop star sound of the time. In every way, she was a representative for teens attempting to turn against mainstream culture. In reality, Lee's look was just as considered as any pop star's. But it perfectly matched the sound of her elegiac music: She wore arm warmers, chains, distressed Victorian corsets and skirts, and looked as though she'd spent her life in mourning.

After the success of Evanescence's debut, mainstream culture swung back into a more normie—and preppy—direction. Abercrombie & Fitch flourished, while Hot Topic suffered. With fallen sales and stocks, Hot Topic tried unsuccessfully to coalesce with the mood of the time. For a moment, it shifted strategy and stopped stocking heavy metal band merch. Instead, they moved towards more mainstream acts, and even scored some partnerships with licensed brands like Hello Kitty and SpongeBob SquarePants. Rather than bringing in hordes of Goths as it once had, Hot Topic brought in a load of moms. While the store catered to a new crowd, it lost its unique selling point and sense of identity.

However, in 2007, the rise of third-wave emo bands like My Chemical Romance, Fall Out Boy, AFI, and Panic! At The Disco, who filled mainstream radio with soft pop-punk, briefly paused Hot Topic's identity crisis. The bands gained exposure by having vast quantities of their merch sold at Hot Topic, while Hot Topic regained its high level of demand by catering to their fans. The store changed tack once again, with music recommendation and spotlighting becoming core parts of the store's strategy. Customers came in not only for

LEFT: Amy Lee of Evanescence, Goth doyenne.

••••••••••••••••••••••••••••• ✦
**Davey Havok of
AFI performing
at the 2006 MTV
Movie Awards.**

merch but to learn about new artists whose
music they'd later pirate on Napster or LimeWire.

A few years before Spotify came into
widespread use, the alternative music scene was
in a healthy space, so much so that Hot Topic
could profit from it once again. The company
hired a chief music officer, John Kirkpatrick,
who installed listening kiosks in stores across
the country so that customers could sample
songs from the hottest new indie bands before
buying their CDs in store. To compete with
Napster and LimeWire, Hot Topic also moved
online and launched their own music download
platform, Shockhound, in 2008. Hot Topic was
in a great place for the first time in years. It was
so influential that, unforgivably, it even helped
popularize the skinny jean trend.

Hot Topic lived on for a couple more
years after that. Its swan song came with the
phenomenon that was *Twilight*. Stephanie
Meyer's novel series and the following movie saga were just as powerful in
moving the Goth needle from the underground to the mainstream as Hot Topic
had been a decade before. The success of the five-part film franchise launched
Goths and vampires back to the center of the culture. It also fed even more life
back into Hot Topic. After the first *Twilight* film was released in 2008, Hot Topic
enjoyed a substantial 6.5 percent increase in sales.

The store refocused its energies into stocking and promoting *Twilight*
merch and making it the first port of call for the Twihards. In *Twilight*, a now
multibillion-dollar franchise, Hot Topic cleverly recognized a once-in-a-lifetime
licensing opportunity. They milked it for all it was worth—wouldn't you?

Hot Topic was an important stop on the films' promotional tours. Robert
Pattinson, who played the glittering vampire Edward Cullen, had the joy of
touring fifteen Hot Topic stores across the country prior to the film's release.
Thousands of teenagers would camp outside Hot Topic the night before he was

••••••••••••••••••••••••••••• ✦
**RIGHT: Gerard
Way of My
Chemical Romance
performing at
the Vodafone Live
Music Awards
in 2006.**

SCAN HERE . . . FOR A PLAYLIST OF HOT TOPIC GOTH SONGS!

"Miss Murder" - AFI

"When I Am Queen" - Jack Off Jill

"Brackish" - Kittie

"Vampires Will Never Hurt You" - My Chemical Romance

"Make Me Bad" - Korn

"Fear of Dying" - Jack Off Kill

"Thank You for the Venom" - My Chemical Romance

"Stitches" - Orgy

"Situations" - Escape the Fate

"Pretty Handsome Awkward" - The Used

"Lying Is the Most Fun a Girl Can Have" - Panic! At The Disco

"Purity" - Slipknot

"Caraphernalia" - Pierce The Veil

"I'm Not A Vampire" - Falling In Reverse

"If You Can't Hang" - Sleeping With Sirens

"Bring Me To Life" - Evanescence

"Radiation" - Merciful Nuns

"Smalltown Boy" - Paradise Lost

BE TRANSPORTED BACK TO THE FOOD COURT

GOTH TOPIC

Salesperson #666

PINK BLACK TOE SOCKS	6.66
BLACK STUD BELT	16.66
TEAM JACOB TWILIGHT TEE	26.66
STICKER	.66
SUBTOTAL	50.64
SALES TAX	6.66
TOTAL	57.30

due to arrive, waiting feverishly for the chance to exchange, at most, five words with him and receive a signed autograph on their Hot Topic T-shirts.

Once Bella and Edward had battled the Volturi and lived happily ever after with their blood-sucking offspring, Hot Topic never quite regained its footing. In 2010, My Chemical Romance—once Hot Topic darlings—released a song called "Vampire Money," which could easily be read as a condemnation of Hot Topic's years of Mall Goth dominance. Gerard Way, the band's lead vocalist, decried the commoditization of Goth in many press interviews throughout this period. Way dyed his black hair bleach blond and left his Hot Topic-baiting days. The rest of the world had moved with them.

With the rise of Spotify as well as online shopping in the late 2010s, Hot Topic and the flock of Mall Goths it had created went the way of the Blackberry. Online stores like Disturbia, Dolls Kill, and Killstar rose up and filled the Mall Goth niche that Hot Topic had suddenly lost.

But back to your mom's attic.

It's now several years later, and when you try on those overly cumbersome pants with those striped arm warmers, they start to kind of look good again. They say that styles come back every twenty years, and that's a theory that holds up with the Mall Goths. *Twilight* has become a seasonal staple, required viewing in the fall as *Elf* is in December. Older siblings have handed down their Mall Goth garments to their Gen Z siblings, who have in turn become famous on TikTok for dancing to a Belarusian Goth band called Molchat Doma while dressed up in the Mall Goth of yore. (They now refer to it as "mall-core.")

You close the box and leave it there for another twenty years. Everything is always evolving, yet staying still at the same time. Just like the mall.

Kristen Stewart and Nikki Reed outside of a Hot Topic during the promotional trail for *Twilight*.

HAUTE GOTH, DARLING!

very few years, trend forecasters seem to ask the same question: Is *this* the return of Goth? But they can save their breath. Goth never left. From Hot Topic to haute couture, Goth has always snuggled cozily into both the high-brow and low-brow fashion worlds. That Gothic fashion so stubbornly resists death and enjoys an eternal life is in part due to the endless well of tradition and inspiration that it draws from, as well as its ability to drink in new influences as it travels through time. We've learned that the Goths have been the dark counter to just about every era of humanity, stretching right back to antiquity. Its influence is now so far-ranging that almost every fashion house in the world has created a Goth collection, whether inspired by the Dark Ages' long, trailing trains and sleeves or the Victorian era's flamboyant mourning dress.

Giving Goth on Gareth Pugh's Fall/Winter 2013 runway.

That the Goth carries with it such a large and vivid visual glossary and imbues its garments with such high drama and character surely stems from the co-emergence of Gothic literature and fashion in the late eighteenth century. Walpole and Radcliffe were as much aesthetes as they were novelists, and in their world-building works they dressed their characters in robes compared to Gothic arches, instilling their garments with a dark romanticism.

Gothic fashion is defined as much by its corsets, leather, lace, velvet, and heavy jewelry as it is by its intense mood and hugely dramatic and romantic streak. It sweeps you up in its sublime story. Fashion, like Goth, lives fast, dies young, and is then reborn for the next generation to take up the mantle. Just as the Victorians looked back to the Dark Ages for Gothic inspiration, the Modernists to the Victorians, and the TikTokers to the Mall Goths, successions of fashion designers have built upon the Goth that their predecessors left in their wake to fashion their own take.

Fashion, also like Goth, is a way to aestheticize the world and all the grief it holds. Queen Victoria knew this when she dressed in the most ostentatious laces and black silhouettes between the time her husband died and her own death. Karl Lagerfeld knew this when he hosted his legendary Black Tragic Dress soirée in Paris in 1977. The Mall Goths knew this, if only intuitively, when they started wearing cargo pants and boots right before the early 2000s recession.

Some theorize, half jokingly, that Goth fashion is a harbinger of a recession. But there is some truth to this. Goths, after all, preceded the collapse of Rome as well the 1980s recession. Goth has been a recurring constant throughout fashion history, but it tends to sprout up most forcefully during times of social and economic instability (as Goth in general has pretty much always done). Goth fashion had a huge moment during the late Victorian fin de siècle period and, more recently, right around the Great Recession of the twenty-first century, as well as after the COVID-19 pandemic.

Goth is one of the most impactful and recognizable visual styles. It allows designers to indulge their most excessive, dramatic, and romantic sides, as well as to exhibit a more intense emotionality that we don't often get to see from them. Goth is a style that tends to pair best with the most daring and

LEFT: Karl Lagerfield with a model on each arm, circa 1984.

THE GREATEST GOTH LOOKS EVER SPORTED ON THE RUNWAY

- **Gareth Pugh Fall/Winter 2013** - Inspired by the Asgarda, a group of modern warrior women who reside in the Carpathian Mountains in Ukraine, Gareth Pugh's AW13 collection saw his models dominate the runway with large black binbag dresses, their shoulders pointed like a knight's armor, while emo fringes touched the tops of their painted-red eyes.

- **Christian Dior Spring Couture 2006** - Taking its cue from the French Revolution, one of history's most Goth moments, this Spring collection cast a darkening gloom on one of fashion's brightest seasons. Models walked out wearing red, billowing capes, cinched leather jackets and crucifix neck pieces with 1789, the year of the French Revolution, etched onto them.

- **John Galliano Fall/Winter 2007** - Skeletons and real-life goldfishes surrounded the stage for one of fashion's most gorgeously deranged moments. John Galliano sent his models down the runway with veils, dripping makeup, and broken dolls clasped in their hands.

- **Alexander McQueen Fall/Winter 1997** - Inspired by H. G. Wells's underappreciated sci-fi classic *The Island of Dr. Moreau*, which follows a vivisectionist who turns animals into humanoids, Alexander McQueen's Fall/Winter collection of 1997 spooked its audience with models contorted into feline-like shapes, animal skins draped across their bodies.

creative designers, which is why it has been the domain of the most legendary names in fashion history.

One of these designers was, of course, Vivienne Westwood. Westwood was a groundbreaking designer as well as a scrupulous researcher of fashion history. Like any good Goth, she continually repurposed garments of the long gone past into edgy new looks striking enough for the present. Westwood

Vivienne Westwood and Sex Pistols' manager Malcolm McLaren, 1977.

was instrumental in carrying the corset—the Goth's go-to rib squeezer—into the twentieth century. Her corsets became iconic as soon as she sold them at SEX, the fetishwear store she opened with her partner, Malcolm McLaren, in 1971. The duo's specialty boutique, which also featured risqué bondage trousers and tees, soon coalesced into the British punk style that would lay the foundation for the Goth subculture of the late '70s and '80s. Westwood styled the Sex Pistols and later Siouxsie and the Banshees, who would don the designer's Goth-meets-fetish pieces, including studded leather sandals and black lacy tees. Westwood has since been the more moneyed and discerning Goth's go-to designer, her once outlandish clothes now part and parcel of mainstream culture.

A wave of Japanese designers also gained prestige in England around the time of Goth's subcultural peak. Yohji Yamamoto was perhaps the biggest, as well as the most Goth, of them all. Ever since his Paris fashion week debut in 1981, Yamamoto has been fashion's master of darkness, with his signature all-black tailoring, off-kilter proportions, and severely dramatic silhouettes.

Yamamoto's love affair with the color black has obviously made him a Gothic darling, and he understands it precisely: Black is supposed to be mysterious, alien, antisocial. When one wears it, one wears it as a kind of sexy shield. It protects you while alluring others to you all at once. Indeed, all of Yamamoto's garments carry this fundamentally Goth attitude. There's a chilliness as well as a seductiveness to his designs. Across four decades of fashion design, Yamamoto has sent models with black eyes and bruised lips down the runway, as well as models with fangs and bleeding mouths. In other words, he perfectly understood the Gothic assignment.

No one took Yamamoto's baton and carried Goth into the '90s so imaginatively as Alexander McQueen. While the Gothic music championed by Bauhaus through to the Sisters of Mercy was fading out of style, designs inspired by the musical subculture were taking hold on the runway. More than any other designer, McQueen, who was said to be the descendent of a Salem witch, brought historically informed Gothic designs to couture. Like Westwood, McQueen was a voracious studier of history, with art inspiring him as much as fashion. Goth was the most recurring historic trope throughout his research and fashion career. He drew inspiration from each of Goth's iterations: medieval cathedrals, Victorian mourning, the Brothers Grimm's fairytales, vampire B movies—really, just about everything we've covered in this book so far.

From his very first public work—his university graduation show, *Jack the Ripper Stalks His Victims*—to his final, unfinished collection in the fall of 2010,

which featured royal cloaks and eternal angels, McQueen imbued everything he created with a touch of the Gothic, the meeting point between death and romance. McQueen was a sartorial storyteller and knew he could wield the Goth to that end. He loved the way the Gothic created a visceral reaction, a shock, and how it created a troubled image of the past. McQueen often presented his collections in macabre fashion, filling his runways with skulls, pushing bloodred contact lenses into his models' eyes, and projecting tattered and worn screen-printed photographs onto the runway.

His most Gothic shows came in the mid-'90s, beginning with his spring/summer 1996 collection entitled *The Hunger*. Named after the Goth-camp film that starred David Bowie, McQueen's *The Hunger* featured a see-through corset made of molded plastic which held a splattering of dirt-covered worms. The following year, for his autumn/winter 1997 collection for Givenchy, which he called *Elect Dissect*, McQueen introduced to the runway a fictitious Victorian surgeon who chopped and repurposed women and animals into tartan, leather, and lace ensembles.

The '90s were seized by a haute couture Goth fever. Fashion magazines throughout Europe, including *British Vogue*, *i-D*, and *The Face*, ran several versions of the same trend piece: The runway had taken inspiration from

the '80s Goth musical subculture and reappropriated it into high fashion. Designers were no longer seeking inspiration from their peers, but from the streets of the recent British past.

In the late '90s, a man named Rick Owens carried on where McQueen left off, filling the runway with shameless Gothic bombast. Intent on shocking the fashion world out of its conformity, Owens painted it black. He consistently dressed his models in only that color, with leather hide hanging from their shoulders, drop-crotch pants covering their thighs, and platform boots raising them high above the audience.

Owens came onto the scene just as Goth and heavy metal were gaining mainstream visibility thanks to musical acts like Marilyn Manson and Nine Inch Nails. Like them, Owens turned countercultural expression into a money-making enterprise and transmuted the horror of the world into compelling romanticism. His trademark glunge (glamor-grunge) is fundamentally Gothic in conception and intention: His endless parade of black was a way to reckon with morality. Death and decay are, in some form, baked into all of his designs, since his garments look better with age. Rather than dying a young death, the tatters and holes that Owens's designs will inevitably accrue only enhance their glunge value. Countering the strictly clean and unimposing aesthetic of the normie world, Owens brought a dark auteurship to fashion in a way that fundamentally influenced millennial Goths.

Model Stella Tennant takes to the runway in Alexander McQueen's slashed leather.

In 2008, Goth had one of its watershed runway moments. Givenchy, Chanel, and Luella Bartley all had Gothic-inspired collections that year and inspired the lacy black designs that would line the storefronts of just about all the major stores the following year. A man named Gareth Pugh, a former intern of Owens's, crystallized the vision of this new Gothic during Paris Fashion Week 2009. While 2008 had seen a more traditional take on Goth, Pugh introduced an entirely new direction, with a collection of shiny, metallic, glittering garments. He paired shredded leggings with tank tops covered in metallic pins. He turned the classic Goth hourglass silhouette into a form that seemed almost post-human, with shoulders stretching out almost a meter from the model's frame. His dresses resembled a scythe. Inspired, as all good Goths are, by the trenches of history—the Victorian and Elizabethan eras, as well as the Gothic romance novels of the eighteenth century—Pugh's garments carried the weight of Gothic tradition while bringing forth a new sensibility.

Giving extra dimension to his dark fashion, Pugh also came to be known for the films that accompanied his runway shows. Chilling and practically itching with spookiness, his films tended to feature heavy sound design, while his models were depicted in some kind of séance. Gothic and horror films have been another core influence upon Pugh's work, particularly his spring/summer 2015 collection, with its pentagrammic motifs and long, flowing garments that drew major influence from the folk horror film *The Wicker Man*.

Fashion week 2016 followed, with a flurry of Gothic film-inspired collections, including those of Alexander Wang, as well as The Row, who borrowed from the occult American Pilgrim-core fits of Robert Eggers's 2015 *The Witch*. Since then, the runway has seemed to grow moodier and moodier,

Models sporting Rick Owens's Goth looks during the Paris Menswear Week in 2009.

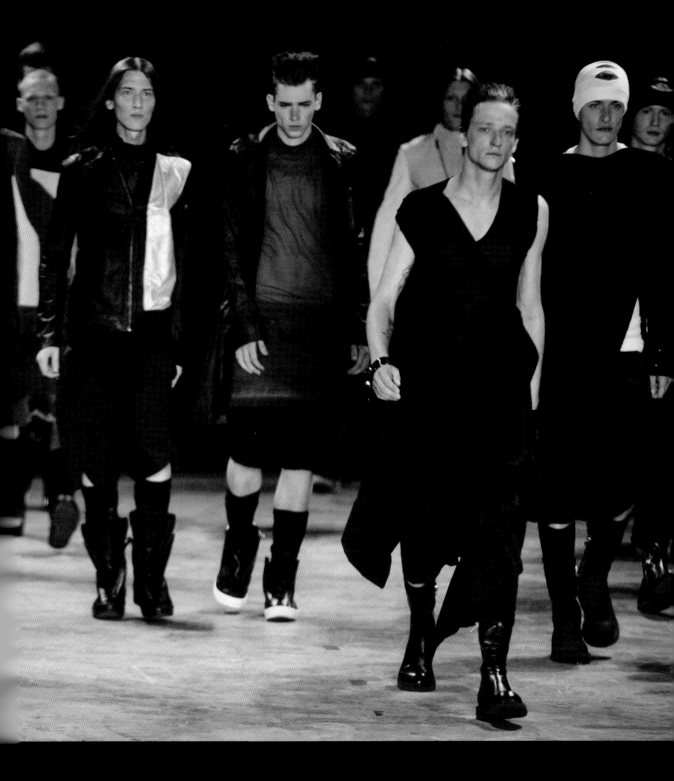

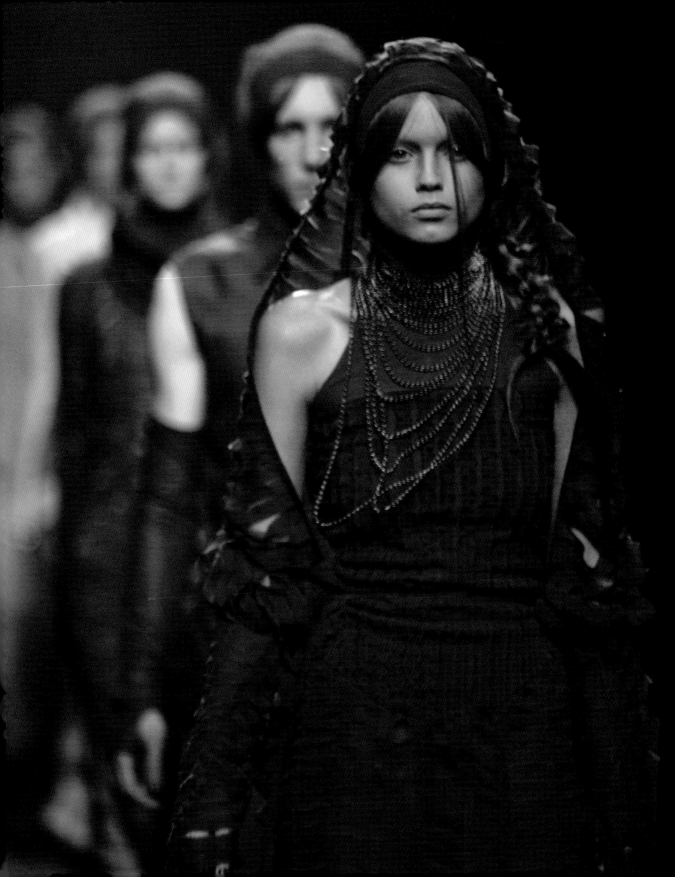

particularly since the COVID-19 pandemic. Prada has gone the way of the Goth, regularly sending trench coats and Frankensteinian patchworks down its runways. Balenciaga has become the new master of darkness. A designer named Dilara Findikoglu has taken the fashion world by storm, sending typically Gothic attire down the runway with an extra rebellious twist.

Goth no longer remains on the fringes, nor is it exclusive to the designers who border on performance art. Goth has almost become as commonplace as florals in spring. Beauty standards have changed, and even the Kardashians—particularly Kourtney, who married Blink 182's smoldering Gothic drummer Travis Barker—have embraced Goth's spooky chic. Just about all the post-pandemic It Girls are in on it, and the consumers of their image are frantically trying to mimic them. Many sites and online shopping stores, including Depop, Pinterest, and Ebay, have reported a dramatic increase in Goth- and Gothcore-related searches.

The unprecedented popularity of Tim Burton's *Wednesday*, the Jenna Ortega-starring spin-off of *The Addams Family*, has also contributed to the ubiquity of both vampy glamor and soft Goth glam, as has the COVID-19 pandemic itself. Never before have we as a culture had to sit with ourselves and the nearby threats of death and decay so intensely as we did in 2020. And since then: inflation, uncertainty, continued introspection, and segregation. Of course, if nothing else, the Goth has flourished.

Fashion—particularly Gothic fashion—has always been a process of indulging in the romantic past, of turning our most dysfunctional emotions into fabulous theater. That Gothic fashion is now so prevalent might suggest that we're in gloomy times, but at least it makes that gloom beautiful. Black is, and always will be, the new black.

DARKNESS KNOWS NO BORDERS: GLOBAL GOTH

O n the other side of the world—a place that is bathed in light during our dark night—a young Goth is getting ready for the day. They tussle their jet-black hair, squeeze their feet into their Dr. Martens, readjust their eyebrow ring, and head out into the sweltering Nairobi sun.

As you read this, millions of Goths around the world are fixing themselves up in similar dark colors, similar boots, with that similar swish of hair—and stepping out into vastly different expanses.

It's not often that those in the West truly think about the global impact of Goth. For too long, Goth has been the domain of Western, particularly Eurocentric, beauty standards, and we've associated Goth with paleness, despite the millions of people of

color around the world who partake in the subculture. With the emergence of the Gothic subculture in the late '70s, its icons have been almost uniformly white. From Bauhaus and Siouxsie Sioux's stretch in the '80s to Marilyn Manson's in the '90s and Amy Lee and Gerard Way's in the 2000s, the most visible of the Goths have had a similar visage.

That paleness is one of Goth's beauty ideals has historically been the subculture's way of separating itself from the blond and tanned fantasies of the Western world. But in reality, this emphasis on paleness has exiled many people with Goth sensibilities around the world from feeling seen in and embraced by the subculture.

Since the '80s, Goth has spread itself around the world and worked its way into the cultures and traditions of many countries. The globalization of Goth alone challenges Goth's pale ideal. And so, we need to enlarge our imagination of the Gothic to form a more accurate vision of it. While "Goth" might bring to mind old European castles and red blood on a pale face, a more accurate image might include the colorful Día de los Muertos (Day of the Dead) festivals of Mexico, the old bungalows of India, or the Filipino vampire known as aswang.

The West's closest understanding of global Goth is naturally its iteration in Japan, the most westernized country in this chapter. Goth became a mainstream talking point in Japan in the late '80s, when young people on the streets of

LEFT: A young punk posing in the streets of Harajuku, Tokyo.

Teens dressed in typical visual kei attire in Harajuku, Tokyo.

Nothing says rock
'n' roll like cat face
paint: the band
Kiss in 1974.

Tokyo began combining punk fashion with the motifs of visual kei (a genre of Japanese music closest in spirit to glam rock and heavy metal). Just as England's Goths had drawn from the punk culture that preceded them, visual kei transformed Japanese punk into something theatrical, flamboyant, androgynous, otherworldly, and, ultimately, very time-consuming to put together.

You can trace visual kei, just like you can trace most of the Gothic subculture, back to David Bowie, as well as to the American rock band Kiss, both of whom left big marks on Japan. Visual kei is still going strong today. In 2018, X Japan, perhaps the country's biggest visual kei band, shared the stage with Marilyn Manson and won the world over.

Global Goths may also be familiar with Lolita culture. Emerging in the '90s on the streets of the Harajuku district in Tokyo, Lolita Goth introduced a cutesy strain to Goth, with its mix of rococo and Victorian era dress, including puffy sleeves as big as clouds, bloomers, parasols, giant bows, tiny top hats, stockings, and frilly dresses. Rising in tandem with Harajuku's rapid commercialization, Lolita was extravagant and gleefully excessive, as much an expression of Tokyo's consumerist culture as it was a resistance to it. All Goth—in any time and any place—is ultimately a resistance to something. The form that resistance takes is specific to the culture in which it's rebelling

against. And the Lolitas were rebelling against the clean-cut aesthetics of Tokyo. Walking down the street and seeing an army of enormous frills and puffs among the suits of the country's capital may have been one of global Goth's most visually arresting resistances, as well as its most colorful.

While Western Goth has a very monochromatic palette of blacks and grays, Lolitas and J-Goths (Japanese Goths) invite a kaleidoscopic collision of gloom and girlishness. What they're rejecting isn't just mainstream conformity but the pressure to grow up. Dressing in Lolita style is a way of prolonging and preserving childhood, a time of pre-sexualization and innocence. In that way, Lolita is a Gothic extension of Japan's famous kawaii culture, which emerged in the 1970s as a kind of celebration of childhood.

While fashion trends come and go, Lolita has endured in Japan for decades. Gothic style in general is still one of Japan's most recognizable subcultures and is a vital part of its kawaii culture. The Western world has been transformed by it too. In America, the riot grrrl punk movement of the '90s took visual clues from the Lolitas, with bands commonly wearing puffy tutus onstage with leg warmers underneath. In 2007, Baby, the Stars Shine Bright, a Lolita-dedicated clothing store, opened in Paris and is still going strong, now with locations worldwide.

Teens dressed in Lolita streetwear in Tokyo.

Spencer Thrust
of Botswana's
premiere death
metal band,
Overthrust.

You can spot Lolitas throughout the world's busiest streets, from London to New York City. It's a version of Eastern Goth that we've seen impact the West in real time, though the East's influence on Western conceptions of Goth stretch back some many hundreds, possibly thousands of years.

So much of Goth's core imagery and sensibility reaches back to the African diaspora, a provenance that has largely been erased from Gothic histories. Every Goth from Siouxsie Sioux to your Mall Goth cousin has worn an ankh—a looped cross—around their neck. A symbol of eternal life—a fundamental tenet to Goth's ultimate mission to transcend death—the ankh is a product of North African symbolism, specifically Ancient Egypt, which has been frequently referenced throughout both Gothic literature and fashion. The Eye of Ra, which resembles a mascara-heavy falcon's eye and is said to ward off evil, is another popular image borrowed from African spiritual mythology.

The skull, perhaps the most iconic of all Gothic imagery, was also lifted from the African diaspora. Among some African tribes, it is still common

practice to preserve the skulls of dead relatives, placing them in the possession of their local priest who cleans and cares for them. The skull is seen as the home of the soul and as such is an item of worship rather than one associated with fear. That the skull has since accrued Gothic associations is part and parcel of how the West has treated Africa in general: It has cast a shadow of darkness upon it and degraded its rituals as forms of witchcraft and savagery.

The music of the African and Caribbean diaspora provided much of the base of Gothic rock. Rock itself was an invention of Black musicians, while the dub that made Bauhaus famous came from Jamaica. To see teenagers walking around Angola, Nairobi, or Kingston in Bauhaus and the Cure shirts feels like some kind of reclamation. With the boom of Africa's youth population over the past few decades, the continent has hosted a rich variety of subcultures, whether the Heavy Metal Cowboys of Botswana or the psychedelia of Zambia—all of which operate underground. While hardly visible in the mainstream—which is just how Goth likes it, no matter where in the world—Goth in Africa has remained consistent across the continent ever since the import of European bands like the Cure and Sisters of Mercy.

As in countries across the continent, Angola's Goth scene grew with the spread of the internet in the 2000s. Not only were nascent Angolan Goths able to send and stream Goth music, but they were also able to organize Goth meetups, which would often attract a few hundred attendees. A Facebook page named Subcultura Gotica Em Angola, which functions like a digital noticeboard of Goth events, as well as an educational guide to the history of the subculture, is among the most popular of Angola's digital Goth forums.

The Angolan Goths, like Goths anywhere, are in the minority. While subcultures in Angola coalesce most popularly around rap, kizomba (Angolan party music), and semba (a kind of dance that emerged in the 1950s), Goth is heavily on the alternative side and often looked upon skeptically. However, attitudes began to shift slightly towards the end of 2016, when the Media Library of Luanda, Angola's capital, hosted a discussion on Goth, with the scene's most seasoned participants in attendance. During the session, they broke down Goth misconceptions, pushing back on the global belief that Goths are the devil's people and painting them as what they truly are: introspective kids who like to dress in black because it makes them look mysterious.

Over 1,500 miles (or 2,500 kilometers) away in Eastern Africa, Kenya boasts one of the continent's largest Goth scenes, in part because it has seen the largest youth population upswing across Africa. In Nairobi, Kenya's capital city, many of the middle-class youth have abandoned their mother tongue in favor of a dialectal melting pot of Swahili and English known as Sheng. They are more influenced by globalization than by their local tribes and have found a new kind of clan among music and fashion-based subcultures, in nightclubs, bars, and alternative stores.

With the import of MTV and Western music channels in the 2000s, Nairobi teens began dressing like the Gothic stars they saw on screen, purchasing leather jackets and black-and-red-striped tees. Yet to this day, Goth is treated more like a costume in Nairobi, something to put on only in safe circumstances. Walking the streets in Goth-coded outfits will commonly draw mocking laughs, sneers, and in some cases, police attention. Goth in Nairobi has caused a moral panic of its own, with many outside the culture misaligning it with Satanism.

But that hasn't stopped Nairobi's small yet sturdy Goth subculture, an insular community who keep one another safe, while trading clothes and sharing historical Goth knowledge with one another. To cater to this crowd, two siblings opened Nairobi's—and very possibly Africa's—first Goth shop in 2009. Aptly named the Goth Shop, the store sits in a mall in one of the city's most affluent neighborhoods and plays Goth rock from its speakers. There are a smattering of tattoo parlors and piercers in the area which draw a similar crowd, most of whom are subject to looks of hostility.

That Goth always persists, no matter where it is and what kind of cruelty it is subject to, is surely one of the subculture's universal qualities. Goths exist absolutely everywhere in the world, no matter how much they're lambasted in their respective societies. This includes Muslim countries, whose governments strongly oppose the subculture; in extreme circumstances—as in Iran—the Gothic lifestyle can be punishable by death.

Despite this, Goths and Goth-adjacent folks—emos, punks, metalheads—have found a way to exist and survive in Muslim societies. Alternative music scenes thrive across Malaysia and Indonesia, despite conservative efforts to put a halt to them. Their resistance is a beautiful sight: women in hijabs moshing

TOP FIVE GOTH TOURIST SPOTS AROUND THE WORLD

1. Bran Castle (Dracula's Castle), Bran, Romania: Because, duh.
2. Island of the Dolls, Mexico: Sitting south of Mexico City, the Island of the Dolls is just that: a mostly abandoned stretch of land occupied only by a bunch of creepy kids' toys.
3. Fengdu (Ghost City), China: Located on a mountain in an abandoned ghost city, Fengdu plays host to a large selection of temples, shrines, and monasteries all dedicated to the dead.
4. The Witchery, Edinburgh, Scotland: A Goth enclave tucked away from the city bustle, the Witchery is a dark, romantic hotel with a lot of dark history. Witches, ghosts, spooky spells—they've got all the good stuff.
5. Barcelona's Gothic Quarter: Exactly what it says on the tin. Gargoyles and spiky spires and dark corners abound.

A sunset over Bran Castle, Transylvania.

Arabia, where Wahhabism—an Islamic reformist movement which emphasizes social modesty and strict adherence to the literal word of the Koran—rules. It means that while Goths can't exhibit themselves as such in public, there are some—mainly university students—who partake in the subculture in private, listening to Bauhaus undercover.

In August 2012, Muslim Goths made international news when a group of cross- and corset-wearing dark-haired teenagers were photographed for BBC News. Reporting on the increased imprisonment of Goths in Uzbekistan, the BBC presented a story of violent conflict between the Goths and the Muslim government, turning a largely apolitical subculture into a site of political dissent. Goths have been a presence—albeit an untold, uncommon one—on the streets of Tashkent, Uzbekistan's capital, since the 1990s. From their very first appearances, Goths were targeted by authorities intent on punishing and making an example of them. Over the years, the Goths of Uzbekistan have become some of the government's go-to scapegoats, and they've been unjustly blamed for, among many other things, vandalism; the destruction of cemeteries; and the spread of immorality across the youth.

However, in India, particularly across major hubs like Mumbai and Calcutta, a Goth subculture has thrived for well over a decade. While some Goths still hide, others have become celebrities in their own right, projecting an image of dark defiance and introducing new standards of beauty against the sparkling behemoth that is Bollywood.

While the Gothic cultures across Africa and the Middle East are largely in dialogue with Western Goth, India's Gothic tradition is slightly more insular and almost exclusively draws from its own well of Gothic signifiers. Western Goth draws from European literature from Radcliffe to Brontë, but India has its own texts worthy of the Gothic canon. In these

A dak bungalow in southern India in the early 1900s.

Mexican
Catrinas figures—
fashionable
even in death.

tales, khansamah (male servants) stalk the pages. Like ghosts, the khansamah
seems to exist beyond time, a presence that haunts the family home. While
castles and abandoned mansions provide scenes of the Gothic in Western
texts, in India, Goth's terrifying sublime takes place in what's known as the
dak bungalow. Often located in remote, scenic places, the dak bungalow once
housed British journeymen during the period of British rule in India between
the mid-nineteenth and mid-twentieth centuries. These journeymen shared
tales of the eerie noises they heard in their bungalows at night. In daks, the
British took on the role of the white, pasty ghost—and, as we all know, there's
nothing scarier than a Brit.

Over 9,300 miles (or 15,000 kilometers) away from these daks lies one of
the world's most Gothic places: Mexico, a country that was Goth before Goth
existed. Gothicism and Mexican culture seem to complement one another
perfectly. Every November, right after Halloween, the country celebrates Día
de los Muertos, a festival that honors the deceased. During the festivities,
families parade around colorful sugar skulls and place photos of their lost loved
ones on *ofrendas* (altars) along with their favorite foods, drinks, and trinkets.
The Mexicans turn grief and death into a kind of whimsy. Smiling skeleton
puppets dance amongst the festival crowds. Children suck on skull-shaped

Gabriel García
Márquez at his
desk, sometime
in the 1970s.

candies. People paint their faces the colors and shapes of *La Calavera Catrina* (Mexico's skeletal representative of death). In Mexico, death isn't seen as an end but as a transition. Not even death can kill the vibrancy of the Mexican soul.

Mexico is colored by this vibrancy, with brightly painted houses and vibrant delicacies. But underlying all this iridescence is a sense of darkness. Death is reveled in, constantly acknowledged, and the supernatural speculation it inspires is widely encouraged. Mexican culture has one foot in a world beyond our current plane. It's not uncommon for people to report encounters with otherworldly spirits. From a young age, children are taught about the specters they too might come across. *La Llorona*—a spiteful spirit who haunts riversides—is one of the most frequent figures in Mexican children's books.

Latin American literature in general can be characterized by its spooky disposition. It's often associated with a genre known as magical realism, a subgenre of literature in which the otherworldly takes place in prosaic settings, popularized by the Colombian novelist Gabriel García Márquez in his landmark 1967 novel *One Hundred Years of Solitude*. Authors across Latin America, including Márquez, have cited Poe as a core influence. They've lifted Poe's macabre and Gothic mode of writing and applied it to their diminishing surroundings. In the '90s, Poe-inspired Gothic writing flourished in Peru, right after the rebel group known as the Shining Path terrorized the country. In Argentina, Gothic literature has risen in tandem with the country's economic and ecological disasters.

Of all the countries in Latin America, Brazil plays host to the most robust spread of Gothic subculture. Even in Manaus, a city in Brazil's Amazon region, Goth kids are willing to dress up in leather and bulky boots, despite living in some of the world's most humid conditions. If that's not commitment, I don't

know what is. Just like every other Goth scene in the world, Manaus's Goths have been charged with unfounded accusations of Satanism, drug addiction, and general violence.

It's the same in São Paulo, Brazil's largest Goth hot spot. Home to some of the world's grandest cemeteries as well as pristine Brazilian Belle Époque (essentially, Brazil's Victorian era) architecture, São Paulo sets the ideal scene for the Goth subculture. Obsessed with death, Bauhaus, and Augusto dos Anjos—Brazil's answer to Poe—the Goths of the city have the same universal interests as Goths anywhere, just as they inspire the same kind of undeserved animosity. It's not uncommon for São Paulo's Goths to be verbally assaulted on the streets or to be accused of witchcraft and heresy. Underground Goth scenes have flourished for decades in the city, particularly with the advent of the internet toward the end of the last millennium. As the subculture moved online, São Paulo's Goths recalibrated and expanded. They scanned the zines they'd made for underground shows that would previously be seen only by an audience of a hundred or less and introduced these artifacts of recent Goth history to a wider digital crowd.

Since 1999, a website called Carcasse (the French word for "carcass") is where these Goths have congregated online. A major web portal and forum dedicated to Goth and dark arts, Carcasse has totally restructured Brazil's Goth scene in its decades of existence. Carcasse allowed for the spread of Goth history, literature, music, and architecture, as well as the spread of Goths themselves, generating a large community. Carcasse also allowed for the organization of large parties across the country, including the popular RIP party, which brings together every strand of Goth and Goth-adjacent music, from Trad Goth like Bauhaus to Mall Goth pop-punk.

With tens of thousands of subscribers, Carcasse has become South America's most popular online Gothic forum and has even become a point of reference for Goths elsewhere. Goth is no longer such a narrow—and pale—point of reference but a universal term that holds every ethnicity, culture, and

BURY A FRIEND: GOTH GOES POP

rom its inception, Goth has set out to disturb the established order, to transgress or simply destroy what we've deemed sacrosanct, eternal, or just straight up normie. Everywhere it travels, Goth reminds us that death and decay will come for everything we love. Pop music, on the other hand, is one of the most commercially viable of all art forms, as well as one that is built upon life, love, youth, and vitality. So, what purpose does Goth serve when it mingles with mainstream pop? And how can the two—which surely oppose one another—fit together?

When you think about it, the life cycle of a pop star is pretty Goth. They assemble themselves from the ashes of past pop stars, die, reassemble, die again, and so on. The female pop star, in particular, is made to endure a series of deaths and rebirths, restyling and reintroducing herself again and again in order to satisfy fluctuating tastes. Across the '90s and early

Billie Eilish performing in 2019.

2000s, most female pop stars seemed to follow a very similar trajectory: They first emerged as well-behaved ingenues, then rebranded as good-girls-gone-bad, then became hot messes, then turned thirty and were therefore dead in the eyes of the pop mainstream.

But the Goth provides a strategy in which to break from this pop star conveyor belt. Though not quite a mainstay of popular music or culture, the Goth emerges every now and again as a rehabilitative tactic for pop stars in need of a severe makeover. It's a costume to try on when the pop star feels like being the villain just for a moment and revolting against the extremely constricting and limited conditions under which they exist. The Goth provides a way of interrogating the violent regime, structure, and maintenance that it takes to be a pop star. There's a reason why Britney Spears dyed her hair dark for her 2007 comeback, right after her very public meltdown.

We can trace so much of this modern template for pop—as well as its Gothic U-turn—back to Madonna. Setting the chameleonic standard for pop stars, Madonna has been many, many different women throughout her career—from Marilyn Monroe-impersonator to grease monkey to sexual provocateur to crying in the club—while ironically distancing herself from all of these feminine archetypes. But in the late '90s, just as haute Gothic couture was hitting the runways, Madonna leaned into sincerity and entered her Goth phase.

SCAN HERE . . . FOR THE ULTIMATE POP GOTH MUSIC EXPERIENCE

"Frozen" - Madonna

"Disturbia" - Rihanna

"Monster" - Lady Gaga

"Glory and Gore" - Lorde

"bury a friend" - Billie Eilish

"vampire" - Olivia Rodrigo

"Look What You Made Me Do" - Taylor Swift

"all the good girls go to hell" - Billie Eilish

"Nightmare" - Halsey

"Bloody Mary" - Lady Gaga

"Dollhouse" - Melanie Martinez

"Dark Horse" - Katy Perry, Juicy J

After giving birth to her daughter Lourdes, Madonna was a profoundly changed woman: spiritually in touch, much more introspective, and not to mention, angsty (a word she used many times in interviews during this era). While in a much more emotionally porous state, she gravitated toward Eastern mysticism and formed a deep and intuitive relationship with the universe. She reintroduced this new version of herself in one of the most Gothic pop culture moments of the '90s: the music video for her 1998 electronica ballad "Frozen." Featuring many Gothic visual signifiers—a black dress, a dark twin, black dogs, black birds, black hair—"Frozen" was Madonna's Gothic wild card moment.

Working with longtime stylist Arianne Phillips for the music video, Madonna dressed as a kind of dark bride meets Gothic geisha. She wore an austerely black dress designed by Belgian designer Olivier Theyskens, which she previously described as a symbol of feminine angst. Throughout the video, she turned her henna-decorated hands to reveal the Hindu symbols of birth, life, and death on her palms, while moving in a kind of interpretive sacred dance—essentially pairing Eastern spirituality with Western Gothic (who have always made good bedfellows). Setting the standard once again, Madonna introduced a new pop star strategy for the twenty-first century artists who would succeed her: If you want to make a hard career pivot or simply reveal a deeper side of yourself, go Goth.

Exactly ten years later, Rihanna took full advantage of this tactic. Though still in an early phase of her career, the "Pon De Replay" and "Umbrella" singer had produced safe, play-by-number hits that were always radio friendly, upbeat, and conceptually straightforward. But three albums in, she wanted to make good on her *Good Girl Gone Bad* promise—the title of her third album as well as a description of her next career arc—by going headfirst into Goth.

In the late summer of 2008, in time for that year's Halloween buildup, Epic Records released "Disturbia," likely one of pop's most explicitly Goth singles since Madonna's "Frozen." In interviews surrounding the song's release, L.A. Reid, then-CEO of Epic Records, said that "Disturbia" prompted Rihanna to take control for the first time. Rihanna persistently debated with the skeptical label bosses, who eventually gave in to her demand to release "Disturbia" as the first single from her third album. Goth is, and has always been, a way to wrest control from the man.

Opening with a bloodcurdling scream and the paranoid gasps of the singer, "Disturbia" came out of left field, particularly for an artist like Rihanna. Thematically, "Disturbia" dared to brush with an emotional palette not often used in mainstream pop: darkness, anxiety, anguish—the plagues of the mind. Sonically, the song fell more into Burton's idea of Goth: It's ooky, goofy, and fun. It's meant to get stuck in your head like a worm trapped in a poisoned apple, while touching on dark themes from a safe distance. In the song's music video, which Rihanna codirected with Anthony Mandler, the singer didn't invoke Gothic narratives so much as display an onslaught of the genre's visual signifiers: tarantulas, wolves, dolls, corsets, white contact lenses, *Thriller*-style jerky dance moves.

Lady Gaga, another pop star of the time, was explicitly built upon the flesh of pop culture's past: a hyper-referential creature of pop allusions whose uncanny familiarity puts her squarely within the Gothic. Gaga, as she has always been well aware, is pop's logical endpoint, its death. Everything that could ever be done has been done. All artists can do now is recycle dead parts and reassemble the dead limbs of pop pasts. Lady Gaga manned this pop cultural graveyard.

Gaga's concept of pop art and fame has always been Goth-camp. She is as much a disturbance to popular culture as she is a reflection of it, as much of a Rihanna as she is a Marilyn Manson. She filters the monstrous, the strange, the grotesque, and the Goth through catchy pop tunes. She is Goth's Trojan Horse: a monster dressed up as a pop star. Her albums, particularly from 2008's *The Fame* to 2011's *Born This Way*, are heavily influenced by Goth dance music. If you listen closely, you can hear Joy Division's motorik rhythms and Nine Inch Nails' industrial beats. Yet Gaga's melodies are so undeniably pop, her

performance so bordering on musical theater, that she finds a way to disguise her music's Gothic backbone and bring Goth to the largest audience.

She carried this juxtaposition through to her visual style, where she combined the monstrous with the beautiful, whether that meant throwing buckets of blood on herself at the VMAs or confusing butchers with strange sartorial requests. The image of Lady Gaga in full glam while draped in a dress made of meat will follow pop music to its grave. That garment not only made millions shudder, but perfectly expressed Gaga's monster-as-pop star ideals.

The infamous meat dress followed *The Fame Monster*, Gaga's second album. Made on the back of her obsession with B monster movies, *The Fame Monster* was Gaga's pop answer to the horror and sci-fi movies of the 1950s. The figure of the monster—like the ones she saw in campy display on her TV screen—perfectly represented to her the state of fame in the twenty-first century: a gorgeous and grotesque display of sex and death. To Gaga, society's monster was no longer a swamp creature, vampire, or grizzly beast, but a celebrity.

Gaga's *Fame Monster* era was a glittering regurgitation of Hollywood monster culture. In her visuals, she made the monstrous extremely chic and high fashion. Her *Fame Monster* music videos, while fundamentally Gothic in spirit, were also among the most stylish of the late 2000s and early 2010s. In "Alejandro," she combined steampunk Goth with latex and leather. In "Bad Romance," she donned a steampunk bra and an insect suit made by Alexander McQueen, while her fashion runway decayed and became a graveyard of glamor.

After this era, Gaga's monster concept became friendlier and friendlier. Just as early Hollywood movies had turned the monster into a misunderstood outsider, Gaga took on that role and invited her fans to follow. During her medley performance at the 2010 Grammys, an actor wearing a business suit threw her into a vat while her backup dancers screamed to get the monster off the stage. Gaga was using the monstrous as a point of resistance. She embodied a sense of individuality that was being exiled by the heartless suits of the world.

From thereon, the monster became the icon of her campaign for self-esteem during her *Born This Way* era, a time when she encouraged her fans to embrace their imperfections and idiosyncrasies. She designated herself Mother Monster

and referred to her fans as Little Monsters. Just as Bowie had made himself a representative for all the outsiders and weirdos, Gaga had become the twenty-first century's queen of the misfits.

Just over five years later, one of pop's most unlikely Goth candidates dressed herself up in the trappings of darkness. While Gaga was pop's monster, this star was gaining more and more recognition as America's sweetheart, a blonde-haired beacon of light who produced arena-sized anthems of teenage heartbreak. That is, until she died in 2017—or, rather, the *old version* of her died. Yes, even Taylor Swift has had a Goth phase.

Taylor Swift performing during her Reputation stadium tour.

In the year leading up to this Gothic reintroduction, Swift was uncharacteristically absent. She hadn't released an album in three years—the longest break in her career—and hadn't posted on her social media for several months. She was still shaken by a highly publicized feud she'd had with Kanye West and his then-wife Kim Kardashian. The world had sided against her.

Just as the summer of 2017 was winding down, Swift began teasing her sixth studio album, *Reputation*, with a series of ominous images on Instagram: snakes, Olde English fonts, dark filters all around. Then came her Gothic *pièce de résistance*: the music video for *Reputation's* first single, "Look What You Made Me Do." Over the span of four minutes, Swift entered her Mall Goth era, becoming a zombified, grave-crawling, demonic version of herself.

Just as it had with Madonna, Rihanna, and Gaga, the Gothic enabled Swift's reflections on fame. While Swift

Billie Eilish in acid green Health Goth.

SPOTLIGHT ON BILLIE EILISH

The very first Gen Z pop star to truly make waves, Billie Eilish spoke for a generation who'd been born into phone addiction, climate catastrophe, and a general sense of ennui. Born Billie Eilish Pirate Baird O'Connell in 2001 in Los Angeles, she was homeschooled as a child and encouraged by her parents to take up creative pursuits. She learned to play the ukulele at six and by the time she was eleven, she'd written her first song. A true Gothic prodigy, that first song lifted episode titles and general inspiration from the TV series *The Walking Dead*. The arrival of her breakout album several years later, *When We All Fall Asleep, Where Do We Go?*, in 2019 became an instant megahit and brought Goth and gore back into the mainstream.

had previously been playing the fame game straight, *Reputation* provided a meta-commentary on modern celebrity, not unlike Gaga's earlier work. *Reputation* was much more inward-facing, though, a reflection on how fame had affected Swift specifically. It had turned her as monstrous as Gaga warned it would. But in Swift's case, all it took was one purge to get rid of the monstrosity. Her Goth moment helped Swift regain her reputation, and she came back two years later with *Lover*, the most saccharine and bubblegum pop album of her career.

In the same year as *Lover's* release, an emerging artist who ate spiders, sang about murdering all her friends, and made music with the sounds of dental drills pushed the macabre to the center of pop culture. For one of the first times in mainstream pop history, a young artist used the Gothic not as a course-correcting strategy but as an unforgettable introduction. Her name was Billie Eilish.

Right from the get-go, the then-eighteen Eilish used the Goth as a force of control. She'd grown up seeing teenage pop stars pulverized by the industry, so she came in wearing demonic spikes (figuratively, though sometimes literally too). Before Eilish, the Goth came in phases or merely as outfit changes for the pop star, but it was the backbone of Eilish's persona. This was all part of Eilish's strategy to repulse her audience, rather than seduce them. Eilish's music videos stretched morbidity as far as it could go without being banned on YouTube. She cried oily black tears. She opened her mouth to reveal large spiders. She was subject to attacks from faceless tormentors who jabbed her with syringes and burned her skin with cigarette butts.

This was the voice that Gen Z needed: a Goth auteur who could scream back at a world on fire. Eilish was one of the first major pop stars to realize that the Goth is aesthetically aligned with Gen Z's existential fears: climate change, social media addiction, general loneliness, and isolation. Eilish's gruesome confrontations with death, decay, and the monsters under her bed has allowed a generation to turn their real fears into the ooky kind. *This* is just what Goth was made for.

BE RIGHT BAT: CYBER GOTH

rom the English novel to the comic and from the first photos to the first movies, the Gothic has always been at the forefront of new inventions. The new is inherently Gothic; there's a spookiness to it, a kind of dark magic in all new inventions. Feel your stomach curdle when you discuss AI? Well, imagine how a Victorian felt when they saw a picture of themselves for the first time. The new is also haunted by death: For something new to come about, an old world has to be laid to rest.

Goths were some of the very first adopters of the internet, just as they were early novelists, photographers, and filmmakers. They embraced this new technology and allowed it to fundamentally change how they functioned as a subculture. That Goth has even survived to the present day is in no small part due to the internet. From its early GeoCities days through to LiveJournal and from MySpace to TikTok, the Goth has mutated with each iteration of the internet, remaining contemporary yet firmly in the past all at once.

Goths at the 2024 Wave Gothic Gathering Annual Picnic in Leipzig, Germany.

All alternative subcultures, not just Goth, have thrived on the internet. Digital gathering places enabled people with niche interests to form their own villages, without locational or other restrictions. The online world also offered a degree of anonymity and a greater freedom of expression. On the internet, Goths could be seen how they wanted to be seen, and by the people they actually wanted to see them. Identities and communities were no longer accidents of biography and geography, but a product of choice.

In the '90s, thanks to the internet, Goth culture boomed. The explosion of the Gothic into the mainstream, with musicians like Marilyn Manson and Nine Inch Nails, and movies like *The Craft* and *The Crow*, was surely facilitated by the growing Goth cyberculture. And for at least its first decade, the internet was seen as a place full of utopian possibilities. Goths could share files with one another with somewhat relative ease and share themselves in an earnest way. They could learn from others and diversify their knowledge.

Among the first online Goths were college students. With access to IT suites in their dorms, these Goths spent a good amount of their downtime learning the ropes of the web while they customized their sites on GeoCities, one of the very first major site hosts. Goths tended to post their website URLs on posters and zines that they'd spread throughout alternative bars and venues, the online and offline culture feeding off one another. Personal websites were really the only way to connect. People would simply post their thoughts and opinions, sharing aesthetics of choice via rudimentary HTML. These early Goth websites functioned as a kind of personal newsletter, which soon morphed into newsgroups. Newsgroups were essentially websites and listings that would be emailed out to subscribers, allowing for a greater sense of connection.

EARLY INTERNET GOTH SLANG

G2G = got to goth ATM = ankh throat model
BRB = bats rushing by LMAO = laughing my ankh off

One of the first and certainly the most popular Goth newsgroups was alt.gothic. Originally a Sisters of Mercy mailing list, alt.gothic expanded into a more general newsgroup in 1990 and invited a mostly American late-night crowd. Rather than a place for swapping music recommendations and Goth lore, alt.gothic initially just brought out the Goths' dark and horny sides, and so it quickly became filled with dirty, NSFW chat. (But what else can you expect from the internet? It's always been the land of cats and porn.) Soon enough, though, the function of alt.gothic expanded beyond an easy, sleazy late-night booty call and became a place for Goths to convene in earnest. They began logging on every day and making digital friends, all the while intensifying their commitment to the Goth subculture.

Hopefully, by the time you read this, alt.gothic will still be accessible. As of this writing, it is still frozen in time, a delightful early internet relic full of dead hyperlinks and dead-ended keyword journeys, laying as living and deceased as a vampire. While it's now covered in digital cobwebs, in the '90s it would have received thousands of hits per day. Once alt.gothic added chat forums to the site in the early twenty-first century, that number increased exponentially. Users would leave hundreds of comments a day, covering every topic under the moon from Goth philosophy to how to navigate Goth-on-Goth relationships. The chat forum became an invaluable Goth resource, as well as a way to consolidate Goth identity. Users discussed amongst themselves and signed into law the proper Goth attire, as well as the kind of media a true Goth should consume.

With the popularization of the chat forums, cybergoth subculture truly emerged, as did a name for the online participants: the net.goths. The net. goths network rapidly expanded worldwide, both online and off. Together, they created new Goth traditions and customs, including annual meetups in cities and towns across the world, the most famous being the yearly meet in Whitby, the supposed birthplace of Count Dracula.

Among the new online traditions was Goth roleplay, most popularly vampire LARPing (live action role playing). Presented with the opportunity to be anything or anyone they wanted online, many Goths of course chose to be blood-sucking, garlic-hating creatures. Soon, net.goth forums catering specifically to vampire LARPers emerged, places where participants could swap neck-biting tips, exchange blood ritual recipes, and moan about sunlight.

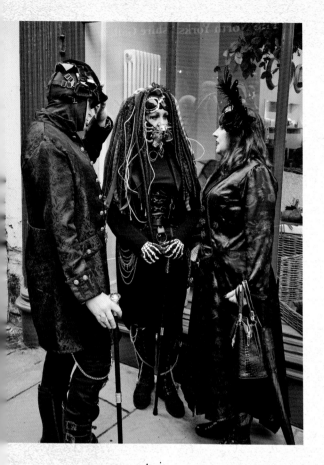

A gaggle of Goths at the Whitby weekend in 2024.

Some online vampires migrated to the aptly-named VampireFreaks—not so much a specific vampire roleplaying site as just another Goth social networking site. Created in 1999 by a university student named Jet Berelson, VampireFreaks—now an online clothing store—swiftly became the go-to dark spot for Goths online, filled with frequent design contests, comprehensive event pages, and interviews with hot Goth figures. Its message board and chat forums were ultra-popular and from them, online users split off into their own self-described "cults." On VampireFreaks, many Goths found love, formed bands, and learned how to code (on VampireFreaks, your social status was sort of determined by how well you could code).

Because of alt.gothic and VampireFreaks, Goth cyberculture was playful and primarily social. That held until the mid-2000s, when the rise of LiveJournal initiated a swing back to the personal and diaristic forms of online communication popular before the advent of forums. Founded in 1999, LiveJournal—a platform that allowed its users to write lengthy posts—truly took off a few years later and produced the world's first generation of bloggers. Many of these were, of course, Goths. Even if LiveJournal didn't necessarily have a social interface, offline at shows and clubs, Goths would often initiate social contact by swapping their LiveJournal usernames. It was a surefire way to establish a pretty intimate connection.

In the mid-2000s, a new website that bridged the gap between the social world of VampireFreaks and the individualism of LiveJournal emerged: MySpace. Created by a dude called MySpace Tom (birth name: Tom Anderson), the site was an immediate hit with Goths, who made up the bulk of the site's user base and helped to define its associated aesthetics going forward. On MySpace, Goths and jocks alike (though mainly Goths) could create online profiles reminiscent of GeoCities, write lengthy blogposts like the ones they'd

TYPICAL GOTH MSN CONVERSATION

˚⁺˙⁺✦†eden<3 bunny˚⁺˙⁺✦:
Hey bbz can i get a hug afterskewl tomoz :3

—✦·†·✦—dnt luk @ me—✦·†·✦—:
-.- i 2 shy

˚⁺˙⁺✦†eden<3 bunny˚⁺˙⁺✦:
Yyyyy shy </3

—✦·†·✦—dnt luk @ me—✦·†·✦—:
Im sewwww ugli ;/

˚⁺˙⁺✦†eden<3 bunny˚⁺˙⁺✦:
no bbz u so haaawt xD

—✦·†·✦—dnt luk @ me—✦·†·✦—:
blush

˚⁺˙⁺✦†eden<3 bunny˚⁺˙⁺✦:
i drink ur bld? Pweeeease :3

—✦·†·✦—dnt luk @ me—✦·†·✦—:
G2G.

written on LiveJournal, post events on bulletin boards as they had on alt.goths, and roleplay and even argue with other Goths as they had on VampireFreaks.

MySpace was the site where Goth cybercultural style became crystallized and homogenized. Just about every Goth username was some variation on something like *XxMissMurderxX*; every Goth used these emoticons: xD, · (o_O), :3; and every Goth spent hours upon hours trying to get their profile

picture just right. On MySpace, the profile picture was of grave importance: It was the Goth's first introduction to the world. While coding had been the way to secure clout on VampireFreaks, on MySpace, the prettier you were, the more Goth clout you gained. To be considered hot by MySpace Goth standards, you basically had to own an airbrushing kit and quickly get used to straightening your hair until it turned stiff and started steaming. Intricate, raccoon-style eyeshadow technique was also of utmost importance. To capture the perfect profile pic, you'd need a mirror, a $100 digital camera, and an arm long enough to point down at yourself for a bird's-eye-view shot. Click. Upload. Reap that sweet, sweet Goth clout.

While MySpace introduced the importance of Goth visual style and personal presentation, this was essentially Tumblr's entire basis in the 2010s. Created by a New York City hipster named David Karp in 2007, right at the peak of MySpace's powers, Tumblr—a self-dubbed "microblogging" site—stole MySpace's Goth clientele. While MySpace invited just about everyone into its fold, Tumblr drew a more alternative crowd. This might have been because Tumblr was simply less intuitive and more of an insular world, one that took a little while to get the hang of. There was a lot of Tumblr lingo to learn: users *shipped* celebrities, hashtagged their posts with a variation of keyboard gibberish like *kjdbfijefbeqpdnfwuix*, and posted GPOYs (gratuitous pictures of yourself). Superfans and misfit kids who hadn't necessarily found their tribe in the real world came to speak this language fluently.

Tumblr was a more visual and emotionally affecting experience than just about any major social media platform that came before it or that has existed since. On it, Goths created visual archives and repertoires by reposting black-and-white images of graves, dead flowers, and bruised knees. Most of the images under the

Cybergoths in Santiago, Chile, in 2007.

Goth rubric channeled images of illness, pain, and harm through a soft and faded light, combining the cute with the abject. Any band whose music did something similar became prime Tumblr fodder.

Since everything on Tumblr was aesthetic-first, users first learned about bands from their image. If a band looked cool enough—as bands like the Cure, Joy Division and Bauhaus certainly did—users would type them into YouTube and go down the Goth wormhole. Every Tumblr post seemed to have an atmosphere or mood to it, which only enhanced the music discovery experience. Bands would come to be associated with certain kinds of aesthetics, like dark academia—a Tumblr creation which met the Gothic with images of old libraries and universities.

These kinds of specific aesthetics came to the mainstream with the swift rise of TikTok during the pandemic of the early 2020s. TikTok essentially brought to the surface what Tumblr had kept underground years before: a series of aesthetics like dark academia and the famous cottagecore, which created a kind of visual grouping with which one would associate themselves. Like living mood boards, TikTokers dressed in the attributes of these aesthetics and circulated them over and over.

With its sheer visual power, TikTok fundamentally reshaped Goth and just about every other alternative scene, converting what we once called subcultures into aesthetics. While subcultures may have once been politically motivated—or were at least a kind of resistance to the mainstream—aesthetics are apolitical in nature and solely about looking the part. With their low barriers to entry, they are the mainstream. You no longer need to attend Goth clubs, sign up to a niche website, or even become the mopey cousin—all you need to do to become a Goth today is buy a Goth-coded outfit from a fast fashion site and post about it on TikTok with the hashtag #goth.

As of writing, multiple billions of users have done so. The data speaks loudly: Goth is no longer a fringe group but one that has overtaken the mainstream. It might be a slightly diluted version of the Goth we once knew, but Goth is here to stay. No matter what happens to us and no matter what happens to the world, the Goth will always travel with us. It is as inevitable and persistent as death. And isn't that as comforting as it is terrifying?

CONCLUSION

reat. We've made it to the end. That means we're not dead . . . yet. But when we do go, we'll fall into our watery graves and find in the darkness the answers we spent our lives searching for.

And if the people we leave behind wonder where our souls have traveled, Goth might not answer their questions, but it will encourage their dark inquiries. So, we'll rest easy in the grave, safe in the knowledge that our kids, and their kids, and their kids, and their kids—and so on—will always have Goth to lean into. Like the barbarians, Goth will be their revolt against the man. Like the medieval architects, it will be their way of finding light through darkness. Like the first Gothic novelists, it will turn their fears into an enticing formula. Like the Gothic parodists, it will be how they find a way to laugh at your funeral. Like the Goths of the 1980s, who turned centuries of castigation into a self-celebrating culture, Goth will be their way of finding community, of dressing fabulously, of dancing, of singing, of screaming, of building relationships strong enough to conquer death.

And, if these kids grow old with Goth, turning from babybats into eldergoths, they'll experience an alternative kind of aging too. While everyone else around them will decay like the picture of Dorian Gray, they will take their final steps to the grave with a twinkle in their eye. They'll know that nothing ages you better than Goth. Goth doesn't see youth, it doesn't see health, it doesn't see the skin covering the skeleton. Goth is just an indiscriminate fact of life, the closest thing the living will ever have to immortality. Forget taxes, the only truly eternal things in this life are death and Goth. Happy dying!

RIGHT: Hurd Hatfield as Dorian Gray in the 1945 film adaption of *The Picture of Dorian Gray*.

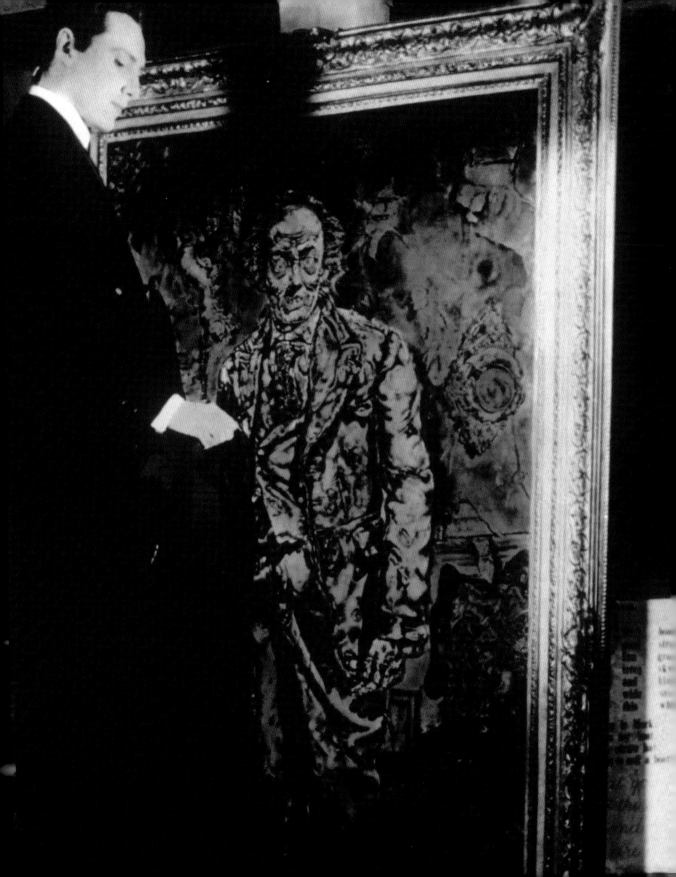

SOURCES

Baird, Julia. *Victoria: The Queen.* Random House Publishing Group, 2017.

Bolton, Andrew. *Alexander McQueen: Savage Beauty.* Metropolitan Museum of Art, 2011.

Brooker, Will. *Batman Unmasked.* Bloomsbury Academic, 2001.

Buckley, Germaine Chloé. *Twenty-First-Century Children's Gothic.* Edinburgh University Press, 2018.

Burke, Edmund. *A Philosophical Enquiry Into the Origin of Our Ideas of the Sublime and Beautiful.* F.C. and J. Rivington, Otridge and Son, 1812.

Byron, Glennis. *Globalgothic.* Manchester University Press, 2015.

Cameron, Ed. *The Psychopathology of the Gothic Romance.* McFarland, Incorporated, Publishers, 2014.

Chalcraft, Anna. *Strawberry Hill: Horace Walpole's Gothic Castle.* Frances Lincoln, 2011.

Crossley, Paul. *Gothic Architecture.* Yale University Press, 2000.

Dery, Mark. *Born to Be Posthumous: The Eccentric Life and Mysterious Genius of Edward Gorey.* HarperCollins, 2018.

Dawson, Ian. *Medicine in the Middle Ages.* Enchanted Lion Books, 2005.

Dougherty, J. Martin. *The 'Dark' Ages: From the Sack of Rome to Hastings.* Amber Books Limited, 2019.

Douris, Alexandra Steele. *Spirits, Seers & Séances.* Llewellyn Worldwide, Limited, 2023.

Ezra, Elizabeth. *Georges Méliès.* Manchester University Press, 2019.

Frayling, Christopher. *Vampyres: Lord Byron to Count Dracula.* Faber & Faber, 1992.

Gilbert, M. Sandra. *The Madwoman in the Attic.* Yale University Press, 1979.

Goodlad, M. E. Lauren. *Goth: Undead Subculture.* Duke University Press, 2007.

Groom, Nick. *The Vampire: A New History.* Yale University Press, 2018.

Gwynn, M. David. *The Goths: Lost Civilizations.* Reaktion Books, 2017.

Hand, J. Richard. *Gothic Film: An Edinburgh Companion.* Edinburgh University Press, 2022.

Harriman, Andrea. *Some Wear Leather, Some Wear Lace.* Intellect Books, 2014.

Hebdige, Dick. *Subculture.* Taylor & Francis, 2013.

Hogle, E. Jerrold. *The Cambridge Companion to Gothic Fiction.* Cambridge University Press, 2002.

Holland, Tom. *The Vampyre: The Secret History of Lord Byron.* Abacus, 1995.

Howard, Vicki. *From Main Street to Mall.* University of Pennsylvania Press, 2015.

Jordan, E. Thomas. *Victorian Childhood.* State University of New York Press, 1987.

Kallen, A. Stuart, *Vampire History and Lore.* ReferencePoint Press, 2011.

Kieckhefer, Richard. *Magic in the Middle Ages.* Cambridge University Press, 2021.

Klein, Bruno. *Gothic: Visual Art of the Middle Ages 1140-1500*. H. F. Ullman, 2012.

Kramer, Heinrich. *Malleus Maleficarum*. Cosimos Classics, 2007.

Kulikowski, Michael. *Rome's Gothic Wars From the Third Century to Alaric*. Cambridge University Press, 2006.

Lyden, M. Anne. *A Royal Passion: Queen Victoria and Photography*. J. Paul Getty Museum, 2014.

Marsico, Katie. *The Columbine High School Massacre*. Marshall Cavendish Benchmark, 2011.

Meikle, Denis. *A History of Horrors: The Rise and Fall of the House of Hammer*. Scarecrow Press, 2001.

Meyers, Jeffrey. *Edgar Allan Poe: His Life and Legacy*. Cooper Square Press, 2000.

Natale, Simone. *Supernatural Entertainments*. Penn State University Press, 2016.

Radcliffe, Ann. *The Mysteries of Udolpho*. G. G. and J. Robinson, 1794.

Rigby, Jonathan. *English Gothic: A Century of Horror Cinema*. Reynolds & Hearn, 2006.

Sade, de Marquis. *The Crimes of Love*. P. Owen, 1800.

Scheunemann, Dietrich. *Expressionist Film—New Perspectives*. Camden House, 2003.

Scott, Geoffrey. *Gothic Rage Undone: English Monks in the Age of Enlightenment*. Downside Abbey, 1992.

Shelley, Mary. *Frankenstein*. Simon & Schuster, 1818.

Spracklen, Beverley and Karl. *The Evolution of Goth Culture: The Origins and Deeds of the New Goths*. Emerald Publishing Limited, 2018.

Steele, Valerie. *Dark Glamour*. Yale University Press, 2008.

Stoker, Bram. *Dracula*. Archibald Constable and Company, 1897.

Sumberac, Manuel. *Steampunk: Poe*. Running Press, 2011.

Toman, Rolf. *Romanesque Art*. Feierabend, 2002.

Tuite, Clara. *Lord Byron and Scandalous Celebrity*. Cambridge University Press, 2015.

Vasari, Giorgio. *Lives of the Most Excellent Painters, Sculptors, and Architects*. Good Press, 2023.

Victor, S. Jeffrey. *Satanic Panic*. Open Court, 1993.

Walpole, Horace. *The Castle of Otranto*. Chadwyck-Healey, 1764.

Weinstock, Andrew Jeffrey. *The Works of Tim Burton*. Palgrave Macmillan, 2013.

Wolfram, Herwig. *History of the Goths*. University of California Press, 1990.

Woodyard, Chris. *The Victorian Book of the Dead*. Kestrel Publications, 2014.

Wright, Angela. *Ann Radcliffe, Romanticism and the Gothic*. Cambridge University Press, 2014.

PHOTO CREDITS

INDEX

ACKNOWLEDGMENTS

I would like to give my eternal thanks to mum, dad, James, Harriet, Edie, Josie, Tina, Jon, Pippy, Koda, Na'vi, Lucy, Daniel, Sarah, George, my angels Rachael and Brie, and most of all, to sweet Hannah, the Mountain where all the beauty came from.

ABOUT THE AUTHOR

Emma Madden was born in Reading, England, and studied English Literature at the University of Sussex. After launching their freelance writing career from an attic in Brighton, Madden now writes and resides with their wife and a puckish King Charles Cavalier in Los Angeles. They write about music, digital culture, subcultures, and sometimes dogs for both print and online publications, including regular bylines in *The New York Times*, *New York* magazine, *GQ*, *The Guardian*, *Pitchfork*, and countless others. Still in their Goth phase, Madden enjoys sulking and moaning about the world's wretchedness while listening to Joy Division.

First published in 2025 by Castle Books, an imprint of The Quarto Group,
142 West 36th Street, 4th Floor, New York, NY 10018, USA
(212) 779-4972 • www.Quarto.com

Castle titles are also available at discount for retail, wholesale, promotional, and bulk purchase. For details, contact the Special Sales Manager by email at specialsales@quarto.com or by mail at The Quarto Group, Attn: Special Sales Manager, 100 Cummings Center Suite 265D, Beverly, MA 01915 USA.

10 9 8 7 6 5 4 3 2 1

ISBN: 978-1-5771-5526-3

Digital edition published in 2025
eISBN: 978-0-7603-9629-2

Library of Congress Cataloging-in-Publication Data

Names: Madden, Emma, author.
Title: Eternal goth : exploring the world's most enigmatic cultural
 movement / Emma Madden.
Description: New York : Castle Books, 2025. | Includes bibliographical
 references and index. | Summary: "Delve into the roots of a macabre
 lifestyle in Eternal Goth, a comprehensive exploration of gothic culture
 through the ages"-- Provided by publisher.
Identifiers: LCCN 2024058175 (print) | LCCN 2024058176 (ebook) | ISBN
 9781577155263 | ISBN 9780760396292 (ebook)
Subjects: LCSH: Goth culture (Subculture)--History. | Gothic
 literature--History.
Classification: LCC HM646 .M33 2025 (print) | LCC HM646 (ebook) | DDC
 306/.109--dc23/eng/20250115
LC record available at https://lccn.loc.gov/2024058175
LC ebook record available at https://lccn.loc.gov/2024058176

Group Publisher: Rage Kindelsperger
Creative Director: Laura Drew
Senior Art Director: Marisa Kwek
Cover Design: Amelia LeBarron
Interior Design: Silverglass
Interior Page Layout: Howie Severson

Printed in China